Hagop Kevorkian Series on
Near Eastern Art and Civilization

The publication of this work has been aided by
a grant from the Hagop Kevorkian Fund.

OTTOMAN ART IN THE SERVICE OF THE EMPIRE

Zdzisław Żygulski, Jr.

NEW YORK UNIVERSITY PRESS
NEW YORK AND LONDON

Library of Congress Cataloging-in-Publication Data
Żygulski, Zdzisław.
Ottoman art in the service of the empire / Zdzisław Żygulski.
p. cm.—(Hagop Kevorkian series on Near Eastern art and
civilization)
Includes bibliographical references (p.) and index.
ISBN 0-8147-9671-0
1. Decorative arts—Turkey—Themes, motives. 2. Art and state—
Turkey. 3. Art patronage—Turkey. I. Title. II. Series.
NK1011.Z94 1991
745'.09561—dc20 91-4446
 CIP

Contents

Illustrations vii

Preface xi

CHAPTER 1
Flags 1

CHAPTER 2
Horsetail Standards—Tughs 69

CHAPTER 3
Sultans' Dress and Arms 101

CHAPTER 4
Tents 153

Conclusion 177

Select Bibliography 179

Index of Names 183

Index of Foreign and Technical Terms 187

Index of the Koran 190

Index of Subjects 191

vi

Illustrations

COLOR PLATES

All color plates appear as a group following p. 52.

Pl. 1. Arab Cavalry with Flags
Pl. 2. ʿAlī Fighting with the Zulfikar Sword
Pl. 3. Ottoman Flag, Zulfikar Type
Pl. 4. Consul Magnus
Pl. 5. Ottoman Saddle and Trappings
Pl. 6. Tughs Carried by Pilgrims to Mecca
Pl. 7. Two Tughs Taken at Vienna, 1683
Pl. 8. The Reception of Polish Envoy by Mehmed IV
Pl. 9. Polygonal Red Tent from Vienna Booty

FIGURES

Fig. 1. Early Vexilloids and Standards 4
Fig. 2. Later Vexilloids and Standards 5
Fig. 3. Flag Shapes and Hoists 6
Fig. 4. Tughra with Sword Emblem of Sultan Selim III 26
Fig. 5. Various Motifs of Crescents and Stars 37

Fig. 6. Motifs of Crescents and Stars in Turkish Art 37
Fig. 7. Two-Horned Motifs in Susa Pottery 38
Fig. 8. Motifs of the Morning Star, Crescents, and the Sun 40
Fig. 9. Motifs of Solomon's Seal 40
Fig. 10. Motifs of the Zulfikar Sword in Ottoman Art 44
Fig. 11. The Czintamani Motif 45
Fig. 12. Motifs of the Hand and of the Lily 50
Fig. 13. Motif of the Solar Bird Fighting With Dragon 53
Fig. 14. The Phoenix and Dragon from a Persian Blade 54
Fig. 15. Floral Motifs from Ottoman Flags 56
Fig. 16. Forms of Tughs Outside Ottoman Turkey 72
Fig. 17. Peculiar Forms of Ottoman Tughs 73
Fig. 18. Mamelukes' Alems for Tughs 74
Fig. 19. Later Forms of Tughs Outside Turkey 95
Fig. 20. Contemporary Turkish Schellenbaum 96
Fig. 21. Various Types of Ottoman Turbans 105
Fig. 22. Various Ottoman Headgear 106
Fig. 23. Various Types of Tents 158

PHOTO ILLUSTRATIONS

Ill. 1. Pilgrims to Mecca with Banners 11
Ill. 2. Sipahis Carrying Lances with Pennons 12
Ill. 3. "Muhammad's Banner" 18
Ill. 4. Types of Ottoman Flags 28
Ill. 5. Janissary Signs 29
Ill. 6. Janissary Signs 30
Ill. 7. Ottoman Infantry Marching with Flags 31
Ill. 8. Ottoman Flag, Inscriptional Type 34
Ill. 9. Ottoman Flag, Zulfikar Type 47
Ill. 10. Zulfikar Sword from Zamoyski's Flag 48
Ill. 11. Ottoman Flag of Many Motifs 51
Ill. 12. Rug with Motifs of the Phoenix and Dragon 52
Ill. 13. Tughs from Army of Maḥmūd of Ghazna 75
Ill. 14. Ottoman Tugh Bearers 76
Ill. 15. Tughs in Armory of Topkapı Saray Museum 77
Ill. 16. Ottoman Tughs Captured at Battle of Vienna 78
Ill. 17. Tugh, Probably from the Vienna Booty 79
Ill. 18. Tugh, Probably from the Vienna Booty 80

Ill. 19. Ottoman Tughs of Seventeenth Century 81
Ill. 20. Ottoman Tughs of Seventeenth Century 82
Ill. 21. Tughs Before Tents of Grand Vizier Süleyman 84
Ill. 22. Tughs Before Tents of Sultan Mustafa II 85
Ill. 23. Ottoman Army Marching With Tughs and Flags 86
Ill. 24. Ottoman Tugh with European Crescent 87
Ill. 25. Pendulous Tugh on the Ship of Shi'ism 90
Ill. 26. Ottoman Boncuk 92
Ill. 27. Boncuk of Gold and Silk Threads 93
Ill. 28. Polish Hetman's Sign 94
Ill. 29. Ottoman Dress Shown in Miniature 108
Ill. 30. Turbans of the Safavid Style 109
Ill. 31. Types of Ottoman Turbans 110
Ill. 32. Janissary Turban with Sign for Bravery 112
Ill. 33. Janissary Turban with Sign for Bravery 114
Ill. 34. Sultan Murad III 115
Ill. 35. Turban Worn by Ottoman Dignitary 116
Ill. 36. Kaftan of Sultan Mehmed II 119
Ill. 37. Kaftan of Sultan Mehmed II 120
Ill. 38. Kaftan of Sultan Selim II 122
Ill. 39. Kaftan of Sultan Murad II 123
Ill. 40. Kaftan of a Sultan with "Saz" Decoration 124
Ill. 41. Portrait of Sultan Mehmed II 126
Ill. 42. Portrait of Painter in Turkish Dress 128
Ill. 43. Sultan Mehmed III 129
Ill. 44. King Stephen Bathory with Ceremonial Handkerchief 130
Ill. 45. Ottoman Mace of the Sixteenth Century 131
Ill. 46. Ottoman Maces of the Seventeenth Century 132
Ill. 47. Ottoman Mace of the Seventeenth Century 133
Ill. 48. A Turkish Mace 134
Ill. 49. Ceremonial Ottoman Mace of Jade and Rubies 135
Ill. 50. Types of Swords, Sabres, and Other Arms 136
Ill. 51. Arms and Armor of Sultan Mehmed II 137
Ill. 52. Ottoman Parade Sabre 138
Ill. 53. Ottoman Sabre with Persian Blade 139
Ill. 54. Ottoman Tuck in Imperial Style 140
Ill. 55. Early Ottoman Helmet 141
Ill. 56. Ottoman Mail and Plates Armor 142
Ill. 57. Ottoman Helmet 143

Ill. 58. Ottoman Saddle (a fragment) 144
Ill. 59. Ottoman Saddle in the Imperial Style 145
Ill. 60. Ottoman Quiver and Arrows 146
Ill. 61. Ottoman Kalkan Shield 147
Ill. 62. Stirrup of Grand Vizier Kara Mustafa 148
Ill. 63. Janissaries Carrying Gigantic Arms 149
Ill. 64. Various Ottoman Tents 154
Ill. 65. Various Ottoman Tents 155
Ill. 66. Sultan Murad II in His Imperial Tent 161
Ill. 67. Imperial Tent of Sultan Süleyman 162
Ill. 68. Miniature Showing Enthroned Sultan Selim II 163
Ill. 69. Tents in Miniature for Sultan Ahmed III 164
Ill. 70. Two-Poled Tent, Captured at Vienna 166
Ill. 71. Three-Poled Tent, Captured at Vienna 167
Ill. 72. Fragment of Ottoman Red Tent 168
Ill. 73. Ottoman Tent, Sayeban Type 170

Preface

The flag has always been a visual symbol of the state. In form and content, flags have been the product not only of the artistic skill of the craftsmen who made them but also a significant expression of political and religious ideas.

The Hagop Kevorkian Center for Near Eastern Studies of New York University asked me to present a discussion of the role flags and other objects had in Ottoman history. This book is based on the lectures I gave in 1989 at New York University in response to that invitation.

The most important single factor in the long history of the Turkish peoples was the change from a nomadic to a settled way of life. The Ottomans succeeded in creating a state with imperial dimensions, replacing the former Roman-Byzantine Empire with a dominion over substantial parts of three continents—Asia, Africa, and Europe. To sustain this state, the Turks used their Islamic faith, of which they had become the most fervent followers, and borrowed numerous symbols and instruments from other nations that proved important for their state. Everything was symbolically subordinated to the idea of empire, which, in turn, was embodied in the person of the sultan.

In this state system art and architecture played a substantial role. The Ottomans followed the patterns of their predecessors, adapting as they saw fit certain practices of the Greeks, Romans, Byzantines, Persians, and Armenians. Ottoman architecture reached its apogee in the creation of the great mosques with all their annexes, in the complex foundations of sultans *(külliye)*, and in the great palaces *(sarays)*.

In estimating the value art and architecture had for the Ottoman state, I am going to concentrate in this study on the minor arts, in which many traditional, still nomadic, features were used to serve the idea of empire—and in which a very high level of craft technology and great invention were found. All this led to the establishment of a unique Ottoman Empire style for ensigns, dress, arms, armor, tents, and various other objects. The main outward purpose of this style was to furnish the state with the richest and most colorful vestments, bearing numerous inner meanings, understandable to the faithful but bewildering or frightening to the enemy. These phenomena have only rarely been the subject of deeper study and reflection. They are often completely ignored in general books on Turkish art and culture.

Any first attempt to examine these problems must remain far from conclusive. Many questions remain unanswered, the key to exact explanations being still hidden in the vast archives of Istanbul and other cities. Not being averse to discussion and criticism, I shall be happy if this book forms one step on the long way to a better understanding of an obscure past, one that we perhaps can never fully comprehend.

ZDZISŁAW ŻYGULSKI, JR.

CHAPTER 1

Flags

INTRODUCTION

Historic Turkish flags pose problems that are complex and so far poorly researched. Generally, flags as a phenomenon of human culture are far from being fully explained.[1] Studies in this field have been led by the International Federation of Vexillological Associations, which organizes congresses for "banneristics," while the Flag Research Center in Winchester, Massachusetts, which has been publishing its *Flag Bulletin* since 1961, also provides a forum for research and discussion. Thanks to the efforts of these sources, some rules concerning the terminology of flags have been established. Terms in English, French, and German can now be translated into other languages, including Turkish.

Although the word *flag* and corresponding words do not always refer to the same object, the words *flag* (English) and *Flagge* (German) are recommended as generic terms for any textile used as an emblem or symbol and fastened at one end, with the other end free.[2] Any full description of a flag should include: the name of the country or nation represented by the flag; the name of the item in that country's language; the user of the flag; the date of manufacture;

1

the shape and size (height and length) of the flag; the material and techniques used in its manufacture; the flag's condition; and information concerning the design of the flag, such as whether or not its front and reverse sides are identical, along with other physical details, such as fringes, pole, tassels, sashes (cravat), finials, toggles, clips, and so on. An analysis of the flag field should include: an indication of its divisions (such as types of fields—tripes, quarters, and so on, and colors), colors and charges (emblems, inscriptions, lettering, and the like), and the colors of charges and their proportions. Generally, heraldic terms—that is to say, the description of coats of arms based on the sixteenth-century European system of blazonry—should be avoided in flag description. It is also recommended that indication of "right" and "left" be omitted; it is best to refer only to the hoist edge (at the pole), the top edge, the fly edge, and the bottom edge of the flag. Western flags are always described as if the front (obverse) were fastened (to a pole or staff) at the left of the observer, with the fly fluttering to the right. Islamic (and Turkish) flags, however, whose inscriptions are always read from right to left, are described from the opposite point of view—that is, with the flag fluttering to the left. A special type of flag, called *gonfalon*, characteristic of Italy and of associations (particularly religious ones) in Western Europe, is hung from a crossbar and generally terminates in scallops, turned down. A similar elongated triangle characterizes the *pennant* or *pendant*, also called a *banderole* or *streamer*, which was fastened to a yard and used on vessels. The Turks used such flags as well.

While flags come in various shapes and are of different proportions, they are predominantly rectangular or triangular. The form of the fly is substantial, and it may be double-pointed, swallow-tailed, even triple-swallow-tailed, rounded, or descate. The last case is typical for most Ottoman flags: they are rectangular, with a triangular fly, and usually have a border. In a descate flag, the length is the distance from the middle of the hoist edge to the middle of the fly edge, and in a triangular flag, to the fly point.[3]

SOME REMARKS ON THE HISTORY OF FLAGS

Ottoman flags were made to the highest standards, since they exhibited a determined state ideology. Achievements of this order in flag

2

making were Asiatic in origin, and some of the best traits of Asian flags were used by the Turks, in combination and often with elaboration. Arab Muslims influenced the Turks in a fundamental way, but pre-Muslim Turkish tradition was also important, as were influences from Mesopotamia, Anatolia, and Persia. In general, the flag was a product of Asia, but even European influences cannot be ignored when looking at Turkish flag design.

Europeans had developed different types of state and of military signs, although the latter did take on strong Oriental characteristics. The most typical case here is that of the Romans, who, in creating their own powerful state, developed a rich system of legal and sacred rules concerning war.[4] The oldest recorded military sign of the Romans was a bundle of straw fixed to a spear *(manipulus)*. In the later years of the Roman republic, the Roman legions fought under the signs of zoomorphic vexilloids: figures of a wolf, eagle, boar, horse, or Minotaur on top of a pole. These signs were venerated almost as gods, all ordinary military activities being carried out in front of them as if in front of a temple; they were credited as carriers of magical forces, had the rights of asylum, and witnessed the oath. It is clear that the loss of these signs in battle was considered a disaster; when they were deliberately thrown off into the enemy's ranks, this was a dramatic signal for attack and recapture. This sacred rite of the standard was continued in various other state systems, particularly the Turks'. The poles of Roman standards were also decorated with symbols. Use of a variety of animals on the standards was stopped in 104 B.C. by the Consul Marius, who ordered that the eagle (silver and then gold) be the sole emblem. The top of the pole was often spearlike, with a laurel wreath below; sometimes the symbol of a hand was placed on the top, or beneath the eagle, the symbol of a thunderbolt (representing Jove). Later on, a small horizontal bar with two metal hangings on a cord or with a small piece of fringed cloth, blue or purple, was included. There was a set of other symbols placed along the staff: round metal medallions *(phalerae)*, medallions with busts of emperors, symbolic towers, crowns, crescents, dragons' heads, and tassels under a metal cone. Some of these were certainly of Oriental origin. Unquestionably Oriental was a three-dimensional dragon *(draco)* used by Roman cavalry, then by Carolingian soldiers, and still seen as late as in the Bayeux Tapestry, with its illustration of the Battle of Hastings.[5] This dragon, made of

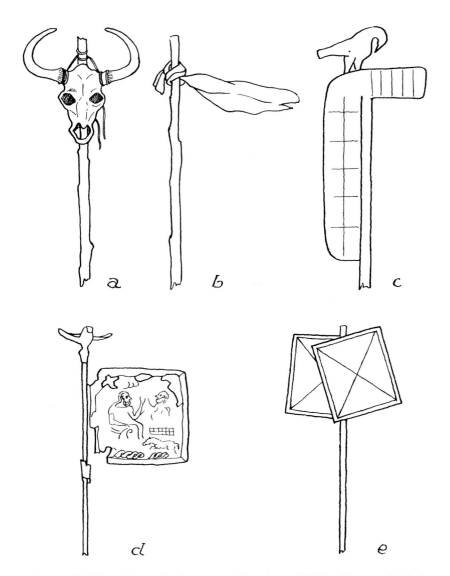

Fig. 1. Early vexilloids and standards a. prehistoric vexilloid with a bull skull on the staff b. primitive standard with a fabric soaked in blood c. Egyptian standard from the Narmer's palette, end of fourth millennium B.C. d. Iranian metal standard from the third millennium B.C. (after W. Smith) e. Persian standard from the fifth century B.C., after a red-figured vase from the Musée du Louvre.

4

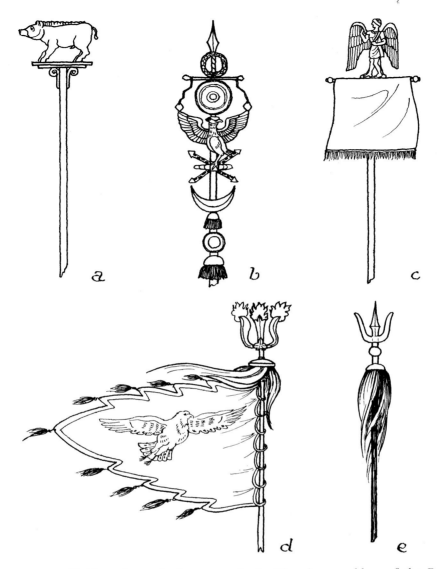

Fig. 2. Later vexilloids and standards a. standard with a boar emblem of the Roman Republic b. Roman standard with an eagle from the late Republic period c. Roman vexillum d. nine-tail standard of Genghis Khan (after W. Smith) e. Mongolian tugh from the Ulan Bator Museum (thirteenth century?).

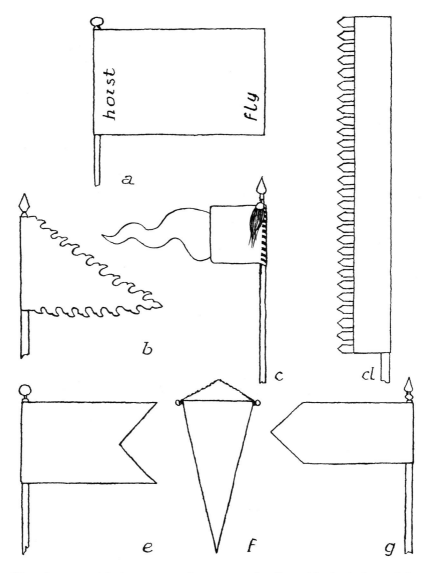

Fig. 3. Flag shapes and hoists a. regular rectangular flag with the hoist and fly marked
b. Chinese flag c. Persian flag with a tugh d. Arab flag e. swallow-tailed flag f. trian-
gular flag, gonfalon type g. Ottoman flag (sanjak).

6

linen, leather, and metal, produced a shrill whistling noise when the wind blew through it. Signal flags were also employed, to indicate tactical maneuvers.

During the late Roman Empire the flag banner was formed; it was purple with gold fringes, decorated with an eagle or ciphers, and hung from a crossbar like the later gonfalon. Byzantine flags were a continuation of the late Roman ones; they were often furnished with the ciphers of Christ, then with the double-headed eagle of the Palaeologs. They never attained a large size.

In the meantime, some new types of state and military ensigns had developed in the Far East, particularly in Mongolia and China.

The nomadic Mongols, close neighbors of the Turkish tribes, had from antiquity used totemic standards that were a kind of vexilloid, made of metal, wood, and animal hair—the *tugh* (tuğ), which will be discussed in the next chapter. Along with these, the Mongols applied to the typical cloth flag (originating in China, the land of silk), their emblems and symbols.

China had established its state symbol several centuries before our era. "In battle all appears to be turmoil and confusion," wrote Sun Tzu in the seventh century B.C. in his *Art of War*, "but flags and banners have prescribed arrangements."[6] Certainly, a great mass of fluttering colors in all shapes and sizes and designs is far more meaningful than decorative, for each flag is a communication from one human being or group of people to others. "The primordial rag dipped in the blood of a conquered enemy and lifted high on a stick —that wordless shout of victory and domination—is a motif repeated millions of times in human existence," writes Dr. Whitney Smith.[7] Thus the Chinese led in this development.

We owe to the Chinese two characteristics of flags that are now universal: their lateral attachment to the staff and a focus on the cloth rather than on its pole and finial. In fact, this marked a turning from a vexilloid to the real vexillum flag. The growth of sericulture (silk) in China, as early as the third millennium B.C., introduced the possibility of a flag that could be light in weight yet large and strong, capable of being dyed or painted to achieve symbolic variations, and reasonably durable in outdoor usage. In the Chinese army flags served to indicate rank, as a signal to soldiers, and were used to terrorize the enemy. Flags were also employed by Chinese naval and fishing boats and in religious processions. Chinese armies were tra-

ditionally organized into units carrying flags of five colors: red, yellow, blue, white, and black, each hue having ancient associations of cosmological and philosophical nature.[8] Red stood for the sun; the red phoenix for the South, for summer, and noon. In philosophical speculations, the phoenix represented the male principle—Yang. Yellow stood for the earth and China itself, while the yellow dragon was imbued with the female principle—Ying. The constant combat of Yang and Ying kept the world in balance. The yellow phoenix represented also the Chinese emperor. Blue stood for the sky; the blue dragon, for the East, spring, and morning. White stood for the moon, the West, autumn, and evening, their emblem being the white tiger. Finally, black was connected with the North, winter, and night, their symbol being the tortoise, known as the Black Warrior. The five colors for flags in China corresponded to the traditional belief that the number five signified a sense of strength and completeness, the full gamut of possible or desirable options within a certain sphere of action.

In the thirteenth century, when the Mongols took over China and founded the Yüan dynasty, the nomadic signs, with horse- and yak-tail standards, were adopted by the Chinese, and, vice versa, the cloth flags of China began to wave over the victorious riders of the steppes. All these ensigns moved westward with the subsequent migrations of the Mongols and the Turks, although it is also true that some flags had already been made much earlier by Iranian and Arab tribes. It is not easy to say whether these innovations were indirectly caused by Chinese influence or whether they came about independently.

Very little is known about old Iranian signs. Most probably they showed some traces of ancient Mesopotamian culture, charged with typical motifs of mythical, astral, and magic origin. A metal standard from third-millennium Iran with an eagle finial, published by W. Smith, is a unique specimen of that kind.[9] It has a field with the incised design of a ruler sitting on a throne, with another figure in front and lions beneath. The majesty of the king, having close contact with the gods, became a speciality of Persian state symbolism. In the Achaemenian period, a peculiar type of vexilloid was used in the Persian army, as documented in Greek vase painting: two stiff panels (possibly of metal) with "envelope" patterns, probably black and red, fixed on the top of a staff.[10] From other sources we know that the eagle was also applied on Achaemenian flags. (It should be noted that at that time the Greeks only rarely, and then only at sea, em-

8

ployed signaling flags.) In the Sasanian period flags were often decorated with tails or tassels, which points to close relations with nomad cultures. At the time of the decline of the Sasanians their large state flag (7 m × 3 m) called *dirafsh-i kāvyānī,* was made of sewn panther skins and adorned with pearls and precious stones. The Arabs captured it in the Battle of Qadisiyya and sold it for 30,000 dinars, although its real value was far greater.[11] One of the oldest images of a Persian flag is in the decoration of a ceramic plate from the tenth century, published by A. U. Pope.[12] However, our knowledge of Persian flags is based mainly on their representation in miniature paintings. Such flags are usually small, come in various shapes and colors, and bear Koranic inscriptions. According to an old Persian tradition attested to in the tenth century in Firdawsi's poem *Shāh-nāme* (The Book of Kings), the form of the Iranian battle flag came from the legendary Kāvah banner. The blacksmith Kāvah, inciting a riot against a usurper, fixed to his spear the leather apron with which he protected his legs from the sparks of the forge. A narrow elongated tooth in the upper part of most Persian flags is a reminder of Kāvah's belt. According to the seventeenth-century report of the French traveler Jean Chardin, the Safavid flags differed from Ottoman ones of the same period. Their fly was usually cut off swallow-tailed, and the field of the cloth had colored stripes, while the general symbol of the Persian state of that time was the lion and the sun. In spite of the traditional splendor of the Persian court and of the superb quality of Persian textile art, nothing compared to the imperial Ottoman art of flags.

Let us now look at Arab flags, which were of basic importance for all the countries of Islam, including Ottoman Turkey.

The oldest flags of Islam were, according to all available sources, quite modest, this corresponding with the simplicity and modesty of the Arab peoples. In all probability several Arab tribes already used colorful flags long before the Muslim era and did so for identification purposes. The first mentioned banner of Muhammad, called *ʿuqāb—* the eagle—was made of a long piece of white fabric fixed to a lance. According to legend, a new convert offered his turban to the Prophet so it could be made into a flag. However, later on at the battle at the Jewish oasis Khaibar, Muhammad fought under the black flag called *rajet.*[13] This black flag was probably associated with the Black Stone of the Kaaba. As we will see later, it was taken for granted that one

9

of the Prophet's flags was preserved as the most venerable of relics, a palladium of victory, and that it ultimately passed into the hands of the Ottoman rulers.

The first caliphs tried to maintain an original simplicity in their signs, appropriate to an ascetic and fighting religion, but soon, especially under Persian influence, the style evolved into one using more representative and pompous images. The Omayyads again used white, and the Abbasids used black, this time probably as an expression of deep mourning for their fallen and martyred coreligionists. There appeared on the Abbasid banners some quotations from the Koran as an apology for their mutiny against the Omayyads. Gradually, the flags became symbols of the dynasty, the color depending on the ruler's choice. Caliph al-Ma'mūn, for example, preferred green.

Some early Muslim flags have survived in Spain from the time of the Reconquista. In the monastery of Las Huelgas in Burgos there is a magnificent banner of Sultan al-Manṣūr of the Almohad dynasty, captured by King Alfonso VIII at the Battle of Las Navas de Tolosa in 1212. In Spain it is called *El Pendon de Las Huelgas*. In the gonfalon form, with tabbed fly,[14] this flag, dated A.H. 534 (A.D. 1140), is distinguished for its large size, sophisticated abstract decoration, and lines of Koranic inscriptions. Another flag, this time of the Almoravids, taken at the Battle of Salado (1340), is preserved in the cathedral of Toledo in Spain.[15]

Various examples of Muslim flags can be found in Arab iconography, particularly in the miniatures of the so-called Baghdad School from the first half of the thirteenth century. For example, an early twelfth-century miniature, attributed to the painter Yaḥya ibn Maḥmūd and illustrating a picaresque adventure, the *Maqāmāt*, by al-Ḥarīrī, shows a ceremonial procession of the Arab cavalry with several flags.[16] They are red, green, black, and blue, rectangular, elongated, fixed in Chinese fashion with the longer edge to the staff, with tabbed fly, and with inscriptions.

THE STOCK OF TURKISH FLAGS

We know that flags were used by Turkish tribes living as nomads in Central Asia. From very scanty sources it appears that their flag cloth was predominantly blue or red. The main flag (*haliṣ*) was surmounted by a horsetail or yaktail. Each of the twenty-four tribes of

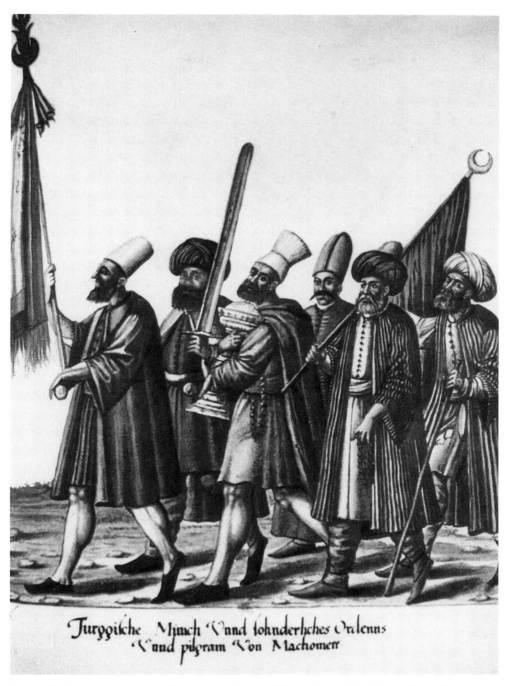

Ill. 1. Pilgrims to Mecca with banners. *Codex Vindobonensis* no. 8626, late sixteenth century. By permission of Nationalbibliothek, Vienna.

11

Ill. 2. Sipahis carrying lances with pennons. *Codex Vindobonensis* no. 8626, late sixteenth century. By permission of Nationalbibliothek, Vienna.

12

Oghuz-Turks had its own emblem *(tamga)* with which a flag was charged.[17] In their migration westward the Turkish tribes entered lands with preexisting cultures, particularly those in the Near East and Asia Minor, where they encountered the Persians and the Byzantines. There is no question that the flag images of these inhabitants was of great importance in the development of new Turkish flags. Of the Seljuk flags we know almost nothing, but the Muslim element would have been visible in them. In any event, this element was powerfully increased in Ottoman flags, which are now the focus of our interest.

The largest collection of Ottoman flags, of about one hundred items or more, is to be found in the major museums of Istanbul: the Topkapı Saray Museum (known also as the Palace Museum), the Askeri Museum (the Army Museum), and the Deniz Museum (the Maritime Museum).[18]

Several Turkish flags kept in Austria, mainly in Vienna, have been displayed at The Historical Museum of the City of Vienna during special exhibitions, organized for anniversaries of the Turkish sieges of Vienna in 1529 and 1683.[19]

Numerous Ottoman flags of various types and dates are to be found in the museums and churches of Italy, with a major group in the Museo Civico Correr (Correr Municipal Museum), in the Arsenal, and in the Palace of the Doges in Venice, where the most impressive is the naval banner taken at the Battle of Lepanto in 1571.[20] A great number of flags and pennants taken at Lepanto, Nikopolis, and Bona decorate the walls of the church of San Stefano ai Cavalieri in Pisa.[21] To this day this church houses an unusual assembly of trophies, not only of flags and banners but also of ships' lanterns *(phanars)*. Single Ottoman flags are kept in the church of St. John in Lateran in Rome, the Cathedral of Urbino, the Royal Armory in Turin, the Stibbert Museum in Florence, and a few other places in Italy.[22]

There are several interesting Ottoman flags in the Department of Decorative Arts of the Hungarian National Museum in Budapest, and a well-researched description of them is available in a special study published in 1960.[23]

A small but very well-documented group of Ottoman flags from the war of 1683, consisting of five items, is in Poland, exhibited in the Wawel Castle in Cracow. The Cracow flags are important, since

they come from the peak period of Ottoman flag development; they have numerous counterparts in other collections.[24]

In addition, specimens of Ottoman banners can be found in some German museums, among others in the Historical Museum in Dresden, the Pergamon Museum in Berlin, the Badisches Landesmuseum (Baden Country Museum) in Karlsruhe, and the Palace of Schleissheim in Bavaria.[25] Some late Ottoman flags are in the Hermitage of Leningrad, in the USSR. The flags in the possession of Austrians, Italians, Hungarians, Poles, Germans, and the Soviets are, with few exceptions, trophy pieces, but there are also some Ottoman flags that reached other European museums, in Paris, Lyon, Brussels, and Stockholm, in various other ways.[26] In the United States two magnificent Ottoman flags may be seen in the Fogg Art Museum in Cambridge, Massachusetts, and are published in an article by Walter Denny.[27] A rare Ottoman banner with inscriptions used by the pilgrims to Mecca has been on display in the Fil Caravan antiquarian shop in New York City since 1983. This one and others are undoubtedly still not recorded or included in scholarly research.

Turkish scholars initiated studies of Ottoman flags, but they concentrated on the materials of their own country and rarely went beyond an inventory and factual analysis. Even a superficial survey of the material indicates a clear and distinct development of flags used for state purposes, mainly for the army and the navy, and particularly from the fifteenth to eighteenth centuries. The number of types and sizes of Ottoman flags is enormous. They were rectangular, rectangular with a triangular cut (swallow-tailed), triangular, and triangular double-pointed at the fly. Red, crimson, purple, green, yellow, and white, and combinations of these colors were adopted. Equally important are the charges of Ottoman flags: of decorative and symbolic value, often with a secret, disguised meaning in which inscriptions held an important position. It would be impossible within the framework of this book to analyze all the types and their evolution, so I will concentrate on Ottoman flags of high rank, which played an important role within the Ottoman state system and which at the same time were produced by a refined artistic consciousness.

THE FABRICS OF OTTOMAN FLAGS

The rapid development of the Ottoman Empire's art of flags and flag hierarchy was based on the developing techniques of weaving

and textile design. Intensive researches carried out in this field in recent years, particularly on the part of Turkish, British, and American scholars, have thrown new light on the subject and have demonstrated the originality of Turkish craftsmen, who earlier were thought to be dominated by Persian style.[28] Very valuable archival sources were found in the Topkapı Library in Istanbul, mainly by Tahsin Öz and his followers. Thanks to them, the evolution of Ottoman textile art—from the time of the absorption of the Seljuk heritage through the fourteenth and fifteenth centuries, until full development in the sixteenth century—became clearer than ever before.

Among various fabrics and costumes in the inventory of the treasury of Sultan Osman I (1299–1326), recorded after his death by the Turkish historian Neşri, a red flag made of *evlādī* fabric was mentioned.[29] This information was confirmed by a later writer, Aşikpaşazâde, who added a note concerning the production of flag fabrics in Alaşehir, a town near Izmir. We also know that the Seljuk Sultan ʿAlāʾ ad-Dīn, acknowledging the sovereignty of Osman, sent him several signs of power, among which was a white flag. This, however, was rarely used by Osman, who tried to erase from memory the fact of his investment by the Seljuks.

In that early period the Turks used plain wool or cotton fabrics for their banners; mention of silk or brocaded textiles is made only rarely. The situation rapidly changed in the fifteenth century, with the political and economic growth of the Ottoman state. The new capital, Bursa, became the most important center for every type of production in the service of the state. Very noble sorts of fabrics, hitherto imported from the East, were now made locally: taffetas, reps, velvets, damasks, and brocades. Silk and metal threads were combined in great quantities. A 1452 edict of the Emperor of China, Ching-Tʾai, written in the Chinese and Uighur languages and fixing the conditions for the export of silk from China to the Ottomans, survives in the Topkapı Archives in Istanbul.[30]

After the capture of Constantinople in 1453 a new chapter in the history of Ottoman art began. Sultan Mehmed II, who was a great protector of crafts, and not only of Turkish crafts, supported and promoted weavers, since he well understood the beneficial role the manufacture and use of magnificent fabrics could have for the state. Soon Istanbul became an important new center of production, satisfying, along with Bursa and other towns of Anatolia, the growing

demand for textiles. The guild system, which partly followed Byzantine patterns, introduced a strict state control of workshops and of their output. High standards were set for the quality of threads and for the densities of warp and weft. Those products not conforming to official standards were confiscated. Documents settling quarrels and imposing fines survive in the Istanbul archives. In some of the most important cases the sultan himself decided by special *firmans* (royal edicts). Lists of fabrics delivered in the sixteenth century to the sultan's court from the workshops of Bursa and Istanbul detail the qualities and quantities of goods and testify to a very high level of production. In the time of Süleyman the Magnificent (reigned 1520–1566), in Istanbul alone about 300 workshops were active, although the sultan's firmans limited production somewhat. Foreign weavers were not allowed to settle.

When speaking of artistic textiles, it is important to bear in mind not only the technical level of the product—the quality of threads and dyes and the kind of weave and finish—but also the repertory and style of decorative motifs. In this field Turkish craftsmen were probably somewhat less advanced than the Persians, but they certainly knew their craft. The designers of Ottoman fabrics, though not without foreign influence, leaned heavily on old Turkish traditions. Their choice of motifs was conditioned by ideological considerations, by national taste, and by aesthetic notions. The Turkish *sunna* (path), based on the teachings of Islam, virtually forbade representation of animals and human figures on objects intended for public view. While geometric and floral motifs dominated, some symbolic elements remained in the repertory of flag decoration. In fabrics prepared for flags the Turks showed great originality, although sometimes similar patterns were used for ceremonial dress. Non-Turkish craftsmen were also active alongside Turkish weavers in the vast Ottoman state. Flags for sultans and for high military dignitaries were made in special workshops in Bursa and Istanbul, and also in some provincial cities, such as Damascus, Amasya, Chios, and Baghdad, where some of the local features might be applied.[31]

The great skill of Turkish weavers and tailors was useful in the construction of flags. According to rank, precious threads of dyed silk and of gold were used, or sometimes simply wool, camel's hair, or cotton; frequently threads of various types were combined in one fabric. In flags of the highest rank, symbolic and ornamental motifs

16

were woven in on the loom. Embroidery was rare, more often the methods of appliqué or the encrusting of colored pieces of fabric were used. These methods were the same as those applied in the making of tents, with the cloth for flags saturated with a special resinlike substance, to render it weather-resistant. For the lowest rank, painting on textile was practised, although covering with gold paint was appropriate for dignitaries.

THE HIERARCHY OF OTTOMAN FLAGS

In the ideology and organization of the Ottoman Empire, flags played an important role, particularly in military and religious activities. Every larger detachment of the army was honored with a flag from the hands of the sultan. Smaller units were furnished with banners called *bayrak,* with various emblems used mainly as recognition signals. On the march or in battle they were carried in the front lines, while in camp they were thrust into the ground in front of the tent or placed on top of it. A separate group of naval flags of various function, size, shape, and colors was formed. Only a few original examples of the latter survive; as mentioned above, the most spectacular one, dating to the Battle of Lepanto in 1571, is in the Palace of the Doges in Venice. Most probably, some flags preserved in the Church of San Stefano in Pisa, so far neglected by scholars, come from Turkish ships.

Various flags were used in religious ceremonies, particularly on pilgrimages to Mecca, and many of the large flags of the Ottoman land army have survived in and outside Istanbul. These latter belonged to sultans and to high dignitaries or large detachments of the army and were called *sanjaks (sancak).* I shall consider them now, starting with the so-called Muhammad's banner, the sacred banner called *sancak-i şerif.* In the hands of the Turks, this banner constituted a visible symbol of their superior position in the world of militant Islam. Even today this particular flag arouses great interest and emotion. Yet, misunderstanding and confusion surround it, as in the belief, for instance, that it was captured by Christians at the Battle of Vienna on September 12, 1683.[32]

SANCAK-I ŞERIF Sancak-i şerif was joined with the original flag of Muhammad (called ʿuqāb, which means eagle). We know that the

17

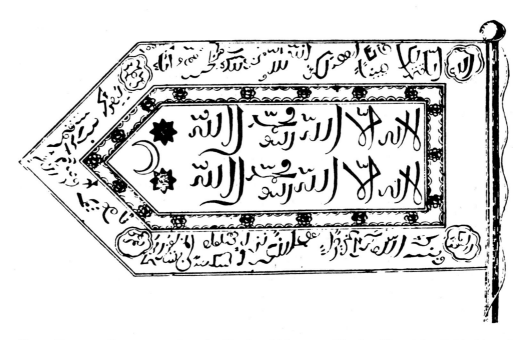

Ill. 3. Ottoman flag captured at the Battle of Vienna, 1683, by King John Sobieski and immediately sent by him to Rome, as the "Muhammad's Banner" (lost); contemporary woodcut. By permission of National Museum, Cracow.

Prophet used various flags in combat and that they were white or black, but we do not know their size, shape, or charges since they were never accurately described. Nor do we have any report as to which of Muhammad's flags was chosen as the principal and worshipped as a most important relic. Indeed, we have no proof that such a flag *could* have survived, although such a possibility cannot be excluded, since there are plenty of examples of the longevity of fabrics. In any case, the Ottoman rulers were themselves fully convinced that the actual flag of Muhammad had survived and that they had inherited it. It had the Arabic names *liwāʾ as-sa ʿāda* or *ʿalam as-sa ʿāda,* meaning flag of good fortune.

Whatever its origins, the fact of the existence in Ottoman Turkey of this particular relic attributed to Muhammad is not in doubt. Already in the sixteenth century, however, there were various and inconsistent versions of its origins. Some Turkish sources, for example, have it that sancak-i şerif was won by Sultan Selim I Yavuz in

18

1517, during the conquest of Egypt.[33] The *Silahdar Tarihi (Silahdar's Chronicle)* indicates that this banner was sent to Sultan Selim by his deputy *(vali)* Khayr-Bey, who governed Egypt after the conquest.[34] L. F. Marsigli, a witness of the Siege of Vienna in 1683 as a Turkish captive, wrote about the sacred banner, but admitted that he had never seen it with his own eyes. J. von Hammer-Purgstall noted in his history of the Ottoman state that this banner was sent by Khayr-Bey not to Selim but to his son and successor, Sultan Süleyman the Magnificent, when he began the siege of Rhodes in 1522.[35] Hammer based his work on the sixteenth-century historians Ibn Zunbul of Egypt and Şükri of Turkey (the work is dated about 1524). Other Ottoman historians preceding Silahdar Mehmed Ağa, such as Mustafa Selaniki (who died soon after 1599) and ʿAin-i ʿAlī (who died in the first quarter of the seventeenth century), reported the later vicissitudes of the banner. According to them, the sancak-i şerif was preserved from 1517 (thus after the conquest of Egypt by Selim I) for seventy-five years in the treasury of Syria, which was a province of the Ottoman Empire. From there it was carried each year by pilgrims to Mecca and then returned to the treasury, which was surely located in Damascus. Finally in 1593, under Sultan Murad III, the troops of Syrian Janissaries sent to the war against Austria took the flag with them to Istanbul. Following this campaign, the sancak-i şerif was returned for a short time to Syria, but soon after, in 1595, at the order of Sultan Murad III, it was transferred for good to the Topkapı Saray of Istanbul.[36]

None of these historians, except for Silahdar Mehmed Ağa, has described the banner, but Silahdar, whose account is fuller than any other, wrote that it was made of black wool. This is both possible and entirely compatible with Muslim tradition. The belief in "Muhammad's green standard" (often circulated in Christian lands) is at least partly founded on the reports of some European (and also Turkish) authors, who took the color of the cover as that of the flag itself. Usually the sancak-i şerifs was transported and stored in a linen case.[37] It is also to Silahdar that we owe the important information that when the aging sancak-i şerifs was near to disintegration, it was cut into pieces that were distributed among three new sanjaks. In this way three new sancak-i şerifs came into being.

The essence of Silahdar's account is as follows:

19

According to tradition, the sacred banner was unique and belonged to the sultan of the prophets, Our Prophet Lord Muhammad Mustafa (God Bless Him and Peace be unto Him forever). It is called ʿuqāb and is made of black camlet wool. It is well known that the name ʿuqāb found in various places [in books] means the sacred banner. It was given to His Majesty Sultan Selim Han, the Conqueror of Egypt, by Khayr-Bey, who recommended in his letter: "Take this banner along with you on war campaigns." In time its sacred parts broke up and therefore, it was decided in the Sublime Porte [the highest office of the empire] to make according to the original three [new] sacred banners and include in each of them two or three pieces of that original one. All of them are made in the same form and style. One of them always accompanies the Sultan's camp and never leaves the Holy Mantle of the Prophet; the other two are preserved in the Sultan's Treasury. One of these, if necessary, is rendered to the Grand Viziers, Commanders in Chief, while the second remains in the treasury.[38]

Once again, unfortunately neither size, shape, color, nor charges were described in this account.

The sacred banner was kept in the saray together with other major relics of Islam, including the mantle of the Prophet, the sacred seal, the Prophet's beard, the Prophet's tooth, the footprint of the Prophet (in stone), the holy Korans, keys to the Kaaba, and historic swords and bows. "Although the collecting and veneration of relics, being a form of idolatry, was hardly consistent with the spirit of Islam, the temptation to cherish and reverence tangible memorials of the Prophet has not been entirely resisted," wrote one of the best experts in Turkish culture, N. M. Penzer.[39] A very competent European source on the sancak-i şerif can be found in the writings of the French traveler Jean Baptiste Tavernier (1605–1689), who undertook several trips to Oriental countries as well as Istanbul. In the context of the friendly relationship between France and the Ottomans, and thanks to his excellent diplomatic abilities, he was able to penetrate into the very inner parts of the saray and to interview some outstanding guardians of the treasury.[40] His opinions on the sancak-i şerif are of the highest importance. Penzer's summary of them and those of other scholars is worth quoting in full:[41]

According to some Arabian historians this standard originally served as a curtain for the tent entrance of Ayesha, the Prophet's favourite wife. The usually accepted tradition is that it was the turban-wrap of one of Muhammad's converted enemies, a man named Buraydat. During the Flight he

20

was sent against Muhammad at the head of a body of horse [cavalry] by the chiefs of Mecca. But instead of attacking he threw himself on his knees, unwound his turban and, fixing it to his lance-point, dedicated it and himself to the Prophet's service and glory. Like the mantle, it ultimately came into Selim's hands and, as mentioned above, was sent to Damascus, where it was deposited in the great mosque and carried every year to Mecca at the head of pilgrims. Realizing its political possibilities, Murad III had it sent to Hungary as an incentive to his army. At the end of the campaign it was conveyed to Constantinople by Mehmed III, who had just (1595) ascended the throne. Henceforth the standard became the symbol of Ottoman domination and was exhibited only when either the Sultan or the Grand Vizier joined the field army in person, or in the case of national emergencies (as in 1826) or on declaration of war, the last occasion being in 1915 when a holy war was proclaimed against the Allies. It would appear that the standard is detached from the pole and enclosed in a rosewood coffer, inlaid with tortoise shell, mother-of-pearl, and precious stones. It is sewed within another standard, said to be that of Omar, and this again is enclosed in forty different coverings of rich stuffs, the innermost being of green silk embroidered with golden inscriptions. Whether there is any significance in the number of wrappings, corresponding with the number of members of the Has Oda, who were the custodians of the relics, I cannot say. White adds that the mantle had also forty wrappers, but the account may be incorrect on this point.[42] The keys of the coffer were kept by the Kizlar Ağasi in virtue of his office as inspector and administrator of the holy cities. White actually saw the pole or staff resting against the angle of the wall. It was surmounted by a hollow globe of silver gilt enclosing a copy of the Koran said to have been transcribed by Omar. Another copy, transcribed by Osman, is folded in the second standard. D'Ohsson describes the receptacle as being in the shape of an apple and containing a Koran by Osman and the key of the Kaaba [the most important shrine in Islam] presented to Selim by the Sherif of Mecca.[43] Tavernier says the standard was kept in a cupboard in the Sultan's bedroom adjoining the Hırka-i Şerif Odası.

The question of the key to the Kaaba, which stands in the courtyard of the Great Mosque in Mecca, was fully explained in the *Silahdar Tarihi* and is also worth quoting here:

Not very long before the expedition of the late Sultan Murad IV to capture Baghdad, the Sherif of the Holy Mecca dreamt that His Majesty the Sultan of Both Worlds [i.e., the Prophet Muhammad] appeared with his four chosen friends [i.e., with the four first caliphs], giving him the following

21

precious instructions: "Send this Key of God's House to the Sultan of the present time. Let him take this Key to the war, and after the conquest of Ajam [i.e., Persia], he should keep the Key himself, and if he would be in need of sending his army anywhere, he should pass it to a Holy Man and go there with the army." Following this instruction the Sherif sent the Key by a man named Munwafi to the Sultan Murad Khan. The Sultan took the Key to the Persian war and then deposited it in the Treasury of his private Chamber and listed it in the inventory of the Treasury. Now the Treasurer [defterdar] Hassan Efendi applied to the Monarch's Throne that this Holy Key should be under the protection of the guardians of the Sultan's Turban along with the casket of the Holy Mantle, and in campaigns it should be tied beneath the finial of the Sacred Banner and taken along. This application was followed by the appropriate firman. The Key is hidden in a case made of silk brocade in A.H. 1043 [i.e., 1633–1634].[44]

It can be assumed that the sacred banner, or rather the three sacred banners, were highly venerated in the sultan's court and throughout the entire Ottoman state, particularly by the army. One banner never left the treasury and the Chamber of the Holy Mantle, the second banner always accompanied the sultan on his travels and expeditions, and the third was handed over to the commander-in-chief, normally to the grand vizier, when going on a campaign in which the sultan did not participate personally. This was a visible sign of Muhammad's intercession and protection over the army of fighting Islam. In time of peace, in Istanbul, these standards were under the care of the forty servants called *sancakdars*. In time of war, protection was undertaken by the clan of *Seyyids*, descendants of the Prophet, whose leader had the title of Sheikh of the Sacred Banner. In battle the Seyyids surrounded the standard, singing the sura of victory from the Koran. It is quite clear that their duty was to save the relic in any emergency. For that purpose they always kept in readiness some fast camels of a special breed.

The sacred banner was sometimes used in domestic affairs, especially at the time of the Janissary riots, when the sultan's bodyguards (the Janissaries) rebelled and attempted a coup. Those loyal to the sultan gathered under this standard in 1826, when, under the rule of Sultan Mahmud II, the corrupt corps of Janissaries were finally destroyed, massacred in their barracks. Until the end of that bloody slaughter the standard was hung from the *mimbar* (pulpit) of the Sultan Ahmed Mosque.[45]

22

Ceremonies and rituals became associated with the housing and movement of this relic. Their descriptions are scattered throughout various sources. One of the most impressive again comes from the *Silahdar Tarihi*. It is a very accurate account of the Turkish campaign of 1683, which ultimately led to the Siege of Vienna and the defeat of the Ottoman army by the allied forces of Austrians, Germans, and Poles under the supreme command of the Polish king, John Sobieski. Sultan Mehmed IV was not present at Vienna, and the siege was probably carried out without his orders. The supreme commander of the Ottoman army was the grand vizier, Kara Mustafa Paşa, a man of insatiable ambition and greed for riches. The Ottoman war against Austria had the direct aim of coming to the aid of their ally Hungary; in fact it was thought by the vizier and his followers to be a radical remedy for the economic and political troubles of the state. The army was to make a brilliant show and to return in glory, loaded with booty and captives. The dress rehearsal took place in Belgrade on May 13, 1683, when with unmatched splendor and ceremony, the grand vizier was nominated commander-in-chief of the army and entrusted with the sacred banner. At the height of the ceremony the sultan took the relic in his hand, kissed it, and said to the vizier: "I place this Sacred Banner into your care, and you under the protection of God almighty. May He become your Defender and Supporter." He then gave the standard into the hands of his servant—the supreme commander. And this one kissed the ground, and when the standard was on his shoulder Vani Efendi (his personal chaplain) offered up prayers. The Vizier left the Sultan's tent with tears in his eyes and the *ağas* (military officers) took from him the Standard and passed it into the care of his imam, Mahmud Efendi. In the afternoon of the same day, the *Silahdar* adds, on the order of the padishah, the key of the Kaaba was handed over to the grand vizier with the recommendation that he tie it under the finial of the standard's pole.[46]

Numerous Ottoman flags were captured by Christians in the famous Battle of Vienna, on September 12, 1683. King Sobieski, the owner of the greatest share of the trophies, was sure that the sacred banner was among the fallen sanjaks. In a letter of September 13, 1683, written in the occupied tents of the grand vizier, Sobieski informed the queen that the "Muhammadan standard given by the sultan to the grand vizier" would immediately be sent to Rome to

Pope Innocent XI.[47] This standard is not in Rome now, but its illustration and description are well known. Obviously, the king was mistaken. The Turks had saved their holy relic, which was returned to Belgrade and then to Istanbul. Similarly in subsequent campaigns the Turks always secured and rescued the sacred banner, as Count Marsigli observed.[48]

Fevzi Kurtoğlu, who tried in the interwar period before 1938 to explain the matter of the sacred banner, was allowed to research the remains of the inner treasury of the Saray, particularly those in the Chamber of the Mantle. In a huge cage of silver grating he found a great chest with locks, covered with black velvet decorated by gold embroidery. In this chest, under several covers of fabric, there was a small flag of green silk (113 cm × 28 cm), with a stripe of crimson satin sewn on it and with a Koranic inscription made in the calligraphic style popular at the turn of the seventeenth century. Along with this, Kurtoğlu also found a bag of green taffeta containing scraps of the textile, probably woollen, almost black, with traces of an inscription, which, however, was not from the times of the Prophet. Probably, these were remains of the famous relic from the time of Selim I, or Süleyman the Magnificent, coming from Egypt or Syria.[49]

SULTANS' FLAGS These mark the second step in the hierarchy of Ottoman signals. They were private flags and were ranked according to their owners' names, titles, and authority. Old Ottoman writers called them *alem-i pādişāhi* (padishah's standard), *alem-i osmāni* (Ottoman standard), or liwāj-i sultāni (sultan's standard). The writers usually attributed seven such flags to the Sultan, since such a number corresponded to the number of *iklims* (climates or spheres of the earth) that were to be subdued by the victorious armies of Islam. An indeterminate Chinese influence is evident in these pages.

There is some dispute as to their colors. Uzunçarşılı expressed the opinion that there was one white flag, one green, two crimson, two green and crimson, and one crimson and yellow.[50] Not all is clear on this point however. Some Turkish historians maintain that the proper sultan's flag was white because it was a white standard that had been given to Osman, the first Ottoman sultan and progenitor of the dynasty, by the Seljuk Sultan ʿAlāʾ ad-Dīn. Others argue for a crimson or purple flag, since these were the imperial colors taken over by the Turks from the Byzantine emperors and their Roman predeces-

sors. Certain remarks in seventeenth-century chronicles indicate that crimson and yellow flags of the sultans were presented to Janissaries. Still, in general, the problem of colors connected to functions is extremely difficult to solve. Miniatures are of little value in this regard, since the flags in them are usually depicted in an inaccurate, conventional way. Nevertheless, nothing can be ignored in scholarly research, and sometimes these miniatures can confirm some statements by historians. For example, in the well-known *Hünernāme* (Book of Achievements) of Seyyid Lokman from 1588, in the picture representing the advance of Sultan Süleyman and his army on Szigetvar, seven flags can be seen at least partially: the central of these is white, the next is green, and the others are red or red combined with green or yellow.[51]

Rıza Nur, who attempted a systematic investigation of 158 flags preserved in the Turkish collections, studied the occurrence of colors. Although he refrained from defining the symbolism and rank of colors, Nur lists the colors as: crimson, green, white, yellow, violet, and blue, in order of decreasing frequency. In the West European literature on Turkish militaria, the phrase *flag of blood* (*Blutfahne* in German) is sometimes applied in connection with the crimson color, but this particular association does not occur in Turkey.[52]

When looking for some existing examples of sultans' flags one must turn to the specimens preserved in the Topkapı Saray Museum and to the Deniz Museum (Maritime Museum) in Istanbul. A crimson flag in the Topkapı (no. 824) has its original pole, with a heart-shaped metal finial inscribed: "Sultan, son of Sultan Selim, son of Bayezid, son of Mehmed, son of Murad, may God strengthen His rule," from which we can deduce that the owner of the flag was Selim I Yavuz.[53] As for shape, inscriptions, and other elements, this flag does not differ from many other specimens, and if not for the words on its finial, we would never guess that it belonged to the sultan. There is no *tughra* ([tuğra], calligraphic monogram) symbolizing this ruler on the cloth, which is inconsistent with the information of Selaniki that at every sultan's enthronement seven flags were made inscribed with his name.

Such flags with each sultan's name artistically rendered by special scribes have survived in Istanbul, but they are from a late period: one of them, manufactured in Baghdad, belonged to Selim III (1789–1807) and another to Mahmud II (1808–1839).[54] Both have ex-

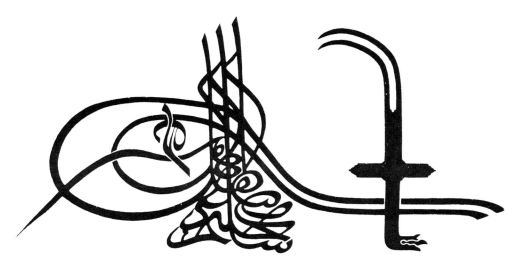

Fig. 4. Tughra with the Zulfikar sword emblem of Sultan Selim III (1789–1807).

amples of extremely rich symbolic and decorative content, and they are of great size (14 m × 7.5 m and 15.4 m × 7.7 m), each almost 50 kg in weight. They may be the largest land flags ever made; however, ships' flags were often much larger. According to Tahsin Öz, huge flags of this sort were donated to sultans at their enthronement by major textile workshops and were never intended for either military or field use.[55] Along with this enlargement of the size of the flag's cloth, a tendency to overload it with ornamental motifs appeared. The flags thus lost their clear symbolic expression and became similar to colossal tapestries or carpets. These flags, like the gigantic swords, maces, axes, and bows that can today be seen in the armory of the Topkapı, are a manifestation of the gigantomania the Turks cultivated in their artistic expression to glorify the empire.

SANJAKS OF PASHAS Intended particularly for military and state dignitaries—the viziers, *beylerbeys,* and *sancakbeys*—a rank of flags was prepared in imitation of sultans' flags. Many were used in battle, and they constituted the main trophies in defeat. Any systematic study of them is still very limited, as is our knowledge of the significance of their colors. Uzunçarşılı suggested that grand viziers used green flags, lower viziers crimson, and beylerbeys red.[56] The report of Andrew Taranowski, in 1570, Polish envoy to Sultan Selim II

26

from King Sigismund Augustus, provides an important source of information. Taranowski witnessed the expedition of Turkish and Crimean troops against Astrakhan in that year and noted that the Turkish commander-in-chief, Kasim, sancakbey of Kaffa, was followed by a white horsetail standard—tugh—and then by "three flags, very large, made of red silk."[57] (A detailed analysis of the symbolic content of sanjaks will be given later in this chapter.)

TACTICAL-USE OR LOWER RANKING FLAGS These are extremely rare, if not nonexistent, in museums. Some flags were used as signals for soldiers in battle. I have already mentioned that the right wing was marked by a red banner and the left by a yellow one. The seventeenth- and eighteenth-century military expert Count Luigi di Marsigli added that before battle the Turks would increase the number of flags, to give the enemy the impression that they were faced by a greater force than was actually the case. There is no limit to the strategems of war.

Small flags, used by separate units of cavalry, infantry, artillery, and other troops, were not often collected as trophies; if ever they were, they must have soon deteriorated, being of rather poor material. Here the numerous iconographic sources of Ottoman and West European origin, many of which are housed in the Topkapı Saray Library, prove valuable. Among these is a rich set of illuminated codes, such as those in the sixteenth-century *Hünernāme* or the *Shāhanshāhnāme* (The Book of the King of Kings), also from the sixteenth century. The latter work includes a miniature showing the capture of Revan by the sultan's army in which flags of various types are depicted, although their accuracy is questionable. The horsemen carry on their spears small triangular pennons, usually red, red and white, or red and yellow. In the Battle of Mohacs (1526), represented in the *Hünernāme*, artillerymen placed on their cannon a fairly large red and yellow flag.[58] More precise are the representations of pennons of *sipahis* (regular cavalry) in the precious *Codex Vindobonensis*. These pennons were made in the late sixteenth century for Emperor Rudolph II in connection with an imperial embassy to Istanbul (National Library in Vienna, no. 8626). In the representations the horsemen carry pennons, mainly red and yellow, with several pointed scallops edging the basic triangular cloth.

Count di Marsigli, surely one of the best-informed persons on the

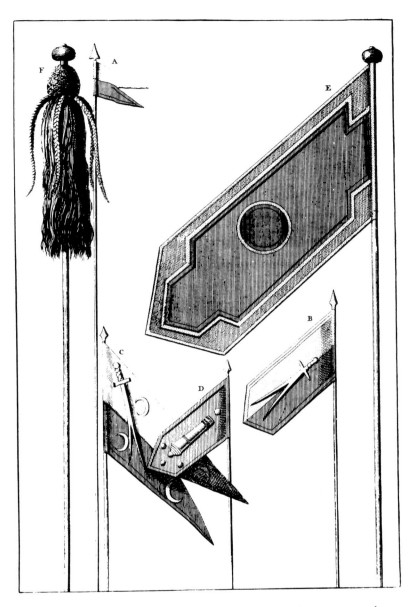

Ill. 4. Various types of Ottoman flags, after Marsigli, *Stato militare* . . . , vol. 2, p. 53.

28

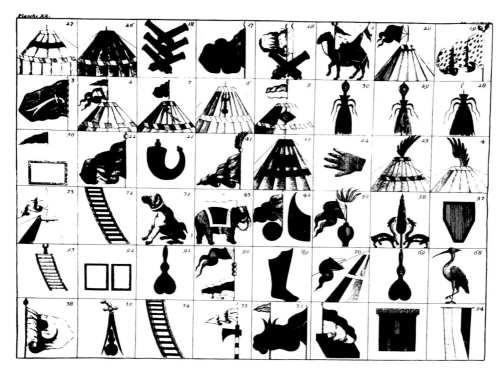

Ill. 5. Janissary signs, after Marsigli, *Stato militare . . .* , vol. 2, pl. 20.

subject, devoted a separate chapter of his book to Ottoman flags.[59] On plate 17 are depicted signs of sipahis (the *kapikulu* cavalry, from the capital, paid by the state treasury), in the form of a small swallow-tailed pennon, and of the *topraklı* cavalry (from the provinces, formed and paid by high land officers—the pashas), which are bicolored, swallow-tailed, and larger than the former, and also have the bifurcated Zulfikar sword and crescents. Such a sword is also found on the Janissary flag with a triangular fly. A very similar flag with a cannon and three balls is explained as belonging to artillerymen, and there is also a large sanjak of the pashas, with a flattened ball at the top of the staff. A horsetail standard is also included on this plate.

Still more interesting are the next four plates of the Marsigli book (pls. 20, 21, 22, and a supplementary plate), showing various signs and emblems used by companies of Janissaries. Altogether there are 162 signs, such as a crescent, banner, horse tail standard, Arabic characters, a tent, tower, minaret, mosque, bow, crossbow, gun, shield, Zulfikar sword, barrel of a cannon, powderhorn, boot, broom, galley,

Ill. 6. Janissary signs, after Marsigli, *Stato militare* . . . , supplement to pls. 20–22.

30

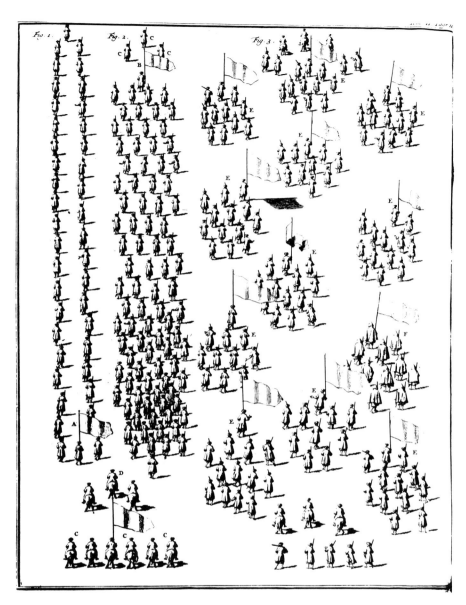

Ill. 7. Ottoman infantry marching with flags, after Marsigli, *Stato militare* . . . , vol. 2, pl. 34.

31

jug, axe, anchor, scissors, ladder, ploughshare, top of a dome *(alem),* palm, cypress, gourd, lion, elephant, camel, dog, crane, falcon, serpent, fish, cypress flanked by two mythical animals, and an animal's skin.[60]

THE SYSTEM OF CARRYING FLAGS Marsigli's work also details the way in which sanjak flags were carried in cavalry or infantry marches. Each unit was preceded by a standard-bearer who carried the flag. In the Ottoman miniatures the sultan's flags, seven in all, go together and are not far from him. In the *Codex Vindobonensis* we see that mounted standard-bearers hold flags on their shoulders in parades. Sometimes, when stored or carried on the march, the flags were furled and secured with a case of green linen. Poles were usually painted red. The finial of the pole, of gilt metal, was at first heart-shaped, mounted with the pointed end upward, the field frequently inscribed with the profession of faith *(shahāda)* but also sometimes with the name of the ruling sultan, as in the case of Selim I. In the second half of the seventeenth century and later, the top of the pole was a gilt metal ball. Beneath these finials small copies of the Koran were tied. A Turkish historian of the sixteenth century, Jelalzade Mustafa, noted that each of the seven sultan's flags had at the top a Koran and explained that for this purpose small Korans called *sancak mushafa* were prepared.[61] The report of Taranowski confirms this custom, and, of course, Korans were not only tied to sultans' flags, since he saw them in the cortège of the Kaffa sancakbey: "these flags are wound round the pole and never undone till the battle starts. Their shafts are surmounted by big golden hearts from which are suspended large sacks of brocade with a parchment book enclosing the Muhammadan creed. When fighting, every soldier has in front his Holy Scripture and is ready to die for it."[62] As we already know, on a war expedition with the sacred banner, the key of the Kaaba was also hung beneath the finial, this custom being established during the reign of Murad IV (1622–1648).

SYMBOLIC AND ORNAMENTAL ELEMENTS OF SANJAK FLAGS

The sanjaks of sultans and pashas, whatever their rank in the hierarchy, were charged with various typical elements that carried either

obvious or disguised symbolism, which are not always easy to explain and frequently demand analysis. The meaning of these symbols was not written down, and it was passed on orally from teachers to students. The life of symbols is always long. They may be used through the centuries and be adopted by various peoples and cultures; often their original meanings may change although their outer forms remain constant.[63]

The symbolic elements used in the Ottoman flags were determined by the dominating Sunni doctrine of Islam. With few exceptions the depiction of living beings, of human figures and animals, was prohibited, and the unimaginability of God was basic. Full reign for total human imagination was given by the Koran to the written word, intended as an inexhaustible source of spiritual strength, moral reflection, and intellectual inspiration. In the vast captured territories of Syria, Mesopotamia, Persia, Anatolia, North Africa, and Spain, however, the Arab's encountered established ancient religions, with astrological, magic, and apotropaic symbols. Almost against its will, Islam was forced in the early years of development to adopt various of these symbols, many based on ancient, pagan traditions, and adapt them, giving them new content.

When, in the course of time, the Turkish peoples dominated the world of Islam, some symbols established for centuries in Central Asia and the Far East stood out.[64] Also, it seems that some symbols were eventually down-ranked and denoted either to the class of semisymbolic motifs or simply to the ornamental.[65]

INSCRIPTIONS Analysis of the meaningful elements of the Ottoman sanjaks should start with inscriptions. They constituted the most important factor in the entire design program. The oldest Muslim inscribed flags are documented from the time of the Abbasids. The words and texts were always in Arabic, and almost exclusively religious in character. This practice persisted in the Ottoman era. The words and texts, taken mainly from the Koran, encapsulated the very essence of the creed, providing good cheer and inspiration for the faithful and the promise of paradise for soldiers fighting and dying for Islam. The words written on the flags also barred the temptations toward idolatry, hideous to every true Sunnite, and, in monumental form, enchanted the illiterate. Most were also endowed with some apotropaic or magic force. The faithful remembered that

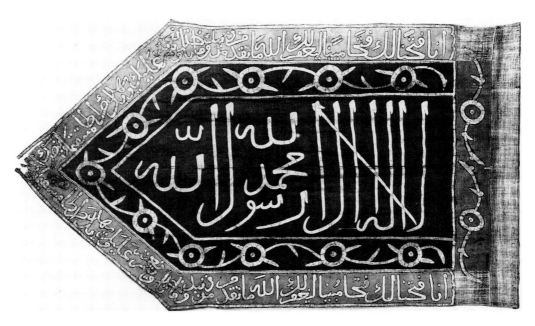

Ill. 8. Ottoman flag, inscriptional type, probably from the 1683 Siege of Vienna. By permission of Heeresgeschichtliches Museum, Vienna.

Muhammad had blinded a wicked wizard by his words alone, spoken under the inspiration of Gabriel.[66] In addition to words from the Koran, the designers of flags also drew on the *hadith* tradition (the Prophet's sayings) to formulate short slogans.[67]

The most important inscription was, of course, the shahāda, the Muslim profession of faith: *La ilāha illa Allāh, Muḥammadun rasūl Allāh* (There is no god but God and Muhammad is the Prophet of God). Short invocations were also used—such as "O, Allāh" or "In the Name of Allāh, the Compassionate, the Merciful" *(basmala)*—as were names alone—such as "Allāh," "Muhammad," "Abū Bakr," " ʿUthmān," " ʿUmar," and " ʿAlī." Verses from Koranic suras, or their combinations, were eagerly applied.

The location on the flag of various inscriptions was determined by the degree of an inscription's importance. Usually a major inscription of great importance was placed in a band across the flag, parallel to the pole. Sometimes writings constituted the whole content of the flag, as, for instance, when the entire main field was filled with the monumental shahāda. Such a type can surely be called inscriptional.

34

It is represented by several examples, mainly from the seventeenth century, such as those in the cathedral of Urbino, in the Armeria Reale (Regal Armory) in Turin, and in the Royal Castle of Wawel in Cracow. The flag in Wawel was one of King Sobieski's trophies, from Vienna in 1683. Two other flags of this type were sent by Sobieski, one to Rome (the one believed to be the sacred banner) and one to Warsaw, although both of them are now lost.

Verses from sura 48 of the Koran, "Victory" *(surat al-fath)*, were favorable, beginning with the words *"Innā fataḥnā laka fatḥan mubīnan . . ."* (We have given you a glorious victory so that God may forgive your past and future sins). Very often verses from sura 61, "Battle Array" *(surat aṣ-ṣaff)*, were chosen, particularly verse 13: *"Naṣrun min Allāhi wa-fatḥun qarībun wa-bashshiri l-mu'minīna"* (Help from Allah and a speedy victory. Proclaim good tidings to the faithful!). More rarely we find verses from sura 2, "Cow" *(al-baqara)*, such as verse 255 about the nature of God: *"Allāhu lā ilāha illā huwa l-ḥayyu l-qayyūmu . . ."* (Allah, there is no God but Him, the Living, the Eternal One. Neither slumber nor sleep overtakes Him . . .). The verses were chosen above all to raise the soldiers' morale, as for example the one from sura 4, "The Women" *(surat an-nisā')*, verse 95: *"Wa-faḍḍala Allāhu l-mujāhidīna ʿala l-qāʿidīna ajran ʿaẓīman . . ."* (Allah has given those that fight with their goods and their persons a higher rank than those who stayed at home). Sometimes there are only small fragments of verses, as for instance the end of verse 88 from sura 11, "Hūd" *(surat Hūd)*: *"Wa mā tawfīqī illā bi-Allāhi . . ."* (My success is only with Allah. In Him I have put my trust). Not infrequently one of the shortest suras, sura 112, "Purity of Faith" *(surat al ikhlāṣ)*, was chosen; it contains the initial words of basmala: *"Bismi Allāh ar-Raḥmān ar-Raḥīm"* (In the name of Allah, the Compassionate, the Merciful. Say: Allah is One. The Eternal God. He begot none, nor was He begotten. None is equal to Him).

Texts that are not Koranic or devotional are very rare. For example, one of the very beautiful flags captured at Vienna in 1683 and preserved in the Royal Castle of Wawel in Cracow has, in two rectangular fields, verses containing good wishes for the owner or bearer, which read:

May rich happiness be renewed *Saʿādāt tajaddadu kulla yawm*
every day

35

And good chance—against him who envies	*Wa iqbālun ʿalā raghmi l-ḥasūd*
And may your days be bright	*Wa lā zālat laka l-ayyām bīḍan*
And may the days of your enemy be always dark.[68]	*Wa ayyāmu l-ladhī yanzalu sūd*

The inscriptions were applied in various places, not only in the main field but also in borders, medallions, and cartouches and were sometimes repeated or reversed, mirrorlike, for symmetry. The inscriptional style, clear and logical, although sophisticated in the sixteenth century, slowly gained exuberance. Writings covered not only the places assigned to them but also the inner fields of various symbols and thus became illegible. An obsession with inscriptions occurred and this phenomenon evolved in Ottoman flags, particularly in the early eighteenth century, at which time a new symbol appeared, the tughrābor sultan's monogram.

The tughra has a long history, from at least as early as the state of Oghuz-Turks in Central Asia, although its origin is still disputed. Most scholars maintain that it was a calligraphic form of a bird (eagle?), a rider, or of the sultan's hand. Some saw in the vertical parts of the sign the symbol of the horsetail standards—the tughs. In Ottoman Turkey, from the time of Orhan (1281–1324), it was mainly applied to verify documents. It may, of course, be compared with European monograms or the blazons of rulers.[69]

Some signs derived from writings or simply cabbalistic ciphers are also to be found on Ottoman flags. The meaning of these is not quite clear. It may have something to do with such forms as the composition of ciphers 8, 6, 4, 2, called *beduh,* a magic square whose power helped to realize an attempted goal.[70] Possibly they were imitations of the famous Chinese magic square, *Lo Shu,* which played an important role in the Han dynasty (200 B.C.–200 A.D.), being a short mathematical formula for a complicated system of cosmological and political worldview.[71]

All inscriptions and signs were united in the field of an Ottoman flag, in a monumental or discreet form, by the exquisite instrument of calligraphy. In the Islamic world the art of calligraphy achieved a position of great importance, as Annemarie Schimmel documents in a book published following a series of lectures she gave at the Kevorkian Center of New York University.[72] The only thing to repeat here

36

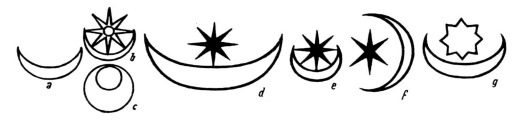

Fig. 5. Various motifs of crescents and stars a., b., and c. Sumerian culture d. Assyria
e. Parthian Persia f. Sassanian Persia g. Byzantium.

Fig. 6. Various motifs of crescents and stars in Turkish art.

is that the rewriting of the Koran, around which all the thoughts and
emotions of the faithful were concentrated, was one of the com-
mandments of the Prophet. Quotations from the Koranic suras were
placed not only in mosques and *medresses* (religious schools) where
they played a role similar to the images of gods or saints in other
religions, but also on numerous movable objects, particularly such
significant ones as flags. The flowing character of Arab writing fa-
vored its use for artistic purposes.

The innovations of calligraphers were unlimited, and national
styles of writing were cultivated. In Turkey they were known as
divani, rıka, and *sülüs.* The monumental sülüs style, originating in the
Persian *naskhi* (with upright, rounded letters), was mainly employed
for Ottoman sanjaks.

CRESCENT, STARS, SUN, SOLOMON'S SEAL, CZINTAMANI
Although the practice of inscribing flags developed earlier than the
Muhammadan era, it was Islam, with its cult of the written word,
that contributed substantially to this custom. Along with calligraphic
inscriptions, various signs associated with, generally speaking, the
sphere of heaven were used. These were a primordial set of non-
iconic astral signs for the moon, the stars, and the sun. They are

37

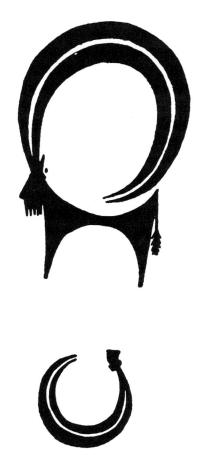

Fig. 7. The two-horned motifs in the Susa pottery, from the third millennium B.C.

represented in numerous examples of sanjak in the museums mentioned earlier.[73] The origins, types, and migrations of these signs are problematical.[74] In this study I must limit myself to some comparative analysis concerning the Ottoman astral signs on flags and those that appeared in earlier cultures.

Almost the entire mythology of the ancient Near East was of astral character; elements were shared by the Sumerians, Babylonians, Hittites, Assyrians, Phoenicians, Egyptians, and Arabs, as confirmed by innumerable monuments and written sources. As early as the Susa ceramics, from the third millennium B.C., noniconic symbols appear: the crescent is represented by the huge horns of the ibex, and the sun by a cross. In Sumerian objects, mainly seals but also in

38

the famous Naramsin's stele (about 2800 B.C. in the Louvre), the crescent, star, and sun are symbols of a triad of gods: Sin, Ishtar, and Shamash. In various Sumerian cities, particularly in Ur and Harran, and later in Babylonian and Assyrian communities, the god of the moon, Sin, also called Nannar (Brilliant), was worshipped more than Shamash, the sun. Probably the cult of the crescent originated in the older, nomadic societies and was introduced to Mesopotamia by Semitic tribes wandering from Arabia, whereas the god of the sun gained his reputation in the later, agricultural stage of cultural development. The moon was respected as the main star of the sky, the creator of all things, father of the gods but the Great Mother dominating Earth, lord of wisdom, ideal of kings, friend of mankind, and the protector of health; it was also very important to all calendrical and astrological calculations.[75] Above all, people were fascinated by the changing phases of the moon and by the perceptible, alarming, magnetic influence it exerted on the earth, the waters, earthly beings, and their affairs. All basic forms of the moon for sacred and state use had been established in ancient Mesopotamia: the moon in the form of a disc with a crescent below, the crescent with open arms, the crescent with closed arms, the crescent with a man standing on it, and the crescent as a horned animal (bull, cow, or gazelle). Some of these forms were later used in Ottoman Turkey. It is worth adding that the Assyrians used to wear a special cult weapon, resembling a sickle with a long handle, undoubtedly connected with the symbol of the crescent.[76]

In the Babylonian-Assyrian circle, a star with eight rays was connected with the Goddess Ishtar, who, as a daughter of the moon—the Great Mother dominating the Earth—belonged to the triad of the highest gods and was worshipped almost everywhere, without a special location of residence. Adopted by various later religious systems, with only a change of forms or names, this cult showed great persistence throughout the centuries and in many lands. Ishtar was the goddess of life, love, fertility, and good harvest, but she also accompanied destruction and death in nature. In the astrological sphere she was associated with the planet Venus, the Morning Star. The visible phases of the planet in summer and in winter were interpreted as two aspects of the goddess: that of giving life and that of bringing death.

The third god of the Mesopotamian pantheon, Shamash, was also

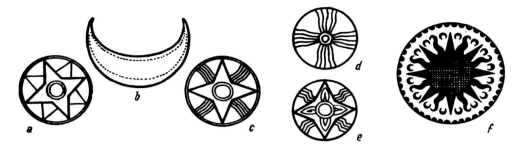

Fig. 8. Various motifs of the morning star, the crescents, and the sun.

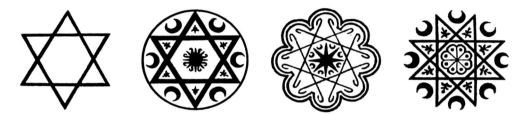

Fig. 9. Various motifs of Solomon's Seal.

a descendent of the moon. He was protector of the law and of the home and brought good omens. His symbol was the sun's disc with inner rays of various composition. Usually from the central circle the undulant rays sprang out to the rim, the whole forming a cross. Very often the inner rays were made of two stars, each one with four triangular rays laid one on the other. In Egypt, Assyria, and Achaemenid Persia the disc was furnished with wings but this form was rejected by the Ottomans. Sometimes the sun was identified with a rosace or rosette, having alternating triangular straight and undulating rays.

The astral cult became established in pre-Muslim Arabia and was particularly discernible in the Sabaean kingdom (tenth to second century B.C.). In the Sabaean creed, which is known from numerous inscriptions, the notion of One God (Allah) developed with the simultaneous cult of the moon and stars as intermediaries between the inaccessible God and the people.[77]

These myths and the astral symbolism continued their development in the Persian cultures of the Achaemenian, Parthian, and

40

Sasanian periods. This symbolism had become strongly bound to the idea of royal sovereignty—for example, the king of Babylon was called the Sun of Babylon. According to the imperial concept popular in the ancient Near East, the royal system was based on the celestial system—the enthroned king among his vassals and satraps was like the sun amidst the stars.[78] Under the kings of the Sasanian dynasty, the crescent was the predominant astral sign and always accompanied the ruler in representative images.[79] Such astral symbols were also employed by Hellenistic, Roman, and Byzantine rulers. In Byzantium, still a Greek colony in the fourth century B.C., the set of the star and the crescent was used on coins.[80]

The later adoption of the sign of the crescent and the star by the Turks has been attributed to Byzantine influence. Allegedly the adoption indicated legalization of Turkish (Ottoman) rule after the capture of Constantinople in 1453. This hypothesis, however, is weak; the origin of the crescent under the Turks is far more complicated and controversial. First of all, the astral origin of the sign has been questioned. W. Ridgeway found a group of amulets or charms in the form of joined pairs of tusks or claws, with the appearance of crescents, used both in very old as well as modern Oriental cultures.[81] Further, the historian Rıza Nur explained the crescent as an apotropaic sign made of animal's horns. He maintained that this very amulet, called by the Arabs ʿalam and by Turks boncuk or nazarlık, was usually hung round the neck of children and horses, in tents, houses, and finally temples.[82] Another scholar, T. Arnold, was also against the lunar origin of the crescent form: he attempted to associate it with the form of the horseshoe, an ancient sign of good luck.[83] An interpretation of the crescent in terms of horseshoe in heraldry was proposed by L. A. Mayer.[84] It is worth adding that in an early description of the Ottoman flag taken by King Sobieski at the Battle of Párkány on October 9, 1683, the crescents are explained as the hoofprints of Muhammad's horse.

All these nonlunar speculations on the crescent seem unconvincing and their origins might rather be reversed, since both double horns and the horseshoe resemble the crescent moon. The combination of the astral symbols of the moon, sun, and stars, however, seems to be firm.

Another question arises concerning the period in which the crescent was adopted by the Turks as the state symbol. Although the

oldest known instance of placing a crescent on the top of a mosque occurred in the eleventh century, when the Seljuk took the town of Ani in the Caucasus and converted the Christian church, a survey made by A. Sakisian, together with Turkish iconographers, indicates a limited use of this symbol between the fifteenth and eighteenth centuries. The crescent was neither a special nor a privileged Ottoman symbol. For topping mosques and minarets as well as flagpoles and the poles of horsetail standards, other symbols were also used, such as a ball, a lily, or a cartouche with arabesques or inscriptions.[85] Quite instructive here is the report of Çelebi Mehmed Efendi, an envoy of the Sublime Porte to the court of King Louis XV, who at the time of his reception in Paris was very surprised to see a crescent used as the symbol of his state. Actually it was used along with many other signs and only in the nineteenth century was it chosen as the sole "heraldic" emblem of the Turkish state. This is also the conclusion of the researches of M. Rodinson.[86]

In the Ottoman flags of the fifteenth through eighteenth centuries the crescent occurs in two forms. The first form is modeled on the appearance of the new moon and may be called the *open crescent,* while the second form makes a figure composed of two eccentric circles in which the smaller one is within and touching the rim of the larger. In this form the ends of the crescent's arms are joined and can be called, after the Italian scholar G. de Lucia, the *closed crescent.*[87] The first type of crescent usually comes without the star; the second type has, in the field of the smaller circle—that is, between the crescent's arms—a star or even a cluster of stars. In earlier Ottoman flags the closed crescent is usually supplemented by an inscription on its surface; sometimes the writing is reversed, mirror-like. From the eighteenth century until the present day, however, the state heraldry of Turkey has been dominated by the open crescent.

The stars depicted on flags, in conjunction with the crescent or separately, were of various shapes. They could have five, six, seven, eight, ten, or eleven rays, which were either elongated triangles or alternately straight and undulant triangles. Since the eighteenth century, the fashion of an eight-rayed star—made from two squares, one upon the other—prevailed.

The symbol of the sun did not differ greatly from that of the star. In an early phase it was depicted as a multirayed star with alternate

42

straight and undulating rays, but later on it developed into a disc with a rosette of very intricate design.

Finally, I should draw attention to a symbol appearing on Ottoman flags that was formally a variety of star, constructed of two equal-armed superimposed triangles, and was called in the Muslim world Solomon's Seal *(Muhr Süleymān, in Arabic)*. It was identical with the Judaic symbol called the Shield of David *(Māgên Dâvîd)*. This hexa-gram was not very often applied, but it does appear on one of the flags in the Topkapı Saray (inv. no. 10165), on some in the Deniz Museum in Istanbul (nos. 66 and 448), and also on the flag in the Wawel Castle in Cracow. The origin and explanation of the symbol are unclear and rather controversial.[88] Solomon's Seal appeared quite early and was known from Babylonian and Assyrian seals dating to 3000 B.C. and from Hebrew objects dating to the seventh century B.C. It was also found on the city walls of Jerusalem, in the Jewish catacombs at the Villa Torlonia near Rome, on Arabic amulets from the ninth century, on Moorish ceramic objects, in Byzantine magic texts, and on Indian architecture. In medieval alchemy it was the sign of the philosopher's stone. The name of David's Shield was noted in the twelfth century in the texts of Judi ben Eliyaha Hadasi, but in the Jewish religion it did not become widespread before the sixteenth century.[89]

With Solomon's Seal, various symbolisms exist, some of which seem almost antagonistic. In astrology the sign was connected with the zodiacal system, joining the signs of fire and air (the other zodia-cal signs were of water and earth), and if angels, spirits, and demons originated from fire and air and if Solomon was their king, the hexagram represented an instrument of domination over them.[90] Sometimes the sign implied a cosmological interpretation concerning the structure of the world. The hexagram represented the days of the week, its counterparts being the six visible planets, and it thus indicated the central position of the sabbath. The rays of the star triangles represented the two worlds, the upper and the lower, visi-ble and invisible, and at the same time the two aspects of God, visible and hidden. They also expressed the birth of the microcosmos (man) from the macrocosmos (the world). From there only one step led to the messianic concept: the birth of the Messiah from the womb of Abraham. The zodiac associated with Pisces the period of the ex-pected coming of the Messiah. A mythological interpretation of the

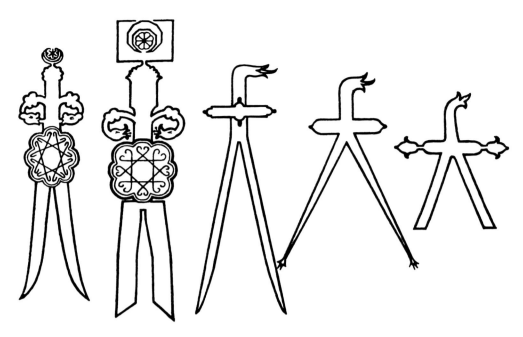

Fig. 10. Various motifs of the Zulfikar sword in Ottoman art.

Seal, not empirically grounded, was proposed by H. Levy, who pointed out its connection to the Babylonian-Assyrian cult of Saturn, whose symbol it was purported to be.[91] Finally, there is the purely apotropaic interpretation of the sign, in which each of the two triangles is regarded as an eye (similar to the Eye of Providence), which gives protection against evil charms and illness. Even the pupil was marked by a point.[92]

The Turks took over Solomon's Seal from the Arabs, but their knowledge of its meaning and symbolism was limited. In the pure form of a hexagram it frequently appeared on the blades of Ottoman sabres as late as the eighteenth and nineteenth centuries. A variation of the sign was a star with eight arms, a derivation with higher magic power. On Ottoman flags various forms of this symbol were used, with freely constructed elements and fields filled by the crescent, small stars, or inscriptions. A characteristic calligraphic starlike knot was regularly inlaid on the sword Zulfikar—another important symbol on Ottoman flags.

Among astral motifs used on Ottoman flags can be discussed the symbol called *czintamani,* consisting of three discs in conjunction with

44

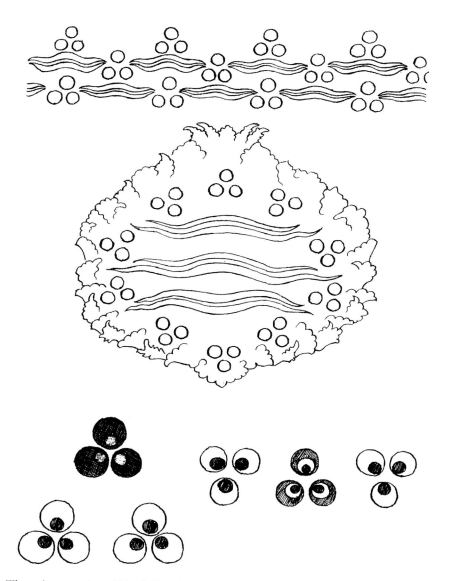

Fig. 11. The czintamani motif in full and reduced forms.

two wavy bands, recalling clouds. The origin and meaning of this symbol are controversial. Always defending the independence of Turkish culture, some Turkish scholars, above all Tahsin Öz, tried to explain the symbol as an imitation of the stripes and spots of such wild animals as tigers and leopards, but this idea was questioned by the Polish orientalist Tadeusz Mánkowski.[93] Czintamani most proba-

bly was of Far Eastern origin and symbolized domination over the three elements of the world—sky, water, and earth. According to tradition, it was used by Tamerlaine. This motif appears in reduced form in Ottoman flags, limited to the three discs in a triangular set. The Turks often changed the disc of czintamani into a closed crescent, as in one of the flags in the Historical Museum of the City of Vienna.[94]

THE SWORD ZULFIKAR The sword *dhu al-fiqār* or *dhu al-faqār*, popularly called the Zulfikar and known also as Muhammad's Sword, ʿAlī's Sword, or the Janissaries' Sword, is one of the characteristic symbols used on Ottoman flags, but its origin and function are still mysteries.[95]

According to Arabic sources, Zulfikar was a sword captured by Muhammad in 623, at the Battle of Badr, from the fallen infidel called Al-ʿĀṣ ibn Munabbih ibn Al-Hajjāj. It was the first great victory of the Prophet, who, while residing in Medina, decided to attack his pagan antagonists in Mecca. This victory became one of substantial importance, and it is no wonder that a legend was built around the battle and the captured sword, to which miraculous properties were attributed.[96] It was said that it was a work of the Arabian sword-maker Marzuq. Zulfikar soon became Muhammad's favorite sword and accompanied him in all battles. Subsequently, it was inherited by ʿAlī, then by his sons Hassan and Hussain, then passed finally into the possession of the Abbasids. Caliph Harun ar-Rashid donated it to the commander-in-chief of his army, Yezid.[97] In the tenth century it was still associated with Caliph Al-Muqtadir, but later information concerning its history is somewhat misty. Some writers maintained that it was for a time in the hands of the Fatimids and then recovered by the Abbasids, who kept it till the end of their time. The oldest images of Zulfikar come from the thirteenth and fourteenth centuries. From the sixteenth century, and particularly under the Moguls and the Ottomans, the fame of Zulfikar increased. The sword was represented in miniatures, put on flags, and reproduced as actual weapons, although the original sword had disappeared.

Since the descriptions of Zulfikar in ancient sources are inaccurate, a controversy arose about the true appearance of this sword. Its basic feature, according to some authors, was the double ending of the blade. Other authors, however, analyzing the name *dhu al-faqār*,

46

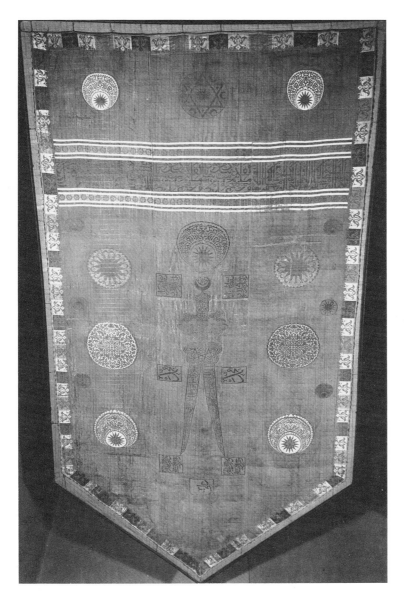

Ill. 9. Ottoman flag, Zulfikar type, captured at the Battle of Vienna, 1683, by Marcin Zamoyski. By permission of Wawel State Collections of Art, Cracow.

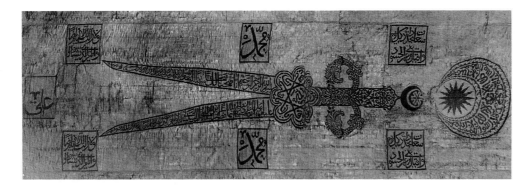

Ill. 10. The Zulfikar sword from Zamoyski's flag. A fragment of Illus. 4. By permission of Wawel State Collections of Art, Cracow.

suggested a blade with hollows, recalling the structure of the human spine. Of course, one feature does not exclude the other. What must be stressed above all is the importance this sword had to early Arab warriors, particularly in the time of the great Islamic expansion. A mystical belief in the necessity for *jihād*, the holy war, was combined with the mysticism and cult of arms, as had been reflected in Arabic culture, especially in poetry. The capacity of the Arabs for poetical metaphors and special verbal associations favored the creation of an enormous vocabulary of synonyms concerning arms. In one of his works (not extant) Firuzabadi assembled about one thousand of the sword's names.[98] The Prophet himself owned, besides Zulfikar, nine more swords whose sophisticated names and features were also recorded by chroniclers.[99]

The sword was respected as the most valuable and noble of weapons, demanding great strength and courage in fighting. Thus, it was also a symbol of bravery and power. It could be found in various Oriental states as the sign of the ruler. Sasanian kings were usually represented as sitting on a throne with a huge sword before them. It is worth noting that in this context a crescent was placed above the king's head.[100] If we remove the throne with the king there would remain the sword crowned with a crescent, which is the way it appeared on Ottoman flags. This does not, of course, mean that the symbol was indirectly borrowed by the Turks from the Persians. Here, rather, exists a general climate of ideas influencing both cultures.

48

Returning to the question of the form of the weapon Zulfikar, we must bear in mind that the Arabs appreciated Indian swords because in India the practice of metallurgy was ancient. It was in India, for example, that high-class watered steel had been invented. It would not be surprising if the sword captured by Muhammad at the Battle of Badr was of Indian or Indo-Persian origin. The vertebrae mentioned in the descriptions could be the hollows sometimes made by swordmakers both to reduce the weight and to increase the rigidity of the blade. Since smooth blades were commonly used by the Arabs of that time, they would have been astonished at the special design of the captured piece. The double point of the blade is not easy to explain, although the technical process of this construction was not beyond the skill of Indian masters. The problem lies in the fact that the splitting of the point in the plane of the blade was completely useless for practical fighting. Actually it made fighting more difficult! In some Zulfikar representations it was sometimes shown not as a double point but as a splitting of the normal, single point. In any case, I am inclined to see in Zulfikar a kind of ceremonial or cult weapon. This doubling of the blade can be easily associated with the symbol of horns and with the symbolism of lunar and apotropaic power.

In Ottoman Turkey the Zulfikar was depicted in two ways, first as a straight sword and then, from the seventeenth century, as a curved sabre. In a miniature in a Turkish manuscript of Lāmi, preserved in the Czartoryski Library in Cracow, ʿAlī is represented with a Zulfikar sabre.[101] Some actual models of Zulfikar sabres from the seventeenth and eighteenth centuries have survived in various collections.[102] The Zulfikar sabre in the Czartoryski Collection, originating probably from the end of the seventeenth or beginning of the eighteenth century, does indeed have a blade with hollows, a double point, and the inscription: *"La fatan illā ʿAlī, lā sayfa illā Dhu al-faqār"* (There is no hero but ʿAlī and no sword but Zulfikar).

In the Ottoman flags of the sixteenth and seventeenth centuries the Zulfikar usually appears in the form of a sword with two parted points. Some interpreters have explained this as representing the domination of the Ottomans over East and West. The pommel of the sword is usually crowned, as noted above, with a crescent or a crescent with a star. The quillons are in the form of two serpents' or dragons' heads turned downward. This is also found on some actual

Fig. 12. Various motifs of the hand and of the lily in Ottoman art.

specimens of Ottoman arms, particularly on sabres and tucks (rapiers).[103] Evidently this shape of quillon was opposed to the hated form of the cross that prevailed in Christian weapons. Dragon heads were, of course, borrowed from the Far East. On the flag Zulfikar, beneath the handle on the blade, there is usually a knot—surely a derivation of Solomon's Seal. A star was sometimes placed between the two points of the blade, which again confirms the thesis of the affinity of the Zulfikar to the crescent. In more sumptuous flags the surface of the sword is nearly always covered with inscriptions, particularly those connecting the sword with ʿAlī. This union is also marked by the placing of a small image of Zulfikar by the name of ʿAlī written on the flag.[104] It is worth adding that ʿAlī was called Shah of Zulfikar *(Shāh-i Dhu ʾl-fikari)*. It is also a hint of Shia tendencies in the Ottoman state. In this, too, yet another feature may be noted, which we might call a nostalgia for (outlawed) human images. When investigating the various forms of Zulfikar on the Ottoman flags, we can observe in some of them a resemblance to the human figure, the pommel being the head, the quillons the arms, the Seal-rosette trousers, and the double points the legs. The anthropomorphism of the sword seems indisputable.

SIGNS OF THE HAND, PHOENIX, AND DRAGON Figurative elements are quite rare in Ottoman flags, but sometimes they are evident on a small, discreet, all but invisible scale.

In some later flags in the vicinity of the Zulfikar there was included the sign of a hand, defined usually as the "Vengeful Hand of ʿAlī," sometimes as "The Hand of Hussain" or, more often (until modern times), as "The Hand of Fatima."[105]

It is well known that ʿAlī and his son Hussain died as martyrs in the struggle for succession after Muhammad died and were worshipped by the Shiites. It must be understood, however, that the hand may also have other connotations. The symbol of the hand

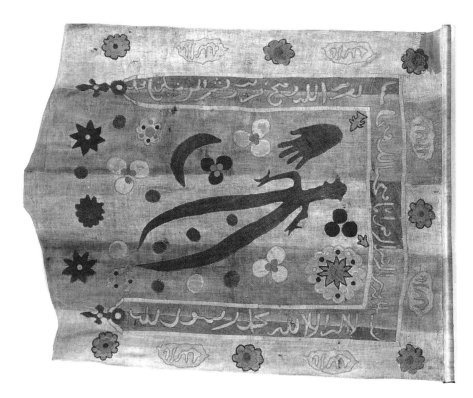

Ill. 11. Ottoman flag with the Zulfikar, inscriptions, the crescent and stars, the hand and
the czintamani motifs, probably captured in 1683 at Vienna. By permission of Heeresges-
chichtliches Museum, Vienna.

appeared in prehistoric times and was one of the first signs used by
primitive man, probably for some magical purposes. We find numer-
ous handprints since the Upper Paleolithic in caves in the Near East,
Europe, and North Africa that were used for shelter or for places of
ritual.[106] Such handprints (and footprints) were found in many parts
of Asia, as well, in Tibet and Afghanistan.[107] The ancient symbols
were taken over by Buddhist art, and a characteristic gesture of the
Buddha himself is his hand stretched out *(mudra)*.[108] For the Semites
this sign always meant the power of God and was often put on seals.
The sign was used in Babylon and in ancient Egypt with a magic,
protective or destructive aim. Roman *signa militaria* (military em-
blems) were often surmounted by a hand.

In Asia the hand symbol began to change its form, deviating from
its original image and becoming a pentapetalous palmette, a crest

51

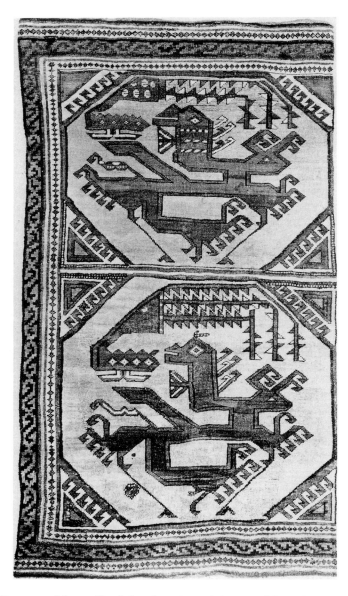

Ill. 12. Anatolian rug with motifs of the phoenix and dragon, fifteenth century. By permission of Staatliche Museen zu Berlin, Islamisches Museum.

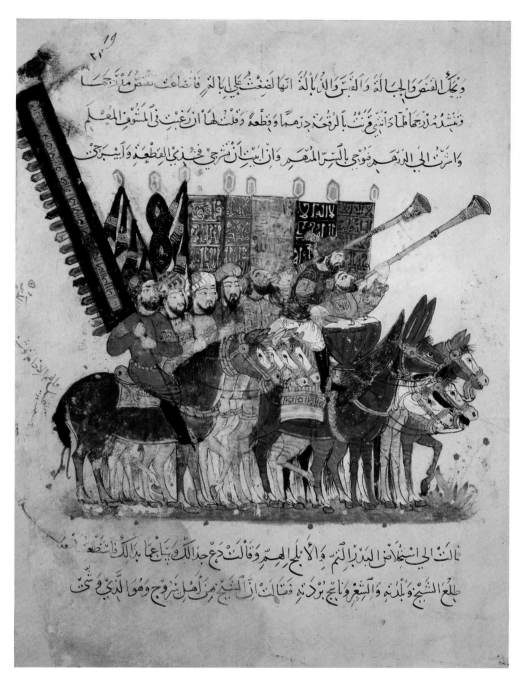

Pl. 1. Arab cavalry with flags, a miniature from al-Ḥarīrī's Maqāmāt, dated 635/1237. By permission of Bibliothèque Nationale, Paris.

Pl. 2. 'Alī fighting with the Zulfikar sword, a miniature from the Lami's poem of the sixteenth century. By permission of National Museum, Cracow, Czartoryski Collection.

Pl. 3. Ottoman flag, Zulfikar type, captured at Vienna in 1683 by Atanazy Miączyński. By permission of Wawel State Collections of Art, Cracow.

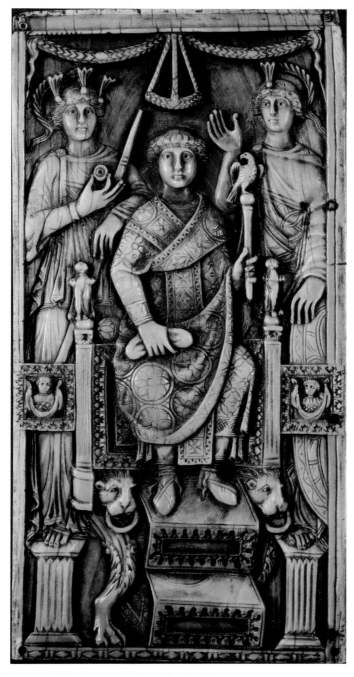

Pl. 4. Consul Magnus with the mappa handkerchief, A.D. 518, an ivory diptych. Cabinet des Médailles, Paris. By permission of Bibliothèque Nationale, Paris.

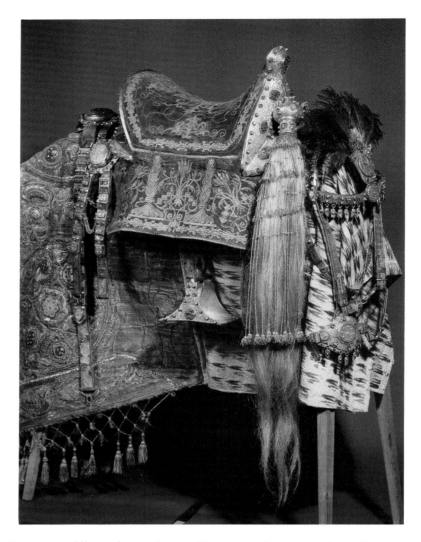

Pl. 5. Ottoman saddle and trappings, with a pendulous tugh (boncuk), seventeenth to eighteenth century. By permission of National Museum, Cracow.

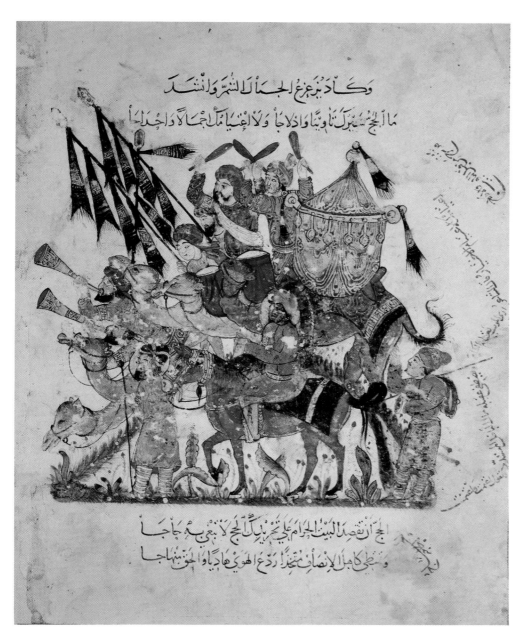

Pl. 6. Peculiar tughs carried by pilgrims to Mecca, a miniature from al-Ḥarīrī's Maqāmāt, 635/1237. By permission of Bibliothèque Nationale, Paris.

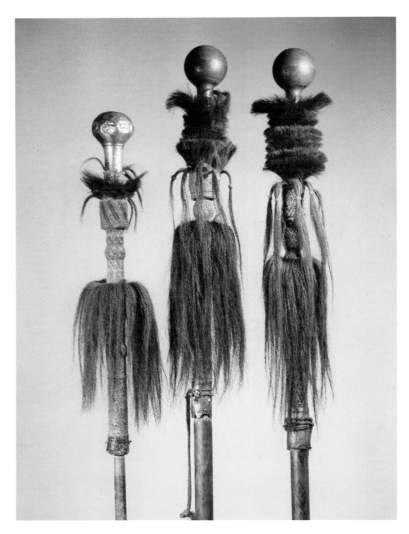

Pl. 7. Two tughs taken at Vienna by King Sobieski in 1683 and donated by him to the church of St. Anne, Cracow, and a tugh (lower) from the Clara Mons monastery at Często-chowa. By permission of Wawel State Collections of Art, Cracow.

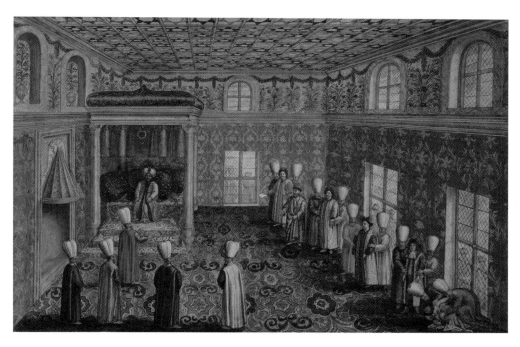

Pl. 8. The reception of Polish envoy Jan Gniński by Sultan Mehmed IV in 1677, in the gouache painting by Pierre Paul Sevin. By permission of National Museum, Cracow, Czartoryski Collection.

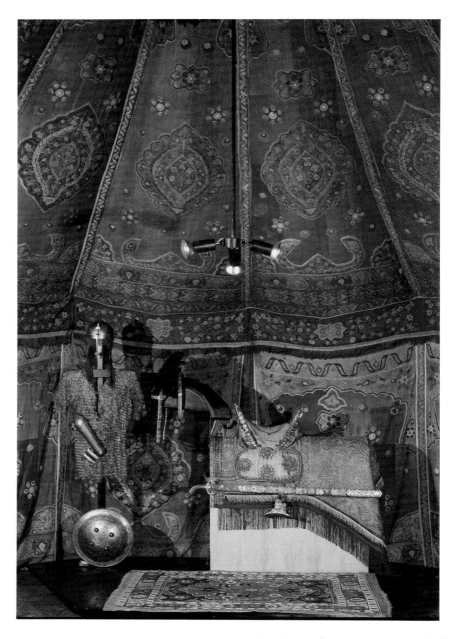

Pl. 9. Polygonal red tent from the Vienna booty in 1683 (a fragment). By permission of Wawel State Collections of Art, Cracow.

Fig. 13. The motif of the solar bird fighting with a dragon in the Párkány flag of the Wawel State Collections of Art, Cracow.

with five prongs, or even a cross with equal arms in which the five points indicated four arms and a crossing. In pre-Islamic Turkish mythology, this last sign represented spirits ruling the regions of the Earth, while in every other form they remained amulets against spells.[109] The number 5 was particularly favored in China in connection with the magical square *Lo Shu,* in which it held the central position; this was also expressed in the Chinese philosophical doctrine called the School of Five Elements.[110] It also should be noted that in their original homeland the Turks used the red handprint as a seal. Later on, the symbol of the hand was set atop the flagpole, particularly by the Mamelukes. Islam associated with the sign the legend of its heroes, although sometimes even the name of Allah was seen in it because of the art of Islamic calligraphy and the composition of letters.[111] More often the sign was interpreted as representing most important members of the Prophet's family: the Prophet himself, his daughter Fatima, his son-in-law ʿAlī, and his grandsons, Hassan and Hussain. In astrology the sign of the hand was associated with Venus and was sometimes joined with a crescent.[112] On Otto-

53

Fig. 14. The phoenix and the dragon from a Persian blade in the Wawel State Collections of Art, Cracow.

man flags the hand symbol appeared in a more or less realistic form, although there always operated the basic principle of the Turkish art of stylization and expression; hence, it was a normal human hand but deformed in stylized fashion. Formally it could even be transformed into a lily.

The symbol of the phoenix and dragon, or, more generally, of the bird and serpent, is very rarely used on Ottoman flags, but it is found on one flag in the Wawel Castle Collection in Cracow. This particular symbol is of cosmological character.[113] It is a representation of the elementary and antagonistic powers of the world: sun-bird and ocean-dragon. The struggle of these powers meant the struggle of light with darkness and good with evil. The myth was attractive because of its evident and understandable content: everybody knew day from night and good from bad. In Han dynasty China (about the second century B.C.), the myth, with its double principles ruling the world was already well established: the male principle Yang corresponded with the sun; the female principle Ying, the Earth and the ocean. The two powers cocreated the world and existed in everything, the tension in their relationship usually shown symbolically as a struggle between a phoenix and a dragon.[114] These symbols were used in various places and in various materials, including Chinese flags, along with motifs of the sun, moon, stars, and tigers.[115] The myth of the solar bird fighting with a serpent was also well rooted in Persian Zoroastrianism. It is well known that in various cultural regions the same ideas were expressed in different forms under different names. The solar bird was shown as an eagle, vulture, falcon, crane, cock, pheasant, or bird of paradise; or as a fantastic bird, the phoenix or the Persian *sīmurgh;* and sometimes as

54

a hybrid, a bird with a human or animal's head. A pheasantlike solar bird was often found in Turkestan from the ninth to fourteenth centuries as well as in Persia in the sixteenth century, which once again demonstrates the migrations of myths and their visual equivalents throughout time and across many lands.

In Muslim ideology the notion of the solar bird was accepted and proliferated by Arab authors. It appeared as a cock "whose wings are set with emeralds, pearls, and hyacinths. And one wing is to the East and the other to the West . . . and when the Resurrection Day will come, God will say: Raise your wings and sing, that the residents of Earth and of Heaven know the Hour."[116] The solar cock was nearer to the Persian tradition, while in Arabic literature the bird took the form of an eagle or a vulture, called *nasr* or ʿuqāb. We return thus to the flag of Muhammad with this very name.

As Qazvīnī described the phoenix, "Being old, blind and weak, he goes to the sky until his feathers burn from the sun's fire, and then he dives down and several times immerses himself in the fountain, coming out reborn and powerful."[117] This myth is fascinating because it originates in pre-Islamic tradition associated with the Kaaba of Mecca. According to this legend, the Kaaba was occupied by a monstrous serpent, which, at God's order, was attacked by a powerful eagle. When the serpent, sitting on the wall of the Kaaba, opened its mouth to swallow the bird, the bird seized it with its claws and carried it up to the mountains."[118] Three cosmic powers were involved: the sun-bird, the ocean-serpent, and the earth-temple. Of birds, the eagle ranked highest. It has been featured on the ensigns and flags of various nations. The flag of Muhammad, I repeat, was called ʿuqāb, the eagle.

Despite the Islamic aversion to figurative symbols, images of birds and serpents were included in the flag repertory; the Turks were especially familiar with this motif that was often found on the Persian blades of their swords and sabres.[119] Typical Turkish stylization (geometrization) of this motif is documented in a well-known rug from Anatolia, dated from the late fourteenth century, now in the Museum of Islam in Berlin.

In the case of the Ottoman flag in the Wawel Castle Collections in Cracow, which was captured at the Battle of Párkány in 1683, the solar bird takes the form of a cock fighting a winged dragon with a snake's head. It is a composition compromising Persian and Turkish

Fig. 15. Floral motifs from Ottoman flags.

styles. In a quadrangular field, thrice repeated, two pairs of fighting monsters are set symmetrically on both sides of the central motif consisting of leaves, a carnation, a tulip, and pomegranate flowers and fruit springing out from crescents. This motif may be interpreted as suggesting the tree of life.[120]

SEMISYMBOLIC AND ORNAMENTAL MOTIFS OF FLAGS The original modesty of Ottoman flag design was followed by a period of decorative exuberance. Ottoman flags of the eighteenth century were of enormous size and had effectively changed into splendid carpets or hangings in which some basic symbols remained intact. Various floral and geometric ornaments were used; the flowers were usually stylized, although their natural models were sometimes suggested. Very early, at the latest in the sixteenth century, the lily flower was adopted, usually in the frieze around the border. The border might also be filled with crescents and stars or with inscriptions. In the seventeenth and eighteenth centuries flags were decorated with bands of floral motifs, in scrolls of carnations, tulips, roses, cypresses, or pomegranates, sometimes springing from vases. A variety of such vases with flowers was adapted from models of Italian weaving.[121] These motifs were to some extent symbolic or at least semisymbolic: for example, the pomegranate meant the bliss of paradise and the cypress immortality. The Turks also stylized flowers into important symbols, thus, for example, making a crescent out of a tulip.

Purely geometric forms appeared in Ottoman flags: triangles, rhombs, squares, rosettes, and zigzags, in closed patterns or endless repeats. I cannot find any clear symbolism here, although this practice does seem to recall the ancient Seljuk decorative style (which was not devoid of inner meaning). The presence of these geometric forms in Ottoman flags demonstrates once more the persistance of

56

tradition, a tradition that revives through the centuries in ever new forms.

CONCLUSION: THE KORANIC INSPIRATION OF OTTOMAN FLAGS

The symbolism that developed in Ottoman flags over the centuries still demands more explanation. On the basis of the analysis made above, it is possible to draw some general conclusions, suggesting some understanding of the flag charges. The symbolic and ornamental elements discussed above make up the main content of the sultans' and pashas' flags that fall within the area of my research and interest. While it is still difficult to establish a typology for the elements used in the flag hierarchy, those flags considered can be categorized according to certain elements of content and composition.

First we must find a full individualization of specimens to include within the typological framework; otherwise, we may be considering very similar but not identical objects. The main field of the flag, usually stitched from three or more pieces, is surrounded by the border, sometimes a double border with fringes, filled with inscriptions or an ornamental frieze.

Ottoman flags of the sixteenth to eighteenth centuries can be divided into three types, two basic types and an intermediate type, according to the content of the main field: the inscriptional type, in which the field is covered with writings and which can be monumental in size, and the Zulfikar type, in which the sword is dominant, although other elements and inscriptions of smaller size do appear. There is a third, or intermediate type, in which the field's composition is similar to that of the Zulfikar type, but without the sword. In the Zulfikar type the main field is usually sewn from three pieces and at some distance from the pole there is a single or double band with inscriptions. Further division of the field is made by a symmetrical set of such elements as crescents, stars, suns, cartouches, medallions, or vases with flowers.

On the basis of the earlier discussion, one can presume that the inscriptional type of flag preceded the Zulfikar type. The latter was a result of the ideological processes developing in the Ottoman state,

above all the growth of militarism. War was regarded as the most powerful instrument of the state's activity, the sword being not only an argument but also a principle of the rule that, in the Prophet's words, all power is born in the shadow of the sword. If the first type of flag was an expression of religious ideology, the second was a manifestation of imperial policy. The two were bound by the Koran, and thus, to understand fully their inner meaning, the Holy Book once again should be considered.

"This Book is not to be doubted," said the Prophet. "It is a guide to the righteous, who have faith in the unseen. This Book is beyond doubt revealed by the Lord of the Creation."[122] In various places in the Koran there is mention of the sun, the moon, the stars. Their interpretation has a cosmological character.[123] It has been written: "Your Lord is Allāh, who in six days created the heavens and the earth and all that lies between them, and then ascended His throne. He throws the veil of night over the day. Swiftly they follow one another. It was He who created the sun, the moon, and the stars, and forced them into His service. His is the creation, His the command. Blessed be Allāh, the Lord of all creatures!"[124] And next: "It was He that gave the sun his brightness and the moon her light, ordaining her phases that you may learn to compute the seasons and the years. He created them only to manifest the truth. He makes plain His revelations to men of understanding. In the alternation of night and day, and in all that Allāh has created in the heavens and the earth, there are signs for righteous men."[125] All this meant that when they looked at their flags in battle, the Turks could see the symbols of the heavenly bodies as signs of the power and protection of Allāh.

The moon also played a role in the eschatological doctrine of Islam. It was written: "The Hour of Doom is drawing near, and the moon is cleft in two."[126] This cleaving of the moon was to be an announcement of doomsday. Some commentators of the Koran attributed to Muhammad the miracle of cutting the moon in two parts with his finger.

Still other functions were given by Muhammad to the stars: By those who range themselves in ranks, by those who cast out demons, and by those who recite Our Word, your God is One: the Lord of the heavens and the earth and all that lies between them: the Lord of the sun's risings. We have decked the lower heaven with constel-

lations. They guard it against rebellious devils, so that they may not hear the words of those on high. Meteors are hurled at them from every side; then, driven away, they are consigned to an eternal scourge. Eavesdroppers are pursued by fiery comets."[127]

There are also some allusions in the Koran to the magical and apotropaic role of the stars: "Say: I seek refuge in the Lord of Daybreak from the mischiefs of His creation; from the mischief of the night when she spreads her darkness."[128] The heavenly bodies were witnesses of the truth of Muhammad's words: "By the declining star, your compatriot is not in error, nor is he deceived!"[129] "By the heaven, and by the nightly visitant! Would that you know what the nightly visitant is! It is the star of piercing brightness."[130] "By the sun and his midday brightness; by the moon, which rises after him; by the day, which reveals his splendour; by the night, which veils him!"[131]

The sun could also be an allusion to Muhammad, since one of his epithets was *khurshid-i sipehr-i nubuwwat* (the sun in the firmament of prophesy). This was often used in ceremonial invocations at the beginning of important documents, as for example, in sultans' treaties with foreign rulers. It is strikingly similar to the symbol of Christ as the sun.

Solomon's Seal appearing in the vicinity of astral signs was rather of demonological and apotropaic character. It would seem to derive from several mentions of Solomon in the Koran, as for instance: "We bestowed knowledge on David and Solomon. They said: Praise be to Allāh who has exalted us above many of His believing servants." "Solomon marshalled his forces of jinn and men and birds, and set them in battle array."[132]

The other symbolic signs, such as the tughra, czintamani, hand, Zulfikar, bird, and dragon, are not so much representations from the Koran as expressions, above all, of imperial ideology, being figures of power and domination. Still, in this field, the Koran nevertheless furnishes various allusions. Here, the white hand of Moses was described, and this whiteness was equivalent with power.[133] If the Zulfikar was a symbol of domination over two sides of the world, the Koran relates: "To Allāh belongs the east and the west. Whichever way you turn there is the face of Allāh. He is omnipresent and all-knowing."[134]

In this way the great Ottoman flag may be considered a represen-

tation of heaven and earth: the sun, the moon, and the stars constituted the cosmic order and expressed the power and protection of God, while other signs and ornaments showed the earthly empire of the faithful, realized to perfection by the Ottoman Empire; and all was bound together by the Koran, the Divine Book whose words were dictated to Muhammad by the Archangel Gabriel.

Notes

1. There is a popular compendium by W. Smith, *Flags through the Ages and across the World*. See also International Association of Museums of Arms and Military History and Dutch Committee for Conservation of Textiles in Museums, *Conservation of Flags*.
2. K. Sierksma, "Flag Glossary and Description Rules," in ibid.
3. Ibid., 26.
4. M. Popławski, *Bellum Romanum: Sakralność wojny i prawa rzymskiego* (Bellum Romanum: The sacrum of war and of the Roman law) (Lublin, 1923).
5. P. Connolly, *The Roman Army* (London, 1975); *La Tapisserie de Bayeux* (The Bayeux tapestry) (Flammarian, 1957).
6. Smith, *Flags*, 1.
7. Ibid.
8. Ibid., 108.
9. Ibid., 34.
10. J. Cassin-Scott, *The Greek and Persian Wars, 500–323 B.C.* (London, 1977), 8, ill. 5.
11. P. Ackerman, "Standards, Banners, and Badges," in *Survey of Persian Art*, A. U. Pope, ed. (Oxford, 1939), 3:2769.
12. Ibid., pl. 577.
13. Ibid., 2773.
14. F. L. May, *Silk Textiles of Spain* (New York, 1957), 58, fig. 39.
15. R. Amador de Los Rios, "La bandera de Salado," *Boletin de la Real Academia de la Historia* 21:464–71, and *Trofeos militares de la reconquista* (Madrid, 1893).
16. Smith, *Flags,* 40.
17. H. Y. Şehsuvaroğlu, "Sancaklarımıza dair" (On our flags), *Cumhuriyet*, May 18, 1957.
18. The basic stock of Istanbul flags was described by F. Kurtoğlu in *Türk Bayrağı ve Ay Yıldız* (Turkish flags: The crescent and the star), a volume that gives plentiful information but lacks pragmatic scholarly method. The problem of flags was exposed by some other Turkish and Arab authors: R. Nur, "L'Histoire du croissant," *Revue de Turcologie* 1, 3 (Alexandria, 1933); Ali-Bey, "Notre drapeau et l'emblème du croissant et de l'étoile," *Revue de l'Institut d'Histoire Ottomane* 46 (Istanbul, n.d.); H. I. Uzunçarşılı, *Osmanlı devletinin saray teşkilâtı* (The structure of the court in the Ottoman state) (Ankara, 1945); H. Y.

Şehsuvaroğlu, "Sancaklarımıza dair" (On our flags); A. Tamūr Pasha, *Tārikh al-ʿAlām al-ʿUsmāni* (A history of Ottoman flags) (Cairo, 1928); Abd ar-Rahmān Zaki, *Al-ʿAlām wa Shārāt al-Mulk fî Miṣr* (Flags and coats of arms in Egypt) (Cairo, 1948).

19. The exhibition of 1883 was arranged in the Vienna City Hall, with a catalogue compiled by J. Karabaček, and the exhibitions of 1979 and 1983, in the Historisches Museum der Stadt Wien (Historical Museum of the City of Vienna), with the following catalogues: *Wien 1959: Die Erste Türkenbelagerung* (Vienna, 1979), and *Die Türken vor Wien: Europa und die Entscheidung an der Donau* (Vienna, 1983). See also W. Hummelberger, "Die Türkenbeute in Historischen Museum der Stadt Wien des 17. Jahrhundert," *Vaabenhistoriske Aarbógen* 15 (1969):9–97.

20. J. Guiffrey and G. Migeon, *La Collection Kelekian: Etoffes et tapis d'Orient et de Venise* (Paris, 1908); G. Lucia, *La Sala d'Armi nel Museo dell'Arsenale di Venezia* (Rome, 1908).

21. The church of San Stefano ai Cavalieri in Pisa was built after a design by G. Vasari in 1565–1595 and given to the Order of San Stefano. Based on the Order of St. John of Jerusalem, this Order was founded by Cosimo I de-'Medici in 1561 and had its original seat on Elba. See M. Scalini, "Gli ordini cavallereschi: La lotta contro il Turco," in *Armi e armati: Arte e cultura delle armi nella Toscane e nell'Italia del tardo Rinascimente dal Museo Bardini e dalla Collezionne Corsi* (A catalogue of the exhibition in Cracow and Florence, 1988–1989) (Florence, 1988).

22. V. Maglioli, *Armeria Reale di Torino* (Turin, 1959). A flag published there on pl. 32 is wrongly attributed to Sultan Mehmed II; in fact, it is of a much later date. The flag captured by Marshal Federigo Veterani in 1691, preserved in Urbino, has not so far appeared in the literature.

23. E. Egyed, *Az Iparművészeti Múzeum török zaszlói* (Turkish flags in the Museum of Decorative Arts) (Budapest, 1960), 169–77.

24. I have investigated the Cracow flags in "Studia do Dziejów Wawelu" (Studies in the History of Wawel). With few exceptions, the results of that study remain valid with respect to the statements here. In 1983, the Wawel group was enriched by an Ottoman flag from the nineteenth century, which came from the collection of E. Hutten-Czapski in Rome, through the hands of A. Ciechanowiecki of London.

25. J. Schöbel, *Orientalica* (Historisches Museum Dresden, 1961); E. Petrasch, *Die Türkenbeute. Eine Auswahl aus der Türkischen Trophäensammlung des Markgrafen Ludwig Wilhelm von Baden,* (Karlsruhe, 1956). See also P. Jaeckel, "Ausrüstung und Bewaffnung der türkischen Heere," in Max Emanuel Kurfürst, *Bayern und Europa um 1700,* (Munich, 1976), 1:373–84.

26. G. Migeon, *Manuel d'art musulman* (Paris, 1907), 2:410; S. Errera, *Catalogue d'étoffes anciennes et modernes* (Brussells, 1907), 120; C. J. Lamm, "En turkish fana," *Malmö Musei Vännes Arsbok* 3 (1940). Some Turkish flags taken by Poles in the wars of the seventeenth century probably later became trophies of Swedes, who invaded Poland in 1655–1657 and then in 1704.

61

27. W. B. Denny, "A Group of Silk Islamic Banners." See also Esin Atıl, ed., *Turkish Art*, pl. 214.

28. T. Öz, *Turkish Textiles and Velvets, Fourteenth through Sixteenth Centuries* (Ankara, 1950) and *Türk kumaş ve kadifeleri* (Istanbul, 1951). See also O. Aslanapa, *Turkish Art and Architecture;* R. Ettinghausen, "An Early Ottoman Textile," in *First Internatinal Congress of Turkish Arts* (Ankara, 1961); L. W. Mackie, *The Splendor of Turkish Weaving* (Washington, D.C., 1973); Walter Denny, "Textiles," in Yanni Petsopoulos, ed., *Tulips, Arabesques, and Turbans: Decorative Arts from the Ottoman Empire* (London, 1982).

It is symptomatic that Denny's piece contains only three sentences devoted to flags: "Another ceremonial use of textiles was in the form of banners. Flags, pennants, and banners of all sorts made in brocaded, appliqué, and embroidery techniques were in common use in Ottoman society. They accompanied army detachments, they were used in religious processions, and they appeared in abundance on festival days" (137).

29. Öz, *Turkish Textiles,* 15.

30. Ibid., 25–26.

31. L. F. Marsigli, *Stato militare dell'Impèrio ottomanno,* 2:51 (The Hague, 1732) (Graz 1972), Kurtoğlu, *Türk Bayrağı ve Ay Yıldız,* 123; Öz, *Turkish Textiles,* 237.

32. Żygulski, "Studia do dziejów Wawelu," 397–99.

33. Uzunçarşılı, *Osmanlı devletinin saray teşkilâtı,* 248.

34. Silahdar Fındıklı Mehmed Ağa, *Silahdar Tarihi* (Chronicle of Silahdar), 2 vols. (Istanbul, 1928). Mehmed Ağa (1658–1723) became the sultan's swordbearer *(silahdar)* in 1703, and his version was surely identical with the beliefs dominant at the sultan's court at the end of the seventeenth century. His texts were translated from Turkish into Polish by Zygmunt Abrahamowicz.

35. J. Von Hammer-Purgstall, *Geschichte des Osmanischen Reiches,* 3:35, 10 vols., (Pest, 1827–1835).

36. Uzunçarşılı, *Osmanlı devletinin saray teşkilâtı,* 248–49.

37. Ibid., 251. Here also a Polish source is valid concerning the departure of Sultan Mehmed IV from Istanbul on his way to the military camp in 1678: "the green banner of Muhammad in the green embroidered case was carried, having to the left an emir of highest rank in a green turban of great size" (F. Pułaski, *Zródła do poselstwa Jana Gnińskiego, wojewody chełmińskiego do Turcji w latach 1677 i 1678* [Source to the embassy of Jan Gninski, *voievode* (governor) of Kulm to Turkey in the years 1677 and 1678] [Warsaw, 1907], 106–7).

38. Silahdar, *Silahdar Tarihi,* 12–15.

39. N. M. Penzer, *The Harem.*

40. J. B. Tavernier, *A New Relation of the Inner Part of the Grand Seignor's Seraglio* (London, 1677).

41. Penzer, *The Harem,* 248–49.

42. C. White, *Three Years in Constantinople,* 3 vols. (London, 1845).

43. Mouradgea d'Ohsson, *Tableau général de l'empire Ottoman,* 7 vols. (Paris, 1788–1824).

44. Silahdar, *Silahdar Tarihi,* 12–15.

62

45. Uzunçarşılı, *Osmanlı devletinin saray teşkilâtı*, 259–60.

46. Silahdar, *Silahdar Tarihi*, 15.

47. J. Sobieski, *Listy do Marysieński* (Letters to the Queen Marysienka) (Warsaw, 1962), 520.

48. Marsigli, *Stato militare*, 52.

49. Kurtoğlu, *Türk Bayrağı ve Ay Yıldız*, 70.

50. Uzunçarşılı, *Osmanlı devletinin saray teşkilâtı*, 243.

51. Topkapı Saray Library, inv. no. H.1524, f.278a.

52. Nur, "L'Histoire du croissant," 335.

53. Kurtoğlu, *Türk Bayrağı ve Ay Yıldız*, 76, fn. 1 and fig. 48; Uzunçarşılı, *Osmanlı devletinin saray teşkilâtı*, 246.

54. Kurtoğlu, *Türk Bayrağı ve Ay Yıldız*, figs. 57 and 53a.

55. Ibid., 86–88.

56. Uzunçarşılı, *Osmanlı devletinin saray teşkilâtı*, 247.

57. J. I. Kraszewski, *Podróże i poselstwa polskie do Turcji* (Polish travels and embassies to Turkey) (Cracow, 1860), 2:52.

58. *Turkey: Ancient Miniatures*, preface by R. Ettinghausen, introduction by M. Ş. Ipşiroğlu and S. Eyüboğlu (Paris, 1961), 18.

59. Marsigli, *Stato militare*, 51–53.

60. The drawings, after which etchings were made for the Marsigli book, are preserved in the University Library of Bologna, ms. 3358. They are published in Z. Abrahamowicz, ed. and trans., *Kara Mustafa pod Wiedniem* (Kara Mustafa in Vienna) (Crakow, 1973), pls. 9–11. It should be noted that Abrahamowicz shows fifty-three drawings, while Marsigli gives 162 engravings.

61. Uzunçarşılı, *Osmanlı devletinin saray teşkilâtı*, 243.

62. Kraszewski, *Podróże i poselstwa polskie do Turcji*, 52–53. Of course, Taranowski was wrong about parchment since paper was used for Korans.

63. From a very large bibliography concerning state and religious symbolism, I cite here but a few works: E. Goblet d'Alviella, *La migration des symbols* (Paris, 1891), published in English as *The Migration of Symbols* (New York, 1956); R. C. Thomson, *Semitic Magic: Its Origin and Development* (London, 1908); R. Paret, *Symbolik des Islam;* G. B. Vetter, *Magic and Religion* (New York, 1958); M. Eliade, "Methodological Remarks on the Study of Religious Symbolism," in *The History of Religions: Essays in Methodology* (Chicago, 1959); F. Schuon, *Dimensions of Islam* (New York, 1969); S. H. Nasr, *Science and Civilization in Islam* (Cambridge, Mass., 1968) (2nd ed., New York, 1970).

64. Ackerman, "Standards, Banners, and Badges," in *Survey of Persian Art*, 3:2705.

65. E. Westermack, *Survivances païnnes dans la civilisation mahomédan* (Paris, n.d.); C. E. Arseven, *L'Art turc,* (Ankara, 1939), 216ff.

66. W. Egerton, *An Illustrated Handbook of Indian Arms* (London, 1880), 53.

67. Throughout this book, quotations are from the Penguin edition of the Koran (1973).

68. Żygulski, "Studia do dziejów Wawelu," 408. The translation from Arabic into Polish was made by Z. Abrahamowicz in Cracow.

69. F. Babinger, "Die grossherrliche Tughra," *Jahrbuch der asiatischen Kunst* 2

(1925):188–96; P. Witteck, "Notes sur la tughra ottomane," *Byzantion* 18 (1948):311–34 and 20 (1950):267–93; E. Kühnel, "Die osmanische Tughra," in *Kunst des Orients* (Wiesbaden, 1955), 2:69.

70. Egerton, *Illustrated Handbook.*

71. S. Cammann, "The Magic Square of Three in Old Chinese Philosophy and Relgion," *History of Religion* 1, 1 (Chicago, 1961).

72. A. Schimmel, *Calligraphy and Islamic Culture* (New York and London, 1984).

73. See, for example, the flags in the Topkapı Saray Museum in Istanbul, inv. nos. 824, 945, 1020, 10165, 27930, 27993, and 28992.

74. See Goblet d'Alviella, *La migration des symbols;* W. Grundel, *Sterne und Sternbilder im Glauben des Altertums und der Neuzeit* (Bonn, 1922) and *Sternglaube, Sternreligion, und Sternorakel* (Leipzig, 1933); W. Deonna, "Le crucifix de la vallée de Saas (Valais): Sol et lune—Histoire d'un thème iconographique," *Revue d'histoire des religions* 122 (1947) and 123 (1948).

75. W. H. Roscher, "Sin," in *Ausführliches Lexikon der griechischen und römischen Mythologie* (Leipzig, 1909).

76. Such an arm is shown in a statue of King Asurnazirpal in the Nimrud Gallery in the British Museum, no. 39. See H. Bonnet, *Die Waffen der Völker des alten Orients* (Leipzig, 1926), 85. See also reproduction of the "moon swords" excavated at Tello.

77. J. Noiville, "Le culte de l'étoile du matin chez les Arabes préislamiques et la fête de l'Epiphanie," *Hespéris* 8 (1928):363–84; J. Henninger, "Über Sternkunde und Sternkult in Nord- und Zentralarabien," *Zeitschrift für Ethnologie* 75 (1944): 82–117; G. Ryckmans, *Les religions arabes préislamiques* (Louvain, 1951); P. Kunitzsch, *Arabische Sternnamen in Europa* (Wiesbaden, 1959).

78. H. P. L'Orange, *Studies in the Iconography of Cosmic Kingship in the Ancient World* (Oslo, 1953).

79. Ibid., figs. 17 and 18.

80. It was probably an allusion to the saving of the city by the appearance of the moon at the moment of the night assault by Philip of Macedonia.

81. W. Ridgeway, "The Origin of the Turkish Crescent," *Journal of the Royal Anthropological Institute* 38 (London, 1908):241–58.

82. Nur, "L'Histoire du croissant," 272ff.

83. T. Arnold, "Symbolism and Islam," *Burlington Magazine* 55 (1928):155–56.

84. L. A. Mayer, *Saracenic Heraldry* (Oxford, 1933).

85. A. Sakisian, "Le croissant comme emblème national et religieux turc," *Syria* 22 (Paris, 1941):66–80.

86. M. Rodinson, "La lune chez les Arabes et dans l'Islam: La lune, mythes et rites," in *Sources Orientales* (Paris, 1962).

87. De Lucia, *La Sala d'Armi,* 145.

88. W. Thomas and K. Pavitt, *The Book of Talismans, Amulets, and Zodiacal Gems* (London, n.d.), 20; A. H. Winkler, *Siegel und Charaktere in der Muhammedanischer Zauberi* (Berlin and Leipzig, 1930), esp. ch. 6, where some important sources on Solomon's Seal are quoted and ch. 7, in which the role of the Seal

in the Muhammedan eschatology is discussed. Older literature also discusses the problem: see G. Salzburger, "Die Salomonsage in der semitischen Literatur," *Schriften der Lehranstalt für die Wissenschaft des Judentums* 2, 1 (Berlin, 1912). See also M. Grunwald, "Shield of David," in *The Universal Jewish Encyclopedia* (New York, 1948), 9:506–7; G. Scholem, "Curieuse histoire de l'étoile à six branches," *Revue de la pensée juive* (Paris, 1950), 53.

89. Grunwald, "Shield of David."

90. J. W. Hirschberg, "Jüdische und christliche Lehren in vor- und frühislamischen Arabien," *Prace Komisji Orientalistycznej Polskiej Akademii Umiejętności* 32 (Cracow, 1939):134.

91. H. Lewy, "The Origin and Significance of the Mâgên David," *Archiv Orientalni* 18 (Prague, 1950):330–65.

92. Arseven, *L'Art turc,* 220.

93. Öz, *Turkish Textiles,* 31; T. Mańkowski, *Orient w polskiej kulturze artystycznej* (The Orient in Polish artistic culture) (Wroclaw and Cracow, 1959), 181.

94. *Das Wiener Bürgerliche Zeughaus.* Historical Museum of the City of Vienna. Neunte Sonderaustellung, April–May 1962, cat. no. 75, fig. 9.

95. The symbol of Zulfikar is to be found on various Ottoman flags, inter alia in the Topkapı Saray Museum in Istanbul, nos. 66 and 448, and on three specimens in the Wawel Castle Collection in Cracow. There is little information on this sword recorded in the literature. See E. Mittwoch, "Dhu'l-fakar: The Name of the Famous Sword which Muhammed Obtained as Booty in the Battle of Badr," *Encyclopedia of Islam* (Leyden and London, 1912), 959. See also some remarks in the literature on arms: G. Klemm, *Werkzeuge und Waffen* (Leipzig, 1854), 435; M. Jahns, *Handbuch einer Geschichte des Kriegswesens von der Urzeit bis zur Renaissance* (Leipzig, 1880), 435; W. Boeheim, *Handbuch der Waffenkunde* (Leipzig, 1890), passim; F. W. Schwarzlose, *Die Waffen der alten Araber* (Leipzig, 1886), 36 and 152. It is hard to find anything revealing.

96. C. Brockelmann, *Geschichte der islamischen Völker und Staaten* (Munich, 1939), 21.

97. Schwarzlose, *Die Waffen der alten Araber,* 152.

98. Ibid., 13.

99. Klemm, *Werkzeuge und Waffen,* 247.

100. L'Orange, *Studies on Iconography;* R. Ghirshman, "Notes iranniennes, 5: Scènes de banquet sur l'argenteria sassanide," *Artibus Asiae* 16 (1953):51–76.

101. "Lām'i, Maqtāl-i ḥaẓret-i imām Hussein," Czartoryski Library, Cracow, ms. 2327.

102. Inter alia, in the Topkapı Saray Museum in Istanbul, the armory of the Capidimonte Museum in Naples, the Rüstkammer of the Historical Museum in Dresden, and the armory of the Czartoryski Collection of the National Museum in Cracow.

103. A beautiful example of Ottoman tuck, with the sultan's tughra, captured at Vienna in 1683 and preserved in the Czartoryski Armory in Cracow, has some dragonlike quillions.

104. Kurtoğlu, *Türk Bayrağı ve Ay Yıldız,* fig. 69.

105. Such signs of a hand are to be seen inter alia on a flag in the Deniz Museum in Istanbul, no. 448, and in the Historical Museum of the City of Vienna.

106. G. H. Luquet, *L'Art et la religion des hommes fossiles* (Paris, 1926), 130; A. R. Verbrugge, *Le symbole de la main dans la préhistoire* (Cousances, 1958).

107. S. Hummel, "Magische Hände und Füsse," *Artibus Asiae* 17 (1954):149–54; A Bruno, "Preliminary Report on the Researches at Hazar Sum (Samangan), Italian Archeological Mission in Afghanistan 2," *East and West* 14, 3–4 (Rome, 1963), fig. 1.8.

108. E. Dale Saunders, "Symbolic Gestures in Buddhism," *Artibus Asiae* 21 (1958):47–63.

109. Arseven, *L'Art turc,* 338.

110. Cammann, "The Magic Square of Three," 56ff.

111. Nur, "L'Histoire du croissant," 338ff.

112. Roscher, "Sin," 906. In this article, there is a reproduction of an amulet in the form of a crescent with a hand between its arms.

113. A. J. Wensinck, "Tree and Bird as Cosmological Symbols in Western Asia," *Verhandelingen der koniklijke Akademie van Wetenschappen te Amsterdam* (Amsterdam, 1921): 1–55; R. Wittkower, "Eagle and Serpent: A Study in the Migration of Symbols," *Journal of the Warburg Institute* 2 (London, 1938–1939):293–325; F. Cumont, "Le coq blanc dans des Mazdéens," *L'Académie des Inscriptions et Belles Lettres* (Paris, 1942).

114. Cammann, "The Magic Square," 50.

115. O. Münsterberg, *Chinesische Kunstgeschichte* (Esslingen, 1912), 2:205, 379, and 402.

116. Wensinck, "Tree and Bird," 36.

117. Ibid., 39.

118. Ibid., 47.

119. Such blades can be found in various collections, inter alia Munich, Vienna, Dresden, Paris, Zurich, and Cracow. See F. R. Martin, *Die Ausstellung von Meisterwerken muhammendanischer Kunst in München* (Munich, 1910), vol. 4, pl. 235, cat. nos. 231–233, pl. 236, and pl. 238, cat. no. 248; H. Stöcklein, *Meister des Eisenschnittes* (Esslingen, 1922), 40, pl. 7; C. Blair, *European and American Arms, c. 1100–1850* (London, 1962), 81. A symbolic bird on the sword of Sultan Süleyman was found in the Topkapı Saray Museum in Istanbul. See E. Esin, "Toğril and Sungkur: Two Turkish Emblematic Prey-Bird Motifs," in *Fifth International Congress of Turkish Art,* G. Fehér, ed. (Budapest, 1978), 295–322; this seems to be the most advanced study on the bird symbol in Turkey.

120. G. Lechler, "The Tree of Life in Indoeuropean and Islamic Cultures," *Ars Islamica* (1937).

121. Egyed, *Az Iparmüvészeti Múzeum török zaszlói,* 172.

122. Koran, sura 2, v. 2, and sura 32, v. 1.

123. H. A. Samaha, "Notes as to Cosmological Ideas in Al Quran," *Lunds Universitets Arskrift,* new series no. 34, 2 (Lund, 1938); L. Massignon, "Les infiltra-

tions astrologiques dans la pensée religieuse islamique," *Eranos Jahrbuch* 10 (1943): 297–303.

124. Koran, sura 7, v. 54.
125. Ibid., sura 10, v. 5 and 6.
126. Ibid., sura 54, v. 1.
127. Ibid., sura 37, v. 1–10.
128. Ibid., sura 113, v. 1–3.
129. Ibid., sura 53, v. 1–2.
130. Ibid., sura 86, v. 1–3.
131. Ibid., sura 91, v. 1–4.
132. Ibid., sura 27, v. 15 and 17.
133. Ibid., sura 7, v. 108.
134. Ibid., sura 2, v. 115.

CHAPTER 2

Horsetail Standards— Tughs (Tuğ)

One of the most characteristic features of the Ottoman Empire was its liveliness, its incessant activity, its self-realization in ceremonies, parades, and pageantry. Even war was for the orthodox Turks not a cruel necessity but a joyful ritual whose effects must always be positive, bringing victory, triumph, and booty on earth, or the delights of heaven so expressively described in the Koran:

They . . . shall be brought near to their Lord in the gardens of delight. . . . They shall recline on jewelled couches face to face, and there shall wait on them immortal youths with bowls and ewers and a cup of purest wine (that will neither pain their heads nor take away their reason); with fruits of their own choice and flesh of fowl that they relish. And theirs shall be the dark-eyed houris, chaste as hidden pearls; a guerdon for their deeds.[1]

Each war expedition was prepared as a festival, providing an occasion for the display of military power and splendor. The luxury of costume, arms, and equipment stood in contradiction to the tough requirements of war. Strangely enough, the Turks succeeded for a considerable time in combining this luxury with strict military discipline.

69

The flags discussed in the preceding chapter were the leaders and guides of these "moving splendors." So too were horsetail standards, or tughs.

Unlike Ottoman flags, tughs have been almost totally neglected in scholarly studies. Any discussion of them has rarely gone beyond the level of museum inventory descriptions. The first attempt to present tughs and to speculate on their function is probably to be found in the work of Luigi Ferdinando, Count of Marsigli, whose investigation of the entire system of seventeenth- and eighteenth-century Ottoman military power was introduced in the first chapter of this book.[2]

SURVEY OF THE STOCK OF TUGHS

The major group of existing tughs, more than thirty-five of them, has been preserved in Istanbul mainly in the Topkapı Saray Museum (about twenty-five items) and in the Askeri Museum (about ten items), but no full description of them has been published. They have been mentioned only in some brief museum guides, and hardly anything about them is included in the standard books on Turkish art, such as the works of C. E. Arseven or O. Aslanapa.[3]

Several tughs have also survived in Hungary, particularly in the Törteneti Múzeum (the Military Museum) in Budapest (six items) and in the Magyar Nemzeti Múzeum (Hungarian National Museum), some of which were described by J. Szendrei as early as 1896, on the occasion of the great exhibition of the Millenium of Hungary.[4]

Tughs captured in the Turkish wars of the sixteenth to eighteenth centuries by Austrians and Germans and preserved in various places —in Dresden, Karlsruhe, and Ingolstadt (single items each), with a major set in Vienna, at least eight items in the Heeresgeschichtliches (Army) Museum and in the Historical Museum of the City of Vienna —have often been mentioned in the German literature, mainly in museum catalogues of special exhibitions.[5] Recently an ambitious attempt at researching tughs was made by Oskar and Edith Fohler in Vienna; they tried to assemble as many references as possible on this subject scattered among the European literature of the sixteenth through nineteenth centuries, but they did not go beyond this area, to the East, where the key to the secret lies hidden.[6]

A survey of tughs in the collections of Venice (eight items in the

70

Museo Civico Correr [Correr Municipal Museum], mainly the trophies of Francesco Morosini, two in the Palace of the Doges, and one in the Church of Santa Maria della Salute) was made not long ago by Giovanni Curatola, although the author gave no more than a regular inventory description of the specimens.[7]

A nice example of an Ottoman tugh is kept in the Danish National Museum of Copenhagen, coming from the Royal Kunstkammer. It is traditionally regarded as a spoil of war brought home by Cort Adeler, who took part in the Turko-Venetian war of 1645–1669, on the Venetian side, and later became an admiral in the Danish fleet.[8]

The tughs in Polish hands are mainly trophies of the 1683 war (at least six items have survived in Cracow, Częstochowa, and Poznań). I have described them in a paper delivered at the Sixth Congress of the International Association of Museums of Arms and Military History in Zurich, in 1972, and in a paper generalizing on the problem for the Eighth International Congress of Turkish Art, in Cairo, in 1987.[9]

A separate question concerns the tughs used by the Mamelukes of Egypt (and a superb set of trophy pieces captured by Bonaparte in 1798–1799 is preserved in the Musée de l'Armée [Army Museum] in Paris). They have been ignored by scholars, however, as have various signs of similar type outside the Ottoman Empire, which are documented chiefly in iconography appearing at various times in Mongolia, China, and Japan, as well as in Sasanian and Islamic Persia and Mogul India.

THE ORIGIN OF TUGHS

In his well-known compendium of flags, which goes back to the beginning of such signs in human societies, Whitney Smith suggests two possibilities for their origins: a scrap saturated with the enemy's blood fixed on a pole or the skull of a horned animal in the same position.[10] The latter was probably earlier, from the period preceding the techniques of weaving. These original signs are depicted on the monuments of the early Egyptian state, somewhere from the time of King Narmer (ca. 3200 B.C.). Figurative or abstract symbols, such as the falcon, fish, elephant, jackal, or sun's disc, horns, triangles, or arrows were fixed on a pole.[11] As Smith notes:

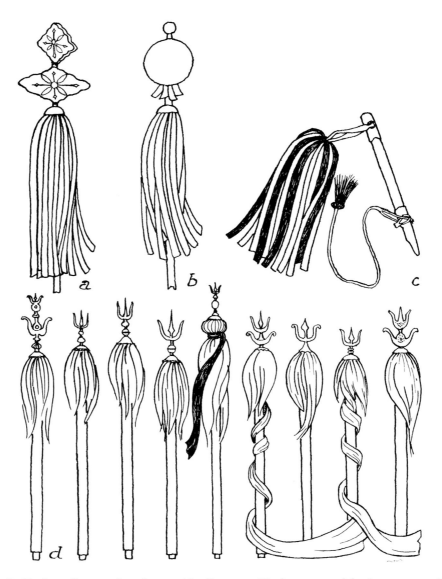

Fig. 16. Various forms of tughs outside Ottoman Turkey a. and b. Japanese tughs of
paper and brass c. Japanese commander's bataon saihai d. Mogul tughs from the Babur-
name.

While the earliest flags were vexilloids, the emblems at the top of the staff
varied. It might have been the tail of a tiger, a metal vane, a ribbon, a
carved animal, a windsock of woven grasses or crude cloth, or a construc-
tion combining more than one material. Since kinship, real or imagined,
constitutes the principal organizing techniques of primitive societies, very

72

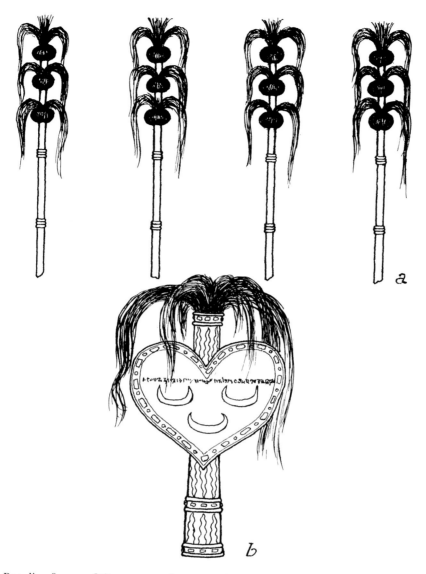

Fig. 17. Peculiar forms of Ottoman tughs a. tughs of Sultan Süleyman the Magnificent as shown in the Hünernāme of Seyyid Lokman, vol. 2, Topkapı Saray Museum, H.1524 b. Ottoman naval tugh (?) from the seventeenth century, National Museum, Copenhagen.

frequently we find the animal from which the clan claims descent and for which it is named—i.e., its totem—as the chief symbol of the vexilloid. The people who carried the totem believed they derived their powers from it; hence vexilloids very early acquired a religious significance they have never lost.[12]

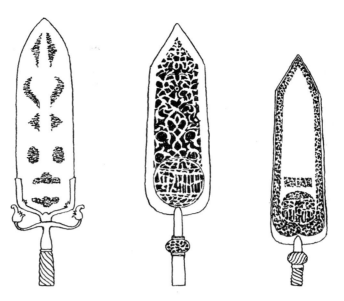

Fig. 18. Mamelukes' alems for tughs, Askeri Museum, Istanbul.

No doubt, emblems of this character appeared as early as people gathered in groups for the achievement of a common aim, particularly in raiding and war enterprises, when they might also be used as signals for tactical movements. Egyptian vexilloids or standards, the sacred emblems probably made of bronze and carried on a staff, were decorated with colored ribbons, which in turn were most probably the starting point for textile flags. Such standards used in Assyria usually had representations of a sacred bull, sometimes with an archer on its back, but beneath the emblem they were adorned with a tassel, quite similar to the later Turkish horsetail standard. This type of vexilloid originated among the nomads of Central Asia and was common to the Mongols and the Turks and closely connected with the totemic cult of the horse and yak, without which life in the steppes might have become impossible. It appeared in various areas throughout Mongolia, China, Korea, Japan, and on various state structures from western Central Asia to Sasanian Persia. Its substantial element consisted of a bundle of horse or yak hair fixed on a wooden staff that was topped with a metal finial. Black yak hair precluded dyeing but some white horse hair or, if possible, hair from the white yak was colored, preferably red, green, or blue.

Some Mongolian tughs are exhibited in the Museum of Ulan

74

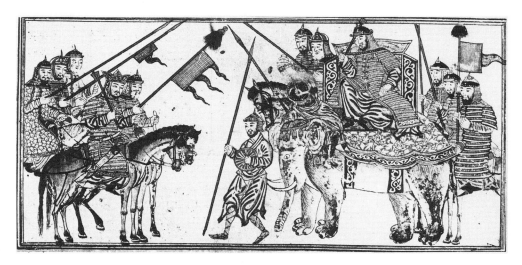

Ill. 13. Flags with tughs in the army of Maḥmūd of Ghazna, a miniature from the early fourteenth century (after B. Lewis, *The World of Islam*, London: Thames and Hudson, 1976, p. 216). By permission of the Edinburgh University Library.

Bator. They have very bushy white hair and a brass trident finial at the top—actually a horn-shaped and spike motif. They are without documentation ascribed to the thirteenth century, which does not seem to me to be possible. Far more reliable are images of Mongols and their equipment in the Japanese painted scrolls of the thirteenth century.[13] The Japanese army may have adopted tughs at that time.[14] Later Japanese tughs were made of oiled paper and brass, as was the commander's tugh, or *saihai*.

Mongolian tughs of hair or the tails of various animals were combined with a typical cloth flag; such, in all probability, was the famous ensign of Genghis Khan, which was reconstructed by Whitney Smith.[15] In all likelihood tughs were already used in the Qarakhanid army in the early eleventh century. In any case, in the excellent miniatures showing the conquests of Maḥmūd of Ghazna painted in the early fourteenth century, the horsetail, or, rather, yaktail, ensigns are visible.[16] A peculiar type of standard with quasitughs fixed to a pole with ʿalam finial is shown in the *Maqāmāt* of al-Ḥarīrī, painted in Baghdad in A.H. 635/A.D. 1237.

Along with the typical cloth banner, the Turkish tugh attained its final Ottoman form, function, and hierarchy in the fourteenth century. One can even speak about a special tugh system and custom. As an impressive sign it was imitated in neighboring and even more

Ill. 14. Ottoman tugh bearers from the *Codex Vindobonensis* no. 8626. By permission of Nationalbibliothek, Vienna.

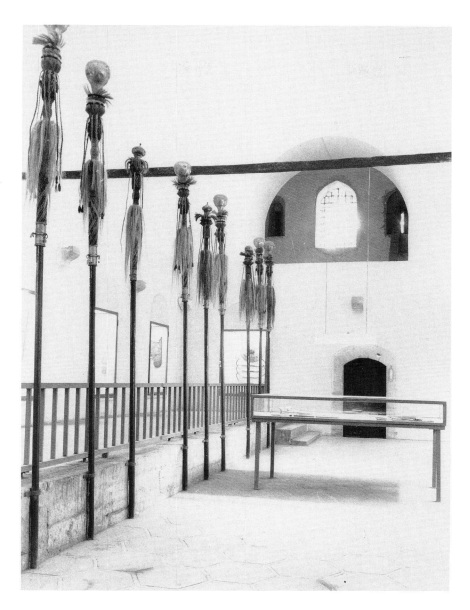

Ill. 15. Ottoman tughs in the Armory of the Topkapı Saray Museum, Istanbul.

distant countries in various ways. As has been mentioned, several original tugh specimens have survived to the present, their use documented in Turkish miniatures and in European iconography. Such use, however, is very often misleading, and to prepare to research the field, a typological classification of the material is necessary.

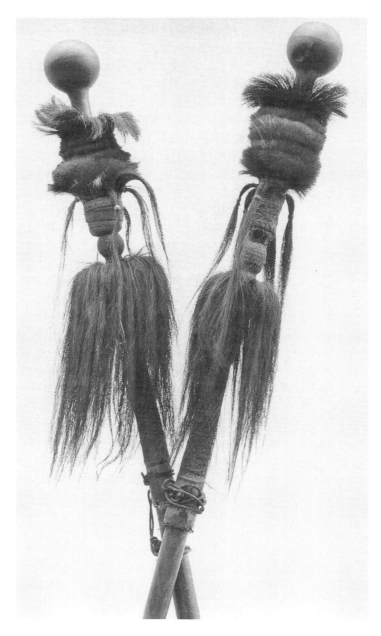

Ill. 16. Ottoman tughs captured at the Battle of Vienna, 1683, offering of King John Sobieski in the church of St. Ann, Cracow. By permission of Wawel State Collections of Art, Cracow.

78

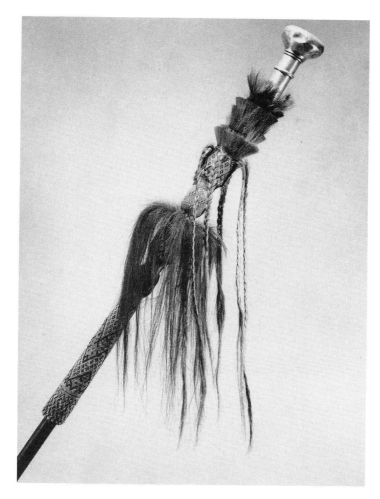

Ill. 17. A tugh probably from the Vienna booty, 1683. By permission of Wawel State Collections of Art, Cracow.

TYPES OF TUGHS

THE CLASSIC OTTOMAN TUGH The shafted tugh, intended to be carried by a walking or mounted standard-bearer, yet still adapted to being staked in the ground, probably dates to the fourteenth and fifteenth centuries. The original examples of the shafted tugh and painted or engraved images of it actually date to later times. Thus, the extant specimens, mentioned above, are almost all from the seventeenth and eighteenth centuries.

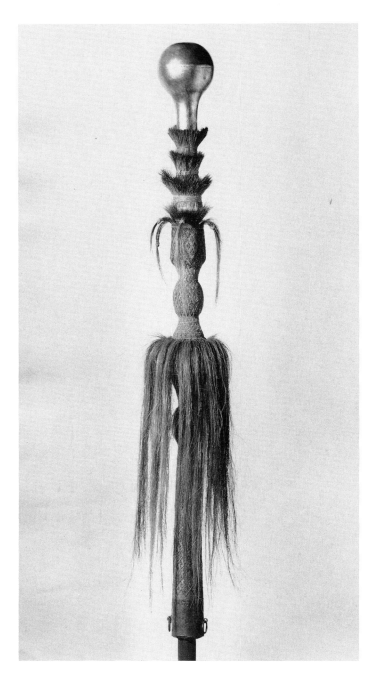

Ill. 18. A tugh probably from the Vienna booty, 1683 (the ball is reconstructed). By permission of National Museum, Poznán.

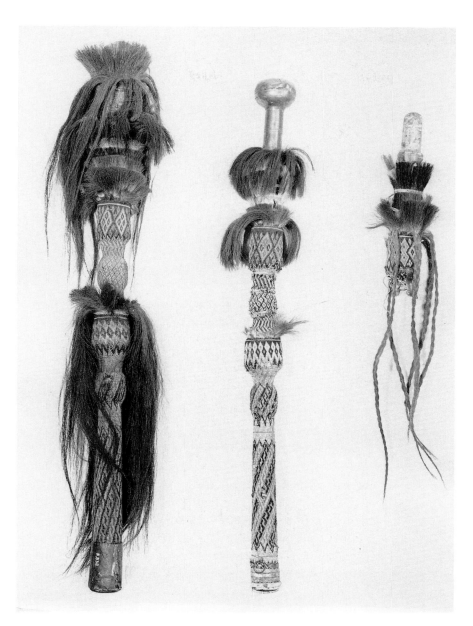

Ill. 19. Ottoman tughs of the seventeenth century. By permission of Hungarian National Museum, Budapest.

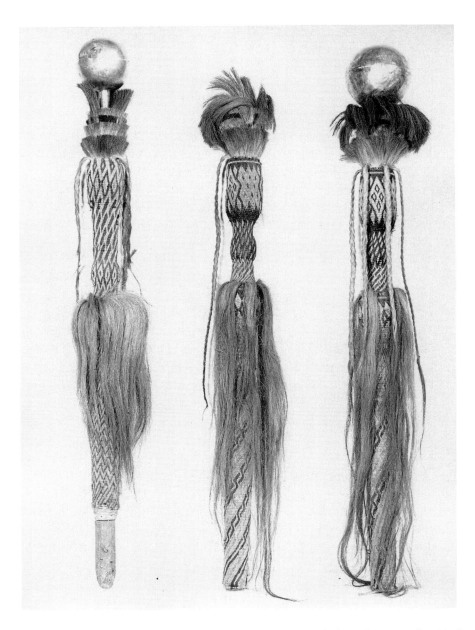

Ill. 20. Ottoman tughs of the seventeenth century. By permission of Hungarian National Museum, Budapest.

The classic tugh consists of two parts. The larger upper part is a long wooden structure with a gilded metal ball on the top, three or four circular brushlike layers of dyed horsehair beneath, and four or six falling braids; the baluster-shaped stem is covered with intricate and colorful horsehair plaitwork, while in the middle there is a loosely falling black, white, red, or green horsetail. The stem is in the lower part. It is covered with the same plaitwork, is hollow and reinforced at the bottom with a metal band, and is usually furnished with metal rings that were practical for transport. The upper part is about 4 feet long. The hollow stem is fitted on a wooden, usually painted shaft, which may be longer or shorter according to need, sometimes having a spike at the bottom. The tugh planted in front of the saray or tughs in front of the sultans' or viziers' tents could be as high as 10 feet.

In the preserved tughs the top ball is rarely a perfect sphere, its shape being oval, flattened, or onionlike. This golden ball, glittering in the sun, could easily be associated with the sun, the braids and hair compared to the sun's rays. In such cases the imagination of Oriental peoples was unlimited. The tugh could also be interpreted as a mysterious being, with a golden head and long beard, and so on. In the Orthodox Islam territories of nonfigurative culture, secret anthropomorphization was not uncommon. Such deductions can also be made from the basic function of a tugh and of a series of tughs: they simply represented the highest authority, especially that of army dignitaries. They were above all signals of war. The declaration of war was manifested by setting the sultans' tughs in front of their sarays. In the campaign they remained close to the sultan and other dignitaries, carried by special officers called *tuğçik*. On the march they were sent ahead to mark camp sites. These functions have been documented by European observers. In the *Codex Vindobonensis* from the end of the sixteenth century we may find the mounted tuğçiks.[17] Engravings in the book by F. L. Marsigli show seven tughs planted in front of the sultan's tent, five in front of the grand vizier's, and three in front of a pasha's.[18] In the same book the tugh emblem appears among typical signs of Ottoman Janissaries (ill. 24). In battle the tughs were kept for safety behind the ranks, but often they marked the place of leaders as a rallying point for dispersed soldiers in the turmoil of combat. This was surely the most practical use of

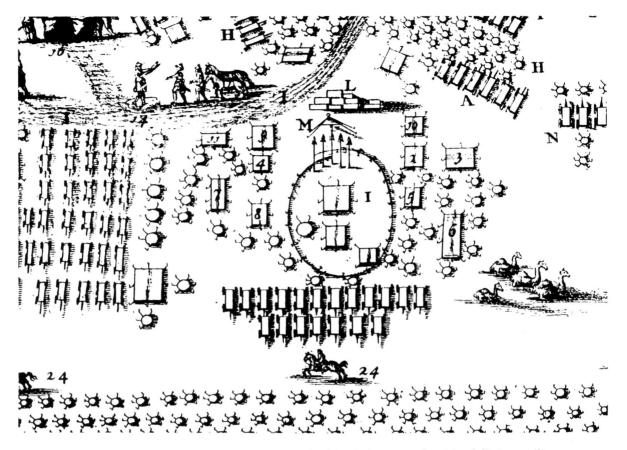

Ill. 21. Five tughs in front of tents of Grand Vizier Süleyman, after Marsigli, *Stato militare* . . . , vol. 2, p. 24.

the tugh. It is not surprising that they were guarded as objects of the highest value. Their loss was a disaster.

In the Ottoman Empire the number of tughs denoted the rank of their owners, as follows: a sultan at war had seven to nine; a grand vizier, five; a vizier, three; a beylerbey, two; a sanjakbey, one. If a pasha were dismissed, the tugh was taken from him.

THE CLASSIC TUGH INCORRECTLY RESHAPED It is well known that Turkish symbols have sometimes been misinterpreted in Europe. Thus, from the sixteenth century on, or even earlier, in Christian countries the crescent was considered to be the sole emblem of the Ottoman Empire. The Austrians who were disappointed not to

84

Ill. 22. Seven tughs in front of tents of Sultan Mustafa II (1695–1703), in a campaign against Prince Eugene of Savoy, after Marsigli, *Stato militare* . . . , vol. 2, pl. 32.

Ill. 23. Ottoman army marching with tughs and flags, after Marsigli, *Stato militare* . . . , vol. 2, pl. 33.

86

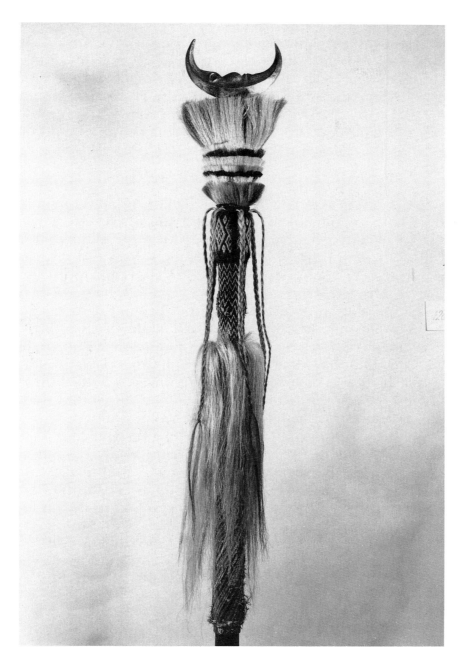

Ill. 24. Ottoman tugh with a European crescent added. By permission of Historiches Museum der Stadt Wien.

find crescents on the top of tughs captured in the Battle of Vienna in 1683 (and in subsequent campaigns) decided to correct such a "deficiency" by fixing the captured tughs' metal crescents, European style, with human faces. These objects, coming from the old City Arsenal of Vienna, are still preserved in the Historical Museum of the City of Vienna.[19] Such crescented tughs were often repeated in graphics and paintings through the following centuries, and one of the tughs of the Palace of the Doges in Venice is also topped by a crescent.[20]

UNUSUAL VARIETIES OF TUGHS Tughs are infrequently depicted in Turkish miniatures, although battle pieces are a favorite subject. A peculiar specimen of a tugh with three gilded balls, one above the other, appears in miniatures by Seyyid Lokman in the second volume of *Hünernāme*, preserved in the Topkapi Saray Museum.[21] The miniature represents the story of Süleyman the Magnificent in his campaign against Austria and his endeavors to capture Vienna in 1529, followed by his final expedition against Szigetvár and his sudden death. On each of the two miniatures four tughs are painted. Each tugh has a shaft adorned with three golden balls, with three black horsetails. I do not know, however, whether these are actual objects or just the artist's fancy.

Together with a classic tugh, described above, a very peculiar tugh is preserved in the National Museum in Copenhagen. This is a silver gilt tube, 21 inches high, ornamented with motifs of undulating flames and set with turquoise, having at the back a large heart-shaped silver-gilt shield with turquoise stones on the border and three open crescents incised in the field, with an inscription in Persian: "The standard of Sultan Murad, Sultan of the most glorious sultans, Emperor of emperors, Padishah of the whole world."[22] The tube is surmounted by black horsetail. In the inventory of 1674 it was recorded that this Turkish standard was taken from the Turkish admiral by Admiral Cort Adeler in 1658.

THE CLASSIC TUGH WITH HORNLIKE AND SPIKE TOP The tradition of the Mongolian type of tugh, not differing from the one shown in the Ulan Bator Museum, can be traced in the *Bāburnāme*, a manuscript dating from about 1580 and held now in the British Museum.[23] As we know, Khan Bābur Ẓahīr ad-Dīn Muḥammad

88

(1483–1530), a descendent of Timur and of Genghis Khan, invaded and occupied India, starting the dynasty of the Great Moguls. Appropriately, he had tughs with him. Apotropaic horns, having an ancient tradition in Asia, where they appeared as amulets, shields, ᶜalams, or the pendulous tugh, the boncuk, were often associated with the crescent, thus their adoption for the tugh is quite understandable. In a miniature of the *Bāburnāme* representing Khan Bābur reviewing his army, nine white tughs of yaktails are planted in the ground.[24] The ceremony of venerating these tughs by Bābur himself is depicted. He is holding a golden cup in his left hand and oiling the tail of the tallest tugh with his right. The standards are acclaimed in the Mogul fashion: they are decorated with long strips of white cloth. A sacred cow stands in the front. The non-Islamic features of this ceremony are apparent. In this same book, the miniature of the battle shows shafts wrapped with colored fabric, which are kept at the back.[25]

THE MAMELUKE TUGH In the Army Museum in Paris, among various Oriental militaria and trophies, we also encounter some from Bonaparte's Egyptian campaign of 1798. There are magnificent saddles and trappings, sabres, javelins, and guns of the Mameluke cavalry, which opposed the French troops at the Battle of the Pyramids. There are also some tughs; they terminate in balls, not differing from the classic Ottoman type, but there are also examples with flat metal shields, a kind of Mameluke ᶜalam, whose meaning requires more profound study. It should be added that such Mameluke ᶜalams are also preserved in the Askeri Museum in Istanbul.[26]

THE PENDULOUS TUGH — THE BONCUK The second basic type, not enumerated above, is the pendulous tugh, or boncuk, its primitive forms being known since antiquity. This is a horse- or yaktail, black, white, or colored, in onion-shaped mountings of gold, silver, or gilded copper, sometimes decorated with niello ornaments or set with precious stones, having the upper part sometimes enclosed in a colored silk net. Most frequently it is used as part of the trappings, tied under the horse's neck. Its purpose, however, is not only to adorn the animal but also to show the special distinction of the horseman. Above all, it is a sign of the heroes of Persian legends and of Turkish sultans and viziers. The examples in miniatures are nu-

89

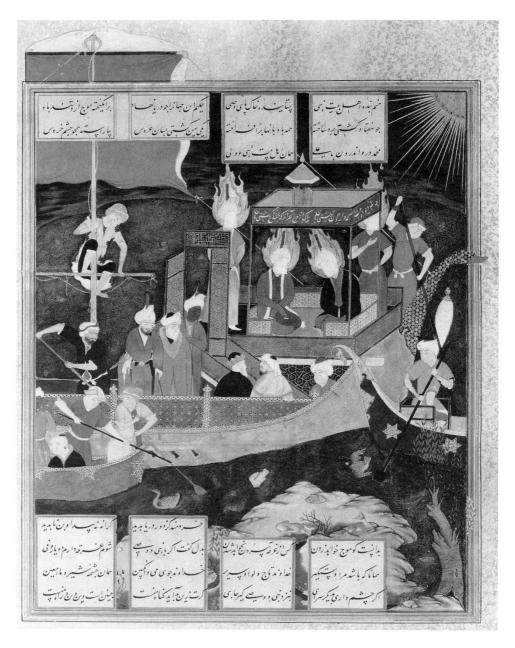

Ill. 25. A pendulous tugh on the ship of Shiʿism from the Shāhnāme of Firdawsi, a copy made in 1576 for Shah Tahmasp (after B. Lewis, *The World of Islam*, London: Thames and Hudson, 1976, p. 156). By permission of Metropolitan Museum of Art, Gift of Arthur Houghton, Jr., 1970.

90

merous, one of them being particularly interesting. In the copy of the *Shāhnāme* made for Shah Tahmasp in 1576, the Shia ship, in voyage through the eternal sea with Muhammad, ʿAlī, and ʿAlī's sons on board, has the prow honored by a tugh.[27]

Such tughs, suspended on a horizontal bar, were carried by Turks or Tartars over their beys, khans, and sultans. This is also documented in the descriptions of the sultan's throne in the *Arz Odası* (throneroom) of the Istanbul saray. The canopy was decorated with silk tassels that hung down.[28] The same is depicted in a very accurate French miniature (one of a series of four) that represents the Polish embassy to the Sublime Porte in 1677–1678, to negotiate a peace treaty. There are eight pendulous tughs over the head of Mehmed IV sitting on his throne.[29] It is worth adding that such a tassel, made of silk and gold threads, has been preserved with the Vienna booty of 1683 in the Czartoryski Collection of the National Museum in Cracow. It is probably one of the five that hung in the tent of Kara Mustafa and were used for official ceremonies. The same collection contains five yaktail pendulous tughs, most probably from the 1683 campaign, while the main department of militaria in the National Museum of Cracow houses two very precious and superbly decorated horsetail pendulous tughs. Similar specimens, dating from the sixteenth to eighteenth centuries, are to be found in various major collections of orientalia in Europe and in Eastern countries.

A SIXTEENTH-CENTURY IMITATION OF THE TURKISH PENDULOUS BONCUK IN VIENNA The Vienna Waffensammlung (Arms Collection) has a splendid example of a pendulous tugh that is sometimes wrongly described as being Turkish.[30] This tugh is crested with boars' teeth in crescentlike form but the decoration of the metal mounting, with small human figures, is surely the work of European hands. This imitation was commissioned by Archduke Ferdinand of Tirol (d. 1595), a great lover of the Oriental style.

THE POLISH HETMAN'S SIGN In Poland, particularly in the seventeenth and the eighteenth centuries, a pendulous tugh applied to a long shaft became a special sign of the highest military authority, of the king or of the military leader, the *hetman*.[31] The shaft was usually surmounted with a spike or with a wooden ball on which a cap was placed to be visible to soldiers in battle. There is a good

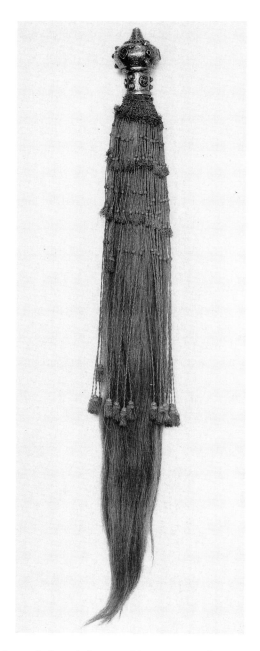

Ill. 26. An Ottoman boncuk (pendulous tugh), seventeenth century, in the National Museum, Cracow. By permission of National Museum, Cracow.

92

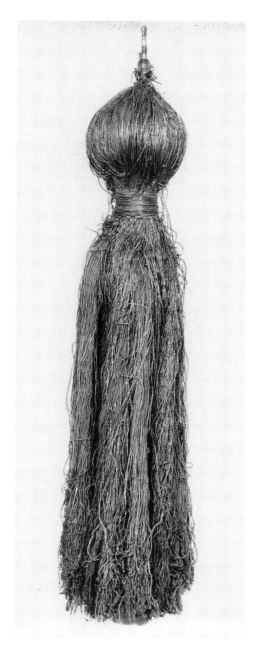

Ill. 27. A boncuk (pendulous tugh) of gold and silk threads from the Vienna booty, 1683.
By permission of National Museum, Cracow, the Czartoryski Collection.

93

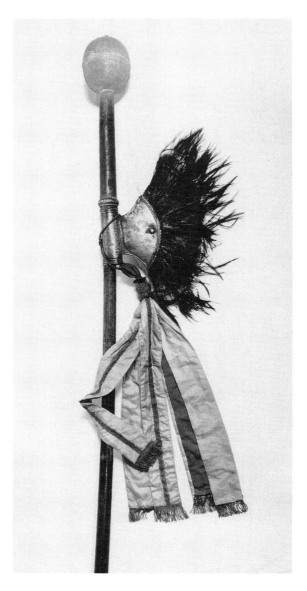

Ill. 28. Polish hetman's sign, early eighteenth century. By permission of National Museum, Cracow.

94

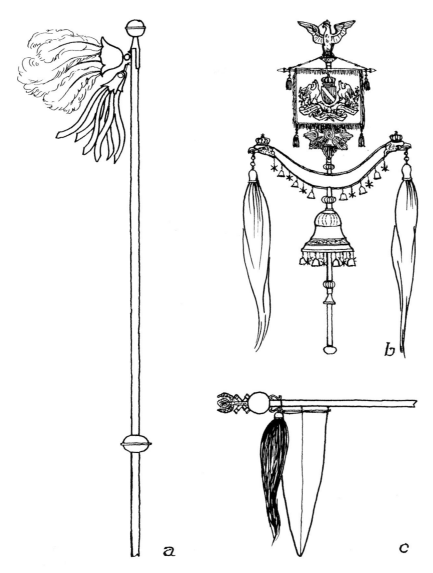

Fig. 19. Later forms of tughs outside Turkey a. Polish hetman's sign, seventeenth to eighteenth century b. German Schellenbaum, nineteenth to twentieth century c. Polish military boncuk from the interwar period.

example of this form in a painting in the Czartoryski Collection in Cracow, representing the victory of King Augustus the Strong over the Swedes in 1704, during the Northern War. The same was reproduced by Julius Kossak, a Polish historical painter of the nineteenth century, in his watercolor composition *The Entry of King John Sobieski*

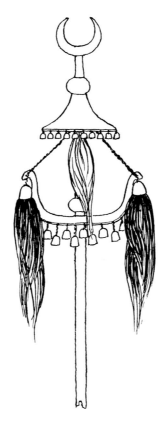

Fig. 20. Contemporary Turkish Schellenbaum of military band Mehter.

to Vienna, 1683.[32] Still further elements were applied to the top of the shaft: a turban, a bunch of ribbons, a wing of crane feathers (as a symbol of alertness), or an eagle's wing (this bird having had a special heraldic significance in Poland). A very few examples of the hetman's ensign have been preserved; one is in the National Museum in Cracow,[33] another in the Armémuseum (Army Museum) in Stockholm.

THE SCHELLENBAUM Before the eighteenth century, Ottoman tughs were frequently accompanied by a military band (*mehter*). Later, throughout the eighteenth and nineteenth centuries, a special kind of pendulous tugh was also adopted by other European armies, especially in their military bands, and in some of them this practice remains in use to this day. It was particularly fashionable in Saxony

96

and Prussia. The standard consisted of a metal construction with long arms that were decorated with bells and tughs, one usually being white and the other red. In German it is called the *Schellenbaum*. Oddly enough, the modern Turkish army has begun to imitate that German type.

THE TUGH TRADITION IN THE MODERN POLISH ARMY
Finally, I wish to devote a few words to the Polish military tughs from the period 1918 to 1947. The Polish Army, reestablished after World War I, endeavored to use as many traditional features as possible. In this the cavalry played an important part. There were troops of uhlans (the major cavalry force), of light horse, of mounted rifles, and of horse artillery, and various prizes were given for the best trained regiments: gold and silver lances, trumpets, and also tughs. Under special circumstances a tugh could become the property of an elite regiment.

The research on these tughs is based upon printed military regulations and old photographs. Only a few symbols of this kind have survived in Polish collections; one of them is kept in the Military Museum of Great Poland in Poznań, a living proof of the old ties between the Polish and Turkish cultures.

Notes

1. Koran, sura 56, v. 4–6 and 12–24. See Z. Żygulski, Jr., "Obraz raju w sztuce islamu" (The image of paradise in Islamic art), in *Orient i Orientalizm w sztuce: Materiłay sesji naukowej Stowarzyszenia Historyków Sztuki* (Warsaw, 1986), 19–41.
2. L. F. Marsigli, *Stato miltare dell'Impèrio Ottomano—L'Etat militaire de l'Empire Ottoman* (The Hague, 1732) (facsimile ed. Graz, 1972). The manuscript of this work, with many excellent drawings, is preserved in the Livrustkammaren (Armory) of the Royal Castle in Stockholm. Already in 1576, "tails mounted as standards" were drawn by Melchior Lorck, a Danish humanist and artist who visited Istanbul, probably in 1555 with the embassy of Augier Ghiselin de Busbecq. His drawings of tughs were, however, inadequate since they had no top balls. See Melchior Lorck, drawings from the Evelyn Collection at Stonor Park, England, and from the Department of Prints and Drawings of the Royal Museum of Fine Arts (Copenhagen, 1962), cat. no. 9.
3. C. E. Arseven, *L'Art turc;* O. Aslanapa, *Turkish Art and Architecture.* A passage on tughs is to be found in Z. Żygulski, Jr., *Sztuka turecka* (Warsaw, 1988), 166–67.

4. J. Szendrei, *Ungarische Kriegsgeschichtliche Denkmäler in der Millenium—Landesausstellung Budapest* (Budapest, 1896).

5. W. Hummelberger, "Die Türkenbeute in Historischen Museum der Stadt Wien des 17. Jahrhundert," *Vaabenhistoriske Aarbøgen* 15 (1969):9–97; J. Schöbel, *Orientalica* (Historisches Museum Dresden, 1961); E. Petrasch, *Die Türkenbeute. Eine Auswahl aus der Türkischen Trophäensammlung des Markgrafen Ludwig Wilhelm von Baden.* See also P. Jaeckel, "Ausrüstung und Bewaffnung der türkischen Heere," in Max Emanuel Kurfürst, *Bayern und Europa um 1700* (Munich, 1976), 1:373–84.

6. Oskar and Edith Fohler, eds. *Der Rossweif in der osmanischen Armee. Ein Anhang zur türkische Feldmusik.* 3–14.

7. G. Curatola, *"Tugh" a Venezia: Studii Eurasiatici in onore di M. Grignaschi* (Venice, 1988), 183–90. There are also some tughs in the Stibbert Museum in Florence.

8. *Ethnographic Objects in the Royal Danish Kunstkammer, 1650–1800* (Copenhagen, 1980), 66. I thank Mr. Kjeld von Folsach, director of the David Collection in Copenhagen, who directed my attention to this excellent specimen, as well as to a unique type of tugh taken in a naval combat with the Turks, which will be presented below.

9. Z. Żygulski, Jr., "Armi Antiche" in *Turkish Trophies in Poland and the Imperial Ottoman Style* (Turin, 1972), text in English and Italian. The bulletin of the congress in Cairo has not yet been published.

10. W. Smith, *Flags through the Ages and across the World,* 12.

11. Ibid., 35.

12. Ibid., 37.

13. B. Smith, *Japan: Geschichte und Kunst* (Munich and Zurich, 1965), ills. 2–3, which reproduce the painting of the Mongol invasion, *Moko shurai e-kotoba* (ca. 1293), Imperial Collections, Kyoto.

14. S. R. Turnbull, *The Book of the Samurai: The Warrior Class of Japan* (New York, 1982), 70–71 and 88.

15. Smith, *Flags,* 62.

16. B. Lewis, ed., *The World of Islam,* 216.

17. *Miniatures painted by Henry Hiendrovsky from the embassy of B. Pezzen to Istanbul on the part of Emperor Rudolph II,* Nationalbibliotek in Wien (National Library in Vienna), no. 8626.

18. Marsigli, *Stato militare,* vol. 2, pls. 24, 27, and 32.

19. Das Wiener Bürgerliche Zeughaus. Rüstungen und Waffen aus 5 Jahrhunderdten. Special exhibition in the Historical of the City of Vienna in Schloss Schallaburg (Vienna, 1977), cat. nos. 860–62.

20. Curatola, *Tugh,* fig. 1.

21. Inv. no. Hazine 1524. See also G. Fehér, *Türkische Miniaturen aus den Chroniken der ungarischen Feldzüge* (Budapest, 1976), pls. 16, 38, and 39ab.

22. *Ethnographic Objects in the Royal Danish Kunstkammer,* 65.

23. Baburnamah. Rasmlari. Hamid Suleiman, ed., *Miniatures of Babur-Namah* (Tashkent, 1978), pl. 20.

24. Ibid., pl. 20.
25. Ibid., 38.
26. *Askerī Müze* (a guide) (n.d.), 15: "The metal devices of the flags belonged to the Egyptian Mameluk sovereigns of the fifteenth and sixteenth centuries," Kayit Bay, Ṣeyh-ul Müeyyed, and Kansu Gavri.
27. Lewis, ed., *The World of Islam,* 257.
28. N. M. Penzer, *The Harem,* 234.
29. Żygulski, *Sztuka turecka,* 167 and pl. 13.
30. D. Nicolle, *Armies of the Ottoman Turks, 1300–1774,* Osprey Men-at-Arms series (London, 1983), the plate facing p. 23.
31. Z. Żygulski, Jr., *Broń w dawnej Polsce* (Arms in old Poland) (Warsaw, 1975), 284.
32. In the National Museum in Warsaw.
33. This object was displayed in the exhibition "The Relief of Vienna, 1683" in the Royal Castle of Wawel, Cracow, in 1983.

CHAPTER 3

Sultans' Dress and Arms

SOME REMARKS ON THE SULTAN'S COURT

As in well-established Oriental tradition—like the Chinese, the Persian, the late Roman, and the Byzantine—the Ottoman court, or the Sultan's saray, was the focus of power and authority and shone with splendor. Not only was the court the sole center of political decisions, it was also the source of grace on which the life of every citizen was based, an object of pride and fear, a matchless model of perfection, a place that was almost a paradise. It was the product of long years of preparation and consolidation, of its architecture and movables, of dress and accessories, and of all the trappings indispensable to daily life, to parades, festivities, religious ritual, and diplomatic ceremony.

The court was also a major setting for the production of costumes, arms, armor, jewels, ornaments, equipment for riding and hunting, and implements for entertainment and learning, particularly books and miniatures. The makers of these things, the court artists and artisans, were Turks as well as Greeks, Persians, Armenians, Hungarians, and Italians—an international assemblage of people in-

101

spired and governed by a common idea, purpose, and style—by, it may be added, the will of style.[1]

The limits of this chapter preclude a consideration of the sarays in Bursa, Edirne, and finally Istanbul. Instead, I will describe generally the dominant style of the Ottoman court and then concentrate upon some important features of dress and arms, especially those of the sultan, who stood at the peak of the whole state structure.

Ottoman imperial style was formed in the course of centuries and was influenced by various factors, the national Turkish tradition predominating, but inspiration was also derived from some other highly developed cultures, such as the Chinese, Mongolian, Persian, and Arab, as well as the Byzantine and, generally speaking, European, mainly Italian, Hungarian, and Austrian. It was at the sultan's court, a melting pot for all these influences and prescriptions, that a new style with consistent quality was created.

The development of the Ottoman style can be divided into three distinct phases: the period of severe style, in the fourteenth and fifteenth centuries, that lasted until the capture of Constantinople in 1453; the period of classical, or rich, style, from the time of Mehmed II until the early eighteenth century; and the period of declining style, with strong European influences, mainly from France, covering almost the entire eighteenth and nineteenth centuries. The defining features of each of these style phases can be found in almost all fields of artistic endeavor, including the arts of costume and arms.

It is well known that several hundred artists and craftsmen resided in the Istanbul Saray, having their workshops in the First and Second Courtyards.[2] But it is also known that many more artisans worked outside the court of Istanbul, in the cities of Bursa and Edirne and in some more distant cities of the empire, such as Baghdad, Damascus, and Cairo.

The court craftsmen, who worked under the eye of the sultan, held a privileged position. They had to submit to rigorous discipline, but they were safe, well paid, and independent, in that they were required to be obedient only to officials. When their works pleased, they were presented with riches; of course, if they lost favor, they could easily lose their heads as well. This was a "special" democracy of the Ottoman Empire: not anyone could be sure of his fate. One could achieve the highest position and honors or, by an unfortunate

deed, achieve the executioner's axe. Islam required that any sentence be accepted with humility and serenity.

City craftsmen were united in guilds, which, like those of Europe, had strict regulations, including statues concerning working conditions and responsibilities. The guilds were associated with religious brotherhoods, which were led by dervishes. The most powerful were the guilds of Istanbul, the essential productive organization of the state. These guilds also played an important role in social and public life.[3] In the second half of the sixteenth century there were about 150 guilds in the Ottoman capital. They participated in state-religious feasts, in folk festivals and entertainments, and in parades before the sultan, demonstrating their technical perfection and astonishing imagination.[4] Since the time of Mehmed II, the Covered Bazaar in Istanbul was the center for trade and played a major role in the economic and financial life of the empire—a role resembling, somewhat, that of the modern banking and exchange system.

The guilds and professions and their members who contributed dress and armaments to the court were privileged in their own right —the weavers, tailors, turbanmakers, armorers, swordmakers, goldsmiths, jewellers, furriers, haberdashers, embroiderers, and taxidermists (who also prepared plumes). The craftsmen in these specialties achieved the highest level of art, arousing the interest and admiration of foreigners, as well as the desire for imitation. Ottoman costume became an important element of state culture, denoting the social status and place in the hierarchy of men. There were regulations that strictly determined each type and style of dress; transgression was dangerous. Wearing dress not appropriate to one's civil or military status and rank was severely punished, sometimes in a manner going beyond European norms. For example, a man wearing a shoe style of a rank higher than his had them removed—together with his feet. A stiff and elaborate code of dress was taken over by the Ottomans from the Persian and Byzantine traditions, but the distant traditions of China were also incorporated. The sultans themselves, starting with Orhan, established dress codes. The regulations multiplied in the times of Mehmed I, Mehmed II, and particularly under Süleyman the Magnificent, Ahmed III, and Osman III and came to include more and more people, ranks, functions, and occasions for the wearing of specified dress, such as during day service,

at the time of annual feasts, in cortèges, or for court audience.[5] Tradition was respected in terms of form and color, and it is amazing that some types were kept unchanged between the sixteenth and nineteenth centuries.

The Ottoman love for splendor and pomp in dress was motivated by a general admiration for precious fabrics. Through close contacts with China the Turks could acquire silk and gold threads. In this area the impact of Persia and Byzantium was also important. China, Sasanian Persia, and the Byzantine Empire created a system of court and state ceremony in which sumptuous textiles, dress, and accessories played a prominent role. The Seljuk rulers indirectly took some ideas from these centers, and their capital, Konya, soon became an important site of textile production, which even included such materials of fine quality as purple brocade.[6] Some workshops (tirazhane), organized after Persian or Byzantine models, produced only for court needs. Fabrics with the two-headed Seljuk eagle were reserved for sultans. The ceremonial dress belonging to the famous mystic and poet, Jalal ad-Dīn Rumi, called Mevlana (1207–1273), survives in Konya and is surely of Seljuk fabric.[7] The custom of preserving the dress of sultans, holy men, and high dignitaries, like the custom that made a relic of Muhammad's caftan and probably deriving from it, was already practiced at this early date.

The early Ottoman art of fabric design and dress differed from the Seljuk both in technique and types. There must have been an intermediary phase at the courts of the Turcoman emirates, but there is practically no information about them. Ottoman textiles were fully developed by the Bursa period of the late fourteenth century. They included patterned velvets, brocades, taffetas, and satins, and this production of luxurious fabrics continued successfully in Istanbul. Various examples of this production demonstrate Persian-Seljuk, Byzantine, and even Italian motifs, but the Ottoman style soon crystalized. Thanks mainly to the researches of a group of young Turkish scholars as well as scholars of Great Britain, Germany, and the United States, there are few problems in establishing the textiles and costume typical of the Ottoman court.[8] Originality, stylistic and programmatic unity, expressive forms, and ornament design, together with great technical skill, place Ottoman products in the highest class of human accomplishment.

The motifs of living beings, animal or human, so often observed

104

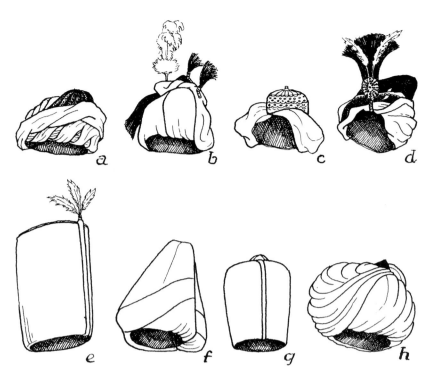

Fig. 21. Various types of Ottoman turbans a. Mehmed II b. Süleyman the Magnificent c. Ahmed III d. Selim III e. turban selimi f. turban mücevveze g. turban kallâvi h. turban örf.

in Persian fabrics, were completely absent in the Ottoman, where only noniconographic and floral symbols could appear. As in flags, dress motifs included stars, crescents, and czintamani designs—a correspondence that indicates the uniformity of this culture. Like the design of flags, the design of dress was suited to function, although the fabric used for dress was not the same as that used for flags and was less symbolic but more decorative.

In studying Ottoman dress, I shall analyze, as usual, actual costumes, particularly those from the Topkapı Saray Museum in Istanbul, iconographic representations, mainly from miniatures, and all accessible written sources, such as the notes of the court's chief tailor. Only a consideration of these three elements together can bring us nearer to the actual appearance of the Ottoman court. I shall now concentrate upon a number of features of Ottoman dress and attributes, particularly those that belonged to the sultan.

105

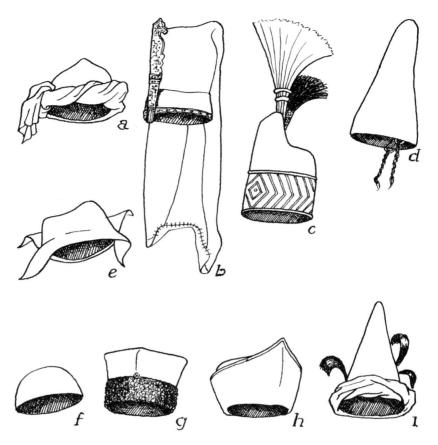

Fig. 22. Various Ottoman headgear a. Janissary turban b. Janissarry cap (keçe) c. Janissary officer's cap d. cap külah e."Bosnian" cap f. cap tekke g. four-cornered cap h. interpreter's (dragoman) cap i. dervish's cap.

TURBANS

To date, turbans have not been the subject of much extensive research. L. F. Marsigli, in his eighteenth-century book on the military aspects of the Ottoman Empire, made some valuable observations, noting, for example, that "There is a custom of the Turks to distinguish ranks by different turbans, as well as by fashion of dress, by the way of wearing sashes, and by the color of shoes, in public and private use."[9] Marsigli mentioned that his contemporary, Sultan Mehmed IV, wore a low turban with a single plume, which best suited his face.[10] In his study he was also concerned with the turbans

106

laid on sultans' tombs. In Bursa the tombs were adorned with great, symbolic turbans with green cones and wraps of muslin, while the sultans buried in Istanbul had on their tombs turbans with red cones.

The turban as a headdress has a long history, reaching back to antiquity. Established in the hot, desert lands of Asia and Africa as a protection against the dangerous rays of the sun, the turban originally was a scarf wound around the head in a defined way. Various types and colors of turbans were developed in Arabia, Persia, India, and Central Asia. It was in use in European countries, especially in Spain, which was occupied by the Moors from 711 to 1492. Some types of turbanlike headdress were also worn by Byzantine dignitaries in the fourteenth century, and turbans were a court fashion in the fifteenth century in Italy and France.[11] The turban served military purposes as a good protection for the head and as padding for the helmet.[12] Conversely, the turban was sometimes wrapped around the helmet.[13] In general, various types of turban contributed to the "monumentalization" of the human figure; the head, as the most important part of the human body, was ornamented and enlarged, and the turban was therefore a good place to exhibit special ornaments, plumes, and jewels.

Turbans may be roughly divided into three types: the simple wrap of cloth, the wrap on a cap, and the wrap on a special construction of stiff materials, such as sticks or pasteboard. In Ottoman Turkey all types were used, but the simple wrap was used only by the lower classes and various minorities. For the wrap on a cap, the inner cap, or *kavuk,* was stiff and made of felt or velvet lined with pasteboard, while the wrap was of a delicate fabric, mostly muslin or, more rarely, silk. The cap could take diverse and even fancy shapes, such as cylindrical, conical, spiked, domed, or puffed. The turban of Safavid Persian style, sometimes used by the Ottomans, had a very tall red spike at the top. The wrap could cover the cap with a single layer or, more often, with multiple layers in a special set, achieving finally the form of a roll, cylinder, ball, or melon. Of course, its volume depended on the height and form of the cap. The fabric for the wrap could be very long, reaching 20 yards or more. It was usually snow-white, more rarely being threaded with gold or colored. Green turbans were adopted by pilgrims to Mecca and were also worn by some privileged persons, such as the descendents of the Prophet.

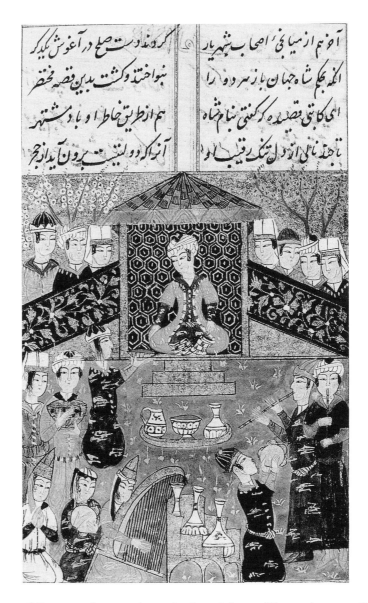

Ill. 29. Types of Ottoman dress as shown in the miniature "Entertainment of a Prince," in Katibi's Külliyat, ca. 1460–80. Topkapı Saray Museum, Istanbul, R.989, fol. 93 a.

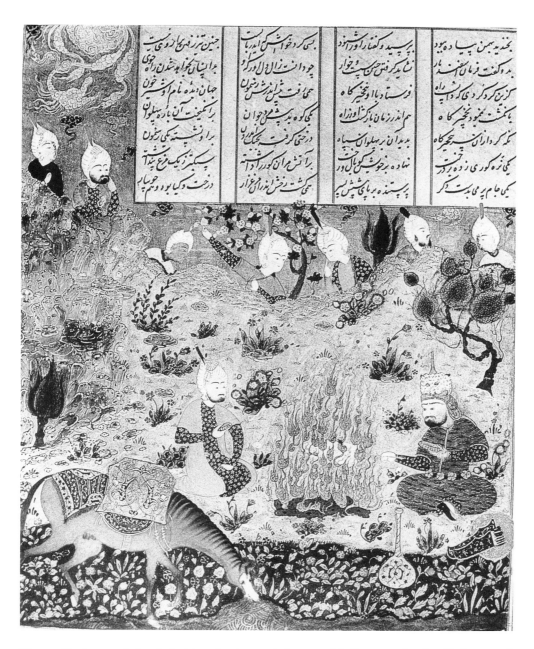

Ill. 30. Turbans of the Safavid style, in a miniature with Rustam, in the *Shāhnāme* of Firdawsi, ca. 1535. By permission of Topkapı Saray Museum, Istanbul, H.1499.

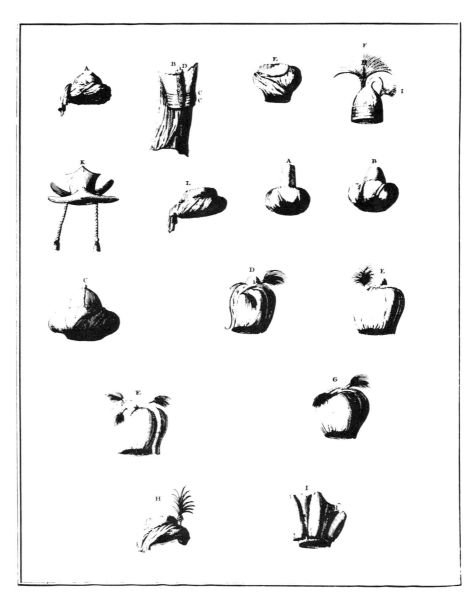

Ill. 31. Various types of Ottoman turbans, after Marsigli, *Stato militare . . .* , vol. 1, pl. 2, and 3.

110

Portraits of Sultan Mehmed II show that sultans' turbans in the fifteenth century had a low cap of red fabric quilted vertically, with a white wrap draped not very high,[14] although in the well-known portrait by Gentile Bellini, the Sultan wears a splendid large turban. The sixteenth century and the first half of the next century was a period of tall, sumptuous turbans for sultans and dignitaries. Wraps were so rich that the only part of the cap visible was the tip, but even this sometimes disappeared completely. The substantial ornament of the sultan's turban was the plume *(balıkçıl)*, called in precious mounting, the aigrette *(sorguç)*. The grand vizier was allowed to wear a turban with two aigrettes, while lower pashas had only one aigrette. Very large turbans with a huge spherical wrap, without ornament, were worn by the Muslim religious dignitaries; these turbans were called *örf* or *muvahhidī*.

Sultan Selim I introduced the third type of turban, called *selimī*, used only by the sultan and the highest dignitaries during some court ceremonies. Its core was of pasteboard in the form of a straight cylinder, about 2 feet high; the core was covered with muslin, convex at the top, and this in turn was covered with red fabric and sometimes decorated with feathers. The turban called *mücevveze* (permitted) was similar to a sugar loaf, but on a square base; it was covered with muslin, red at the top and decorated in front with a diagonal band of gold. Still another type of dignitary turban was expanded at the top, looked like a jug or vase, and was called *kallavi* (which in Arabic means jug); it was about 15 inches high, wrapped with muslin, and decorated with a silver band. Selimī, mücevveze, and kallavi were without actual wraps in the conventional meaning but nevertheless are regarded as turbans and were worn only for special occasions and ceremonies. In the second half of the seventeenth century a new type of turban called *paşalı kavuk* (pasha's headgear) came into fashion. It consisted of a high cylindrical cloth cap, sometimes enlarged at the top, backstitched vertically, with a low white wrap crossed above the forehead. It was worn by court officials, dignitaries, and rich patricians, as well as by the Sultan himself, although in his case with a rich aigrette in front. Sultan Mahmud II has a diamond aigrette on his paşalı kavuk as represented in the costume book painted by Fenerci Ahmed in 1811.[15]

A special official of the sultan's court, the aga of turbans, or *tülbend*

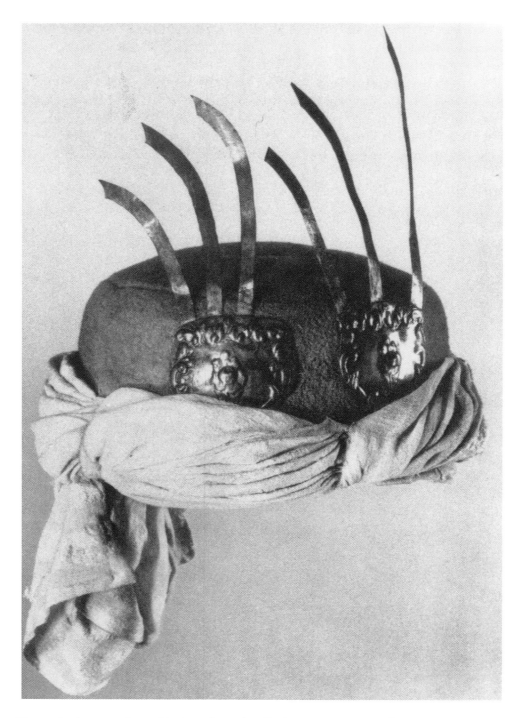

Ill. 32. Janissary turban with the çeleng sign for bravery, seventeenth century. By permission of Heeresgeschichtliches Museum, Vienna.

ağası, with his attendents, was responsible for all questions concerning the sultan's headgear, as well as that of all dignitaries.

Feathers constituted an important element of the Ottoman splendor in dress. Imported from exotic countries, these were always chosen with great care, prepared, dyed, and scrupulously mounted.[16] In this field the Turks outdistanced not only European countries but also their Oriental neighbors, such as Persia and India. They were fascinated by the colors, fluffiness, lightness, and durability of feathers. The wings and feathers of birds of prey were symbols of courage, bravery, and force in attacking and taking spoils. The same associations were applied to the skins of wild animals, such as the lion, tiger, leopard, or lynx. All these beliefs were based on the legends of Oriental heroes, like Rustam, and on such ancient heroes as Hercules or Alexander. There are innumerable fables of fantastic birds, of the phoenix rising anew from the ashes, of simurgh fighting with a dragon, or of gigantic birds called *roc* or *anka*. Apart from this symbolic context, feathers were attractive for their purely sensuous properties: soft and undulating, almost with a life of their own (in this respect they were similar to flags), they aroused the erotic imagination. From the fifteenth century onward, great quantities of ostrich feathers were imported from Africa. The Turks soon became masters in preparing, dyeing, and elongating (by addition) these feathers. From the Far East they imported the feathers of birds of paradise, which were often considered phoenix feathers. Eagles, vultures, falcons, and hawks lived in huge numbers in the vast territories of the Ottoman Empire, particularly in Anatolia and Rumelia, but aquatic birds were also greatly appreciated as a source of beautiful costume decoration. The heron was especially suitable, having sumptuous feathers at mating season; usually blackened with henna, these were affixed to sultans' turbans.

During the ceremony of enthronement, the climax of which was the girding of a sabre in the Eyyub Mosque in Istanbul, a sorguç was attached to the sultan's turban. At that time the plume was white; only after his first victories was it changed for a black one. The number of aigrettes was chosen according to the fashion and the fancy of each sultan. Occasionally a sorguç was decorated with a golden chain wound around the turban, which was probably a very old symbol of sovereignty, going back to the Omayyad caliphs, while the plume decoration was surely a product of Central Asia.[17]

113

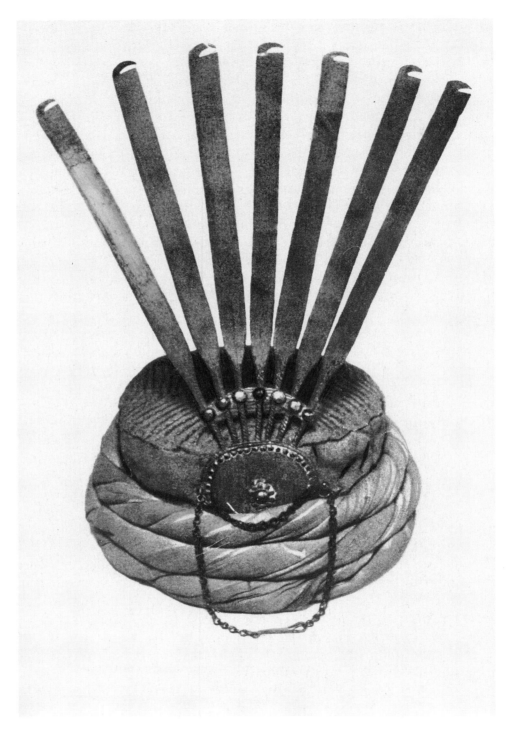

Ill. 33. Janissary turban with the çeleng sign for bravery, seventeenth century. By permission of Heeresgeschichtliches Museum, Vienna.

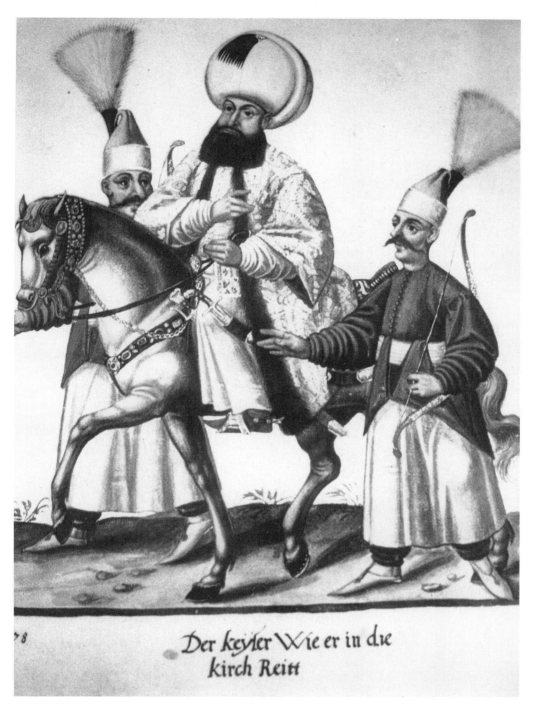

Ill. 34. Sultan Murad III (1574–95) in ceremonial dress. *Codex Vindobonensis* no. 8626. By permission of Nationalbibliothek, Vienna.

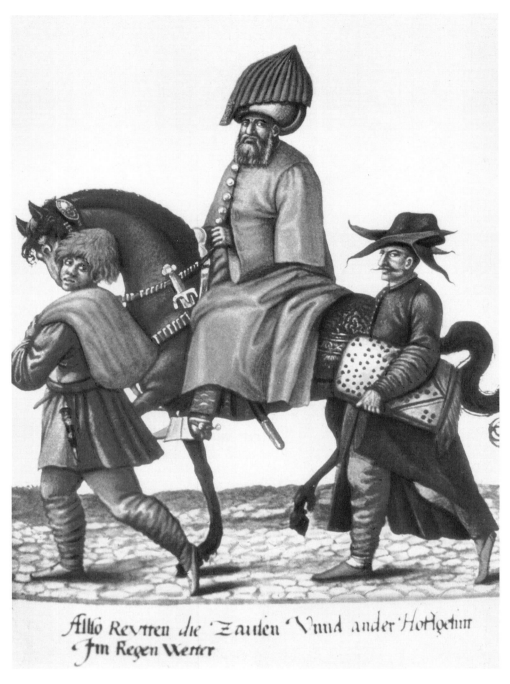

Allso Revtten die Zaulen Vnnd ander Hoffgehnn
Jm Regen Wetter

Ill. 35. Turban worn in rainy weather by an Ottoman dignitary. *Codex Vindobonensis* no. 8626. By permission of Nationalbibliothek, Vienna.

116

Sultan Süleyman the Magnificent used to wear a single aigrette with a tall plume, while the sultans of the seventeenth century adopted three aigrettes, two with standing plumes, and one with falling ones. In the eighteenth century, when the paşalı kavuk came into fashion, it was adorned with a solitary sorguç with an enormous ruby or diamond in the center.

In some ceremonials two turbans accompanied the sultan, one on his head and the other at his side on a bench, symbolizing his rule over the two parts of the empire, Asiatic and European.

CAFTANS AND FURS

Special dress, above all turbans, distinguished the ruling class, headed by the sultan, from the multiracial, multiethnic, and multireligious subjects of the Ottoman Empire. Starting from the fifteenth century, dress became more and more sophisticated and diversified, as was particularly suited to the multitude of official and military ranks. The state became more and more bureaucratic, and old costumes were abrogated for new designs. From the time of Süleyman the Magnificent court dress ceased to be a question of custom and tradition and became, instead, subject to strict regulations, which were codified in the Law of Ceremonies *(Kanun-i Teşrifat)*.[18] Prescriptions determined types of fabric, cut, sizes, colors, and ornaments for all important dress, special officials being appointed to supervise and be responsible for their observance. Aside from the aga of turbans, there was the chief official for the sultan's dress—*çuhadar*—as well as the chief guardian of caftans—*kaftancı*—and the chief guardian of furs—*kapanıçacı*. Ceremonial and award caftans, called *hilats,* made of brocade of various kinds and lined with satin or bordered with fur, were an important instrument of the sultan's grace and also an instrument in diplomatic activities.

The ceremoniousness of the Ottoman court probably surpassed that of various Oriental states; it also excelled the different forms of etiquette in Europe, which reached their climax in seventeenth-century Spain and France. Possibly still higher were the Byzantine court ceremonials, pervaded by the mystic atmosphere of the Orthodox Church, and with this the Ottomans, in spite of all their endeavors, could not compete. In any case, the history of the Ottoman Empire was a drama of costume. Every dignitary, every member of the court,

117

every state official, officer, or soldier had prescribed, easily recognizable headgear and dress. Each one had also a prescribed place in the sultan's cortège proceeding to the mosque for the festival of Bairam, at the time of the ceremony of circumcision of a prince, at the ceremony of greeting a foreign envoy or the departure of the sultan on a hunting or war expedition, or on the occasion of the fleet's setting sail. On these occasions a pomp never before seen was displayed. Women did not participate in full: they appeared in public anonymously, completely covered with veils. Their dress was actually inviolable, their outer garmets as untouchable as the walls of the harem.[19]

Ottoman male dress of high rank was generally distinguished by gravity and dignity, features that were accentuated by length, harmonious colors, and sumptuous patterns. Apart from the turban, the ceremonial (or often everyday) dress of the sultan and high dignitaries of the court consisted of a shirt *(gömlek)*, inner garment *(entari)*, often with a sash *(kuşak)* or metal belt set with gold and stones *(kemer)*, trousers *(şalvar)*, outer garment *(kaftan)*, which was an overcoat usually lined with fur, and high boots *(basmak)*, shoes *(mest)*, or slippers *(çedik* or *çizme)*.

There were various kinds of caftans, each with a special name. A caftan with short and wide sleeves was completed by a second pair of sleeves that were long and fixed by special bands.

The most valuable caftan was lined with dignitary fur; it was very large and long, was covered with silk or brocade, and had double sleeves trimmed with braid, of gold lacing, and precious buttons. Caftans lined with various types of furs included: *divan kürkü,* covered with woollen cloth, with wide sleeves; *üst kürk,* covered with brocade, with double sleeves and a large collar; and *erkan-i kürk,* an honorary fur of white sable, covered with gold-flowered brocade, with a large collar and short sleeves.[20]

The supply of skins and furs necessary for costume came from the empire's own lands as well as from foreign countries. Some parts of Anatolia and of Rumelia, with a cold winter climate, justified the use of furs, but in the court fashion of Istanbul furs signified simply the highest rank and wealth. Particularly in demand were the sable, squirrel, and black fox needed for the lining and edging of hilats (ceremonial caftans) and mantles of brocade. Sables come from the vast territories of Siberia, the great markets for them being in Mos-

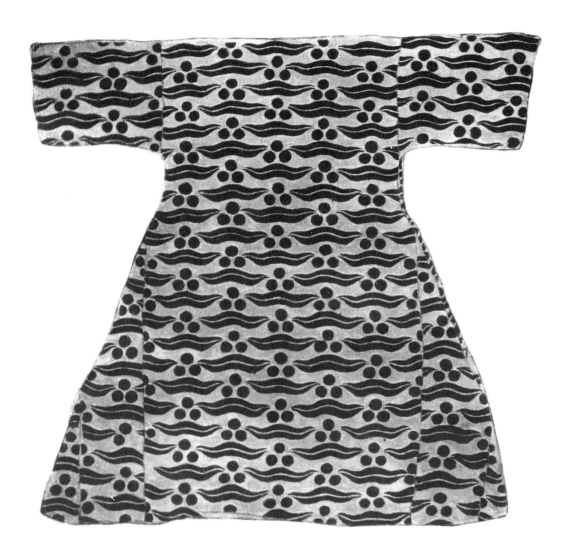

Ill. 36. Kaftan of Sultan Mehmed II (1451–81), with the czintamani motif. By permission of Topkapı Saray Museum, Istanbul.

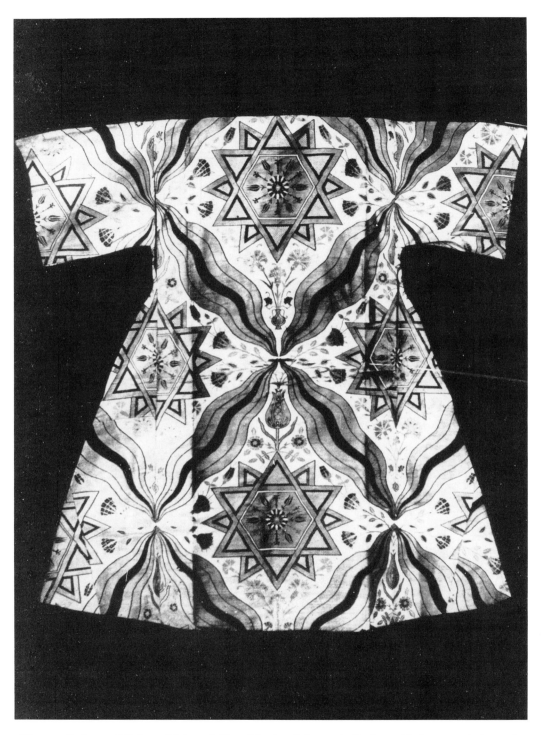

Ill. 37. Kaftan of Sultan Mehmed II, with the Solomon's Seal motif. By permission of Topkapı Saray Museum, Istanbul.

cow, Novgorod, Pskov, and Kiev, where the best sorts of sable were sold. These were of different colors—from dark brown, almost black, to light brown and white from albino animals—rich in coat, soft, and strong. A unit of forty sable skins *(sorok)* tied together under a cover of brocade was a gift eagerly accepted by Ottoman dignitaries and by the sultan himself. Sultan Ibrahim (1640–1648) was a little mad on this point: he decided to line the walls of his apartments in the saray with sables, ordering their purchase in great quantities in the bazaars, and when the price went up, he confiscated them all over the country. His folly brought him the name of the "Sable Sultan."

As for the private dress of Ottoman Sultans, we are in an unusual and fortunate situation: beginning in the fourteenth century, at the time of Sultan Osman, there developed the custom of preserving the most precious items of the sultan's court, keeping them in sacks inscribed with the appropriate ruler's name, and of embellishing the coffin of a dead sultan with his garment. Some of these priceless objects have survived and have been investigated in the 1940s by two outstanding scholars, Tahsin Öz, curator of the Topkapı Saray Museum, and A. J. B. Wace, curator of the Victoria and Albert Museum in London. Their cooperation resulted in the authoritative book on sultans' dress.[21] The two authors made an inventory of the remnants of sultans' wardrobes and a detailed study of various types of dress fabric produced in Bursa, Istanbul, and other Ottoman centers of weaving, such as Amasya, Baghdad, Damascus, and Chios. Various kinds of silk, velvet *(kadife),* and brocade *(kemha)* were analyzed, and old technical terms, such as *diba, çatma, beneki,* and *serengi* were defined; *seraser* was an Istanbul brocade woven with gold and silver and intended for honorary hilats; and *zerhaft* was brocade of the highest class. It is needless to summarize here the valuable work of these scholars, but one point should be made: they were not particularly interested in the symbolism of the sultans' dress. Öz, for example, classified the symbolic motifs of czintamani as simply an imitation of tiger's skin as that worn by the Persian hero Rustam.[22] Even from a superficial survey of the costume stock, one may learn that most of the fabrics had symbolic designs, which, as I have said above, were sometimes very near to those of flags. Surprisingly enough, there were caftans with inscriptions, such as one of silk sewn from fabric decorated with cream lines and serrated leaves on a dark green ground. The inscription in Arabic letters reads: "Our kind Sultan

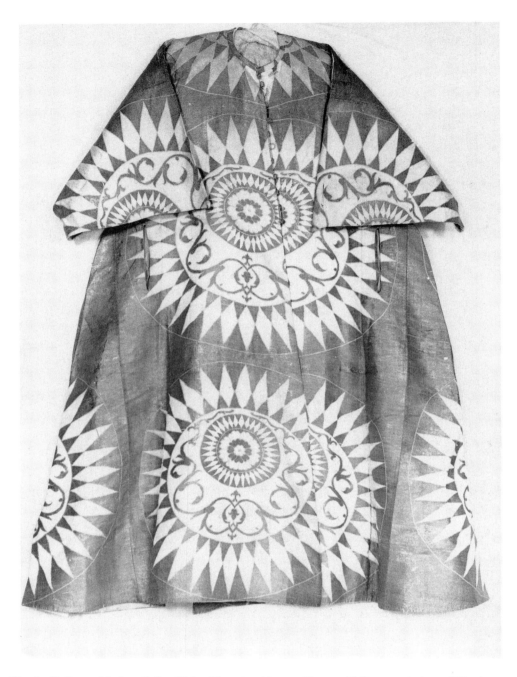

Ill. 38. Kaftan of Sultan Selim II (1566–74), with sun-like motif. By permission of Topkapı Saray Museum, Istanbul.

122

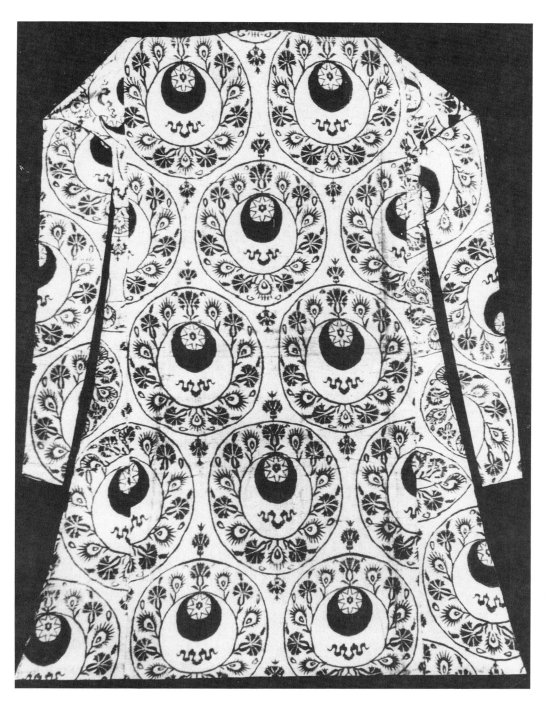

Ill. 39. Kaftan of Sultan Murad II (1421–51), with motif of the closed crescent. By permission of Topkapı Saray Museum, Istanbul.

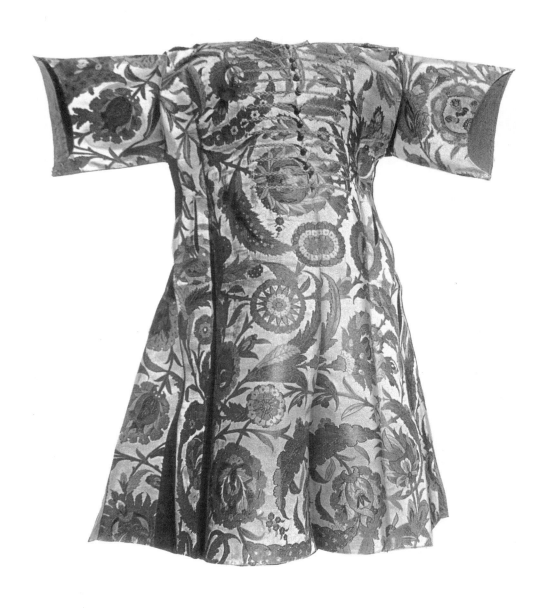

Ill. 40. Kaftan of a sultan from the second half of the sixteenth century, with the floral "saz" decoration. By permission of Topkapı Saray Museum, Istanbul.

Süleyman Shah, son of Selim Shah—May God make his kingdom higher and his glory last—commands that this cloak be made. There is no God but Allah, Moses is His hearer [sic]."[23] Also surviving in the collection of the Topkapı Saray Museum are short cotton shirts for military use, intended to be worn under armor and entirely covered with Koranic verses—these providing the best protection in the perils of war.[24] Apart from these, there are caftans with crescents, crescents and stars, and the Solomon's Seal, this last being attributed to Sultan Mehmed II.[25] Sometimes the czintamani is reduced to three discs or balls, as in the case of the caftan of Selim I.[26]

The sultan's most important fur was the so-called *kapaniça*, a large and most sumptuous mantle of satin, gold, or silver seraser with an enormous collar and wide sleeves, reminiscent of the Byzantine *dalmatica*, and lined with sable or black fox. It was placed on sultans' shoulders, always with great ceremony, with the burning of aloes and singing pages. On exceptional occasions it was also placed momentarily on the shoulders of princes or viziers. In the seventeenth and eighteenth centuries the grand vizier, at the start of a campaign, was given, from the hands of the sultan, a special fur called *veda kürkü*, the fur of farewell, as a sign of blessing and the expectation of a victorious return; and then two aigrettes with diamonds were pinned to his turban.[27]

All these ceremonies were strongly bound with the ancient symbolism of the mantle, which, covering the whole human body, gives protection and security. Above all, the mantle is also a symbol of grace. Although imperial and royal mantles or copes (*pluviale*) belonged to the trappings of coronation in Europe, in the world of Islam, the memory of the Prophet's mantle was vivid—and its venerable relic was kept in the very heart of the saray.

In the late Ottoman period the style of kapaniça developed some excessive features. In the codex illuminated by Fenerci Mehmed in 1811, Sultan Mahmud II is represented as wearing a fur with the front regularly set with large diamonds, which, unexpectedly, recalls the *tablion* (an ornamental patch) of Byzantine emperors from the sixth or seventh century.[28]

All costume accessories were designed and made with utmost care. For example, a traditional ring worn by sultans was the thumb-ring or archer's ring (*zihgir*), used in drawing and loosing the bow.[29] It was made of ivory, horn, jade, or gold and was sometimes inlaid with

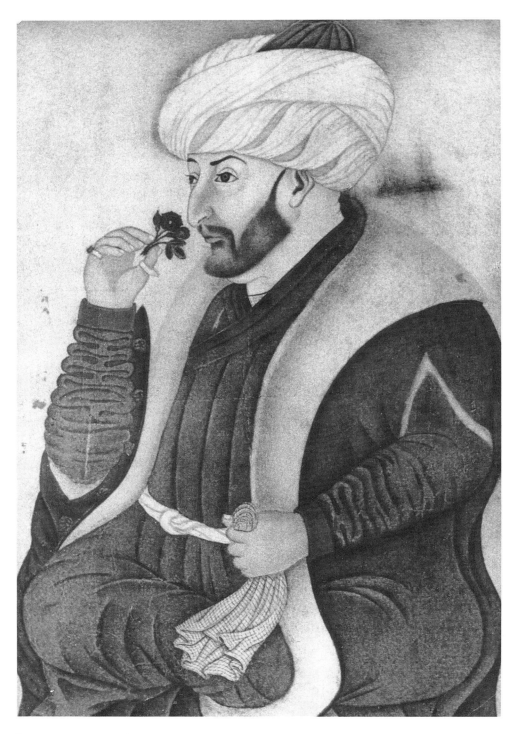

Ill. 41. Portrait of Sultan Mehmed II, painted by Sinan Bey, with ceremonial handkerchief and thumb-ring. By permission of Topkapı Saray Museum, Istanbul.

precious stones. Mehmed II wears it in the famous miniature portrait of him.[30]

The pomp and magnificence of the Ottoman court developed through the influence of the Byzantines and Persians, but the Ottoman style of goldsmiths' work was original, including not only jewelry but such objects of practical use as arms, armor, shields, saddles and horse trappings, mirrors, cups, water bottles, pen-cases, and other objects.[31] Sometimes imported Chinese porcelains were redecorated with and mounted in gold and jewels. Various objects were covered with sheet gold or silver gilt, engraved with tiny flowers and leaves, and set in high mounts with rubies, emeralds, turquoise, jade, garnets, almandines, or spinels. Turquoise and jade were imported from China and regarded as lucky stones for warriors, as were carnelians. Ordinary everyday objects were transformed into jewelry. The people of western Europe, observing this fashion, spoke about "barbarian taste" but avidly endeavored to capture such objects as spoils.

Christians often applied to the sultan the title of emperor and showed him in paintings or engravings in a peculiar crown, holding a scepter. This was, of course, an error. In the Ottoman Empire the signs of highest authority were quite different, including the special turban with sorguç or the kapaniça fur described above as well as others that have been forgotten or were little known. Some are described below.

THE SULTANS' HANDKERCHIEF AND MACE

A very interesting paper on handkerchiefs in the Topkapı Saray Museum was read by Nuhayat Berker of Istanbul for the fifth congress of Turkish Art held in Budapest in 1975.[32] It appears that handkerchiefs of a special kind, made of thinnest cotton, pure white or decorated with silk and silver yarn, were used by Ottoman sultans as a symbol of authority. Seven handkerchiefs are in the Topkapı collections. This custom is further documented by several miniature portraits, as in the one of Mehmed II mentioned above.[33] Princes also held this sign. It is said that the sultan, in choosing an odalisque, threw on her his handkerchief, this being a signal to the harem servants that she was expected that night. Berker is surely correct in ascribing the origins of this sign to the *mappa* carried by the Byz-

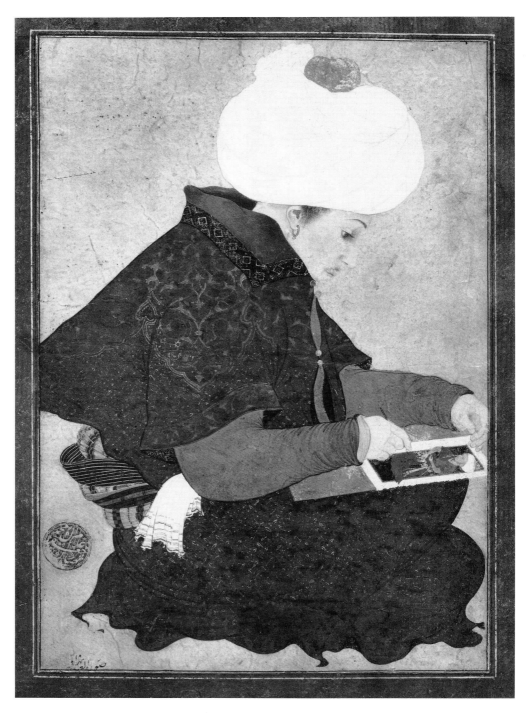

Ill. 42. Portrait of painter in Turkish dress, with ceremonial handkerchief, ca. 1480. By permission of Freer Gallery of Art, Smithsonian Institution, Washington, D.C.

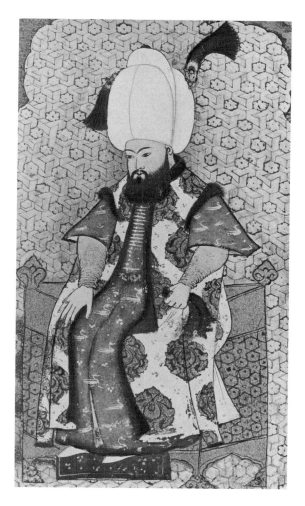

Ill. 43. Sultan Mehmed III (1595–1603), with ceremonial handkerchief, a miniature in the Badisches Landesmuseum in Karlsruhe. Reprinted by permission.

antine consuls during the fifth and sixth centuries, and with which they gave the signal for starting the games in the circus or hippodrome. It is worth adding that such a ceremonial handkerchief in a sultan's hand was painted by Giotto in the murals of the Bardi Chapel, in the church of Santa Croce in Florence.[34] In Turkey even the *peri cini* (Islamic angels) were represented with such signs of authority.[35] Still more intriguing is that the same mappa appears in the hand of the Polish king of Hungarian origin, Stephen Bathory, in his majestic portrait from 1583.[36] A similar handkerchief ap-

129

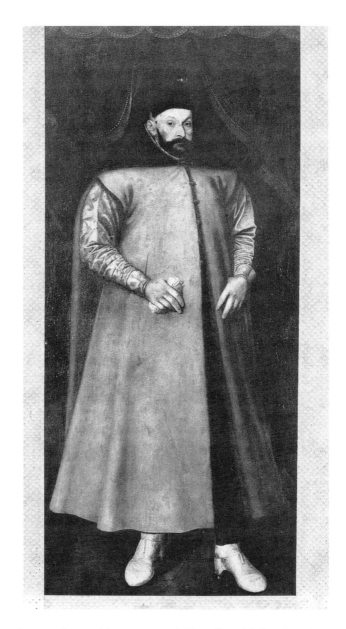

Ill. 44. King Stephen Bathory with a ceremonial handkerchief, painted in 1583 by Marcin Kober, the Missionaries' Monastery, Cracow. By permission of National Museum, Cracow.

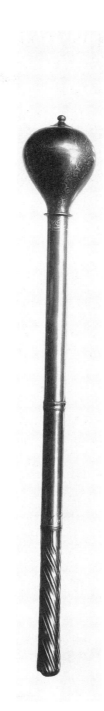

Ill. 45. Ottoman mace of the sixteenth century. By permission of Heeresgeschichtliches Museum, Vienna.

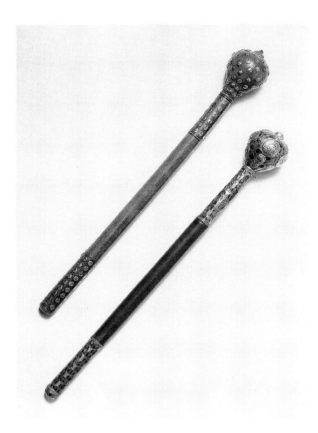

Ill. 46. Ottoman maces of the seventeenth century. By permission of National Museum, Cracow, the Czartoryski Collection.

peared in the Western world in the fifteenth century as a tournament signal and in the sixteenth century in the hands of Austrian princesses.

A mace with a ball-shaped head, a *topuz,* was the sultan's sign of highest military authority, as documented in numerous Ottoman miniatures. The mace was used by the Turks from earliest times as weapon and then as a symbol of military rank.[37] Of course, sultans' maces were of a special make, of precious metals and ornamented with gemstones. Some are preserved in the Topkapı Saray Museum and in other collections. One of these maces, an extraordinary item made of jade and set with rubies on the head, appeared in the United States at the exhibition "Art Treasures of Turkey" in 1966–

132

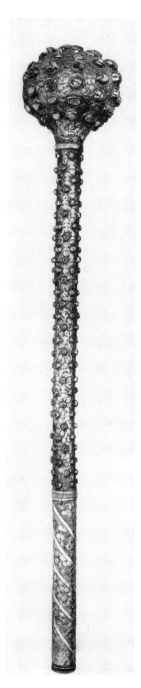

Ill. 47. Ottoman mace of the seventeenth century, Imperial style, the Clara Mons monastery, Czestochowa, Poland. By permission of National Museum, Cracow.

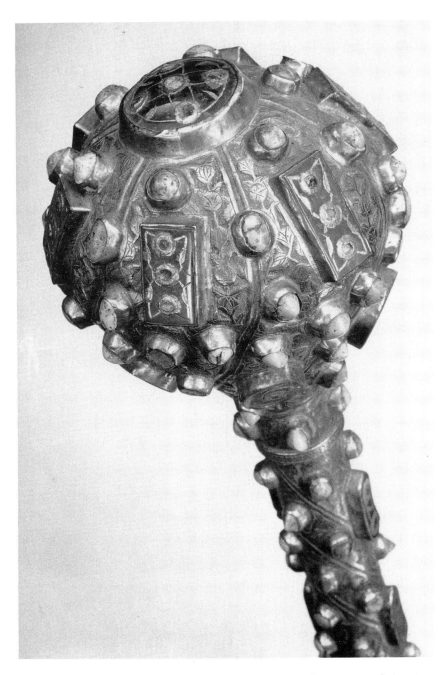

Ill. 48. A Turkish mace offering of S. Jabłonowski, Grand Hetman of the Crown, co-commanding in the Battle of Vienna, 1683, the Clara Mons monastery, Czestochowa, Poland. By permission of National Museum, Cracow.

134

Ill. 49. Ceremonial Ottoman mace of jade and rubies. By permission of Topkapı Saray Museum, Istanbul.

135

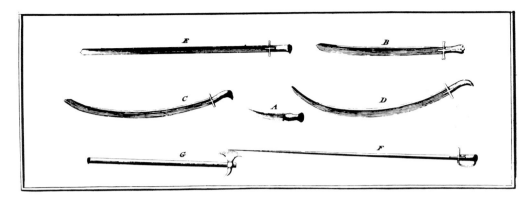

Ill. 50. Various types of swords, sabres, and other arms, after the Marsigli, *Stato militare* . . . , vol. 2, pl. 6. By permission of Topkapı Saray Museum, Istanbul.

1968.[38] Sultans used to send the maces to their vassals, as symbols of "investiture" or dependence.

In general, the mace belongs to the oldest type of human arms. Originally, it could be a special branch of a tree (as used by gorillas and other primates) or a round stone fastened to a wooden shaft (as used by early and primitive cultures). It is remarkable that in very early civilizations, the weapon passed from practical to symbolic use, often in connection with a religious cult. The mace with a spherical head was in the hands of pharaohs as well as in those of Mesopotamian kings—as, for example, it appears with King Eannatum, on the Stele of Vultures from Tello in the Louvre, dated third millennium B.C. Maces are also found among Mesopotamian temple votive offerings and were used later in the same region by the kings of Assyria and Persia.

From Turkey the sign of the mace came to Hungary and then to Poland, where it was called *buława*. We know that Sultan Selim II, when acknowledging Stephen Bathory as the *voievode* (governor) of Transylvania, presented him with a mace.

ARMS OF MEHMED THE CONQUEROR

The most venerable assemblage of arms is housed in the inner treasury of the Topkapı Saray Museum, in the Chamber of the Holy Mantle, together with the sacred banner. This place might be called the Holy of Holies of both the Ottoman Empire and the Islamic

136

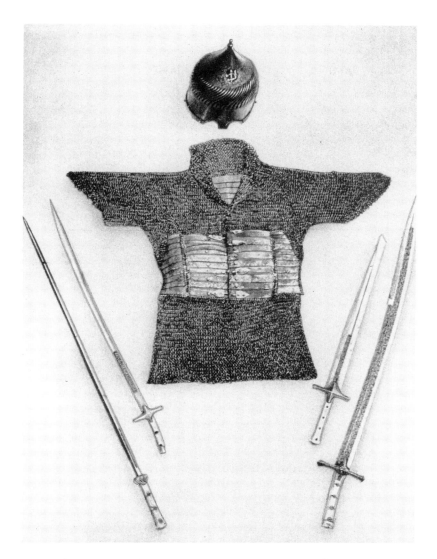

Ill. 51. Arms and armor of Sultan Mehmed II. By permission of Topkapı Saray Museum, Istanbul.

tradition. One of the noblest relics is Muhammad's bow, made of bamboo, with a silver case added by order of Sultan Ahmed I.[39] Archery was cultivated and admired throughout all Islamic countries, not least among the Turks. The Topkapı houses probably the largest collection of Oriental bows in existence, which, together with archery equipment, bow-cases, quivers, arrows, and thumb-rings,

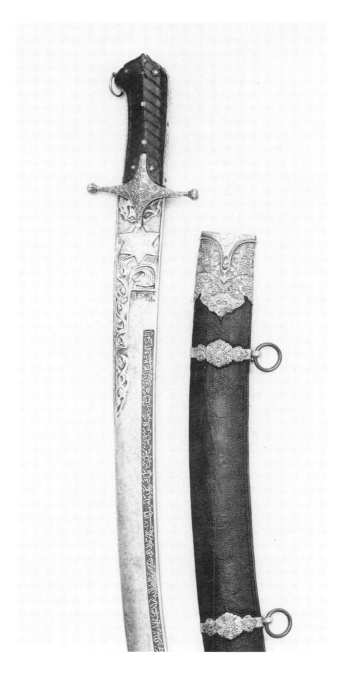

Ill. 52. Ottoman parade sabre with karabela hilt, seventeenth century. By permission of Wawel State Collections of Art, Cracow.

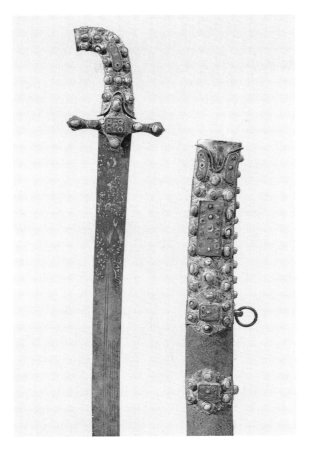

Ill. 53. Ottoman sabre with Persian blade (fifteenth century) in the Imperial style of the seventeenth century. By permission of Wawel State Collections of Art, Cracow.

offers a most encouraging field for study. The collection of swords and sabers is also of great value and includes two swords attributed to Muhammad (of which the hilts and scabbards are probably from the sixteenth century), swords of the first four caliphs—Abū Bakr, ʿUmar, ʿUthmān, and ʿAlī—and twenty-one other swords of the early heroes of Islam and later caliphs. Many of them combine a straight and broad medieval blade with the curved, sabre-type hilt of later date.

Innumerable items of arms and armor, displayed in the armory of the Topkapı Saray Museum and in several other rooms, are connected with Ottoman sultans. The limits of this book do not allow me

139

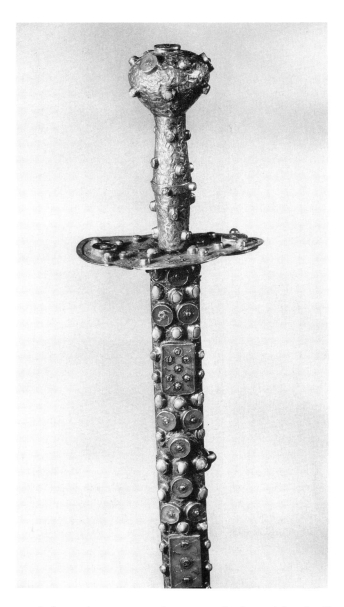

Ill. 54. Ottoman tuck from the seventeenth century, in Imperial style. By permission of National Museum, Cracow, the Czartoryski Collection.

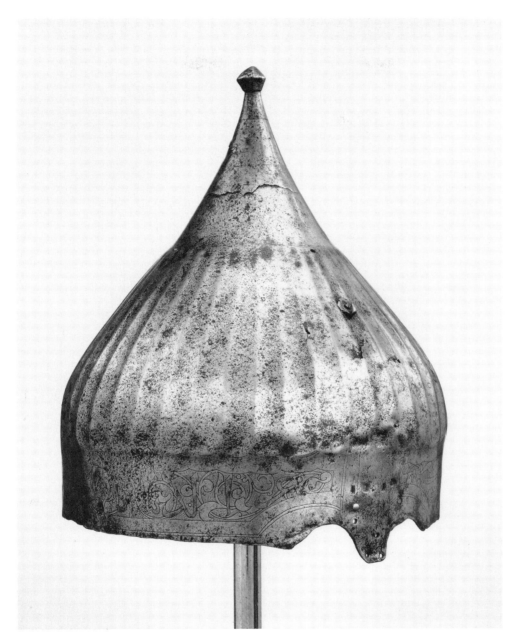

Ill. 55. Early Ottoman helmet (ca. 1500). By permission of Wawel State Collections of Art, Cracow.

141

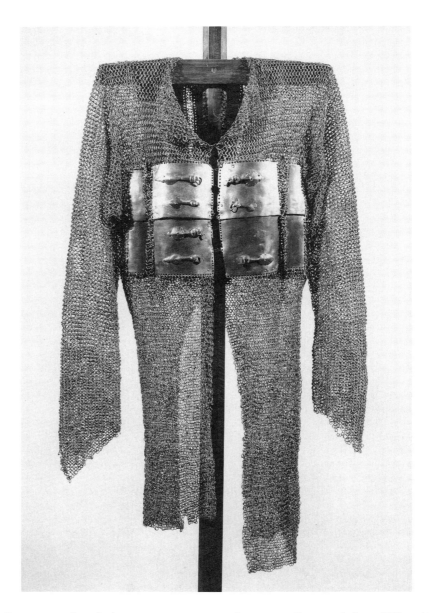

Ill. 56. Ottoman mail and plates armor, seventeenth century. By permission of Wawel State Collections of Art, Cracow.

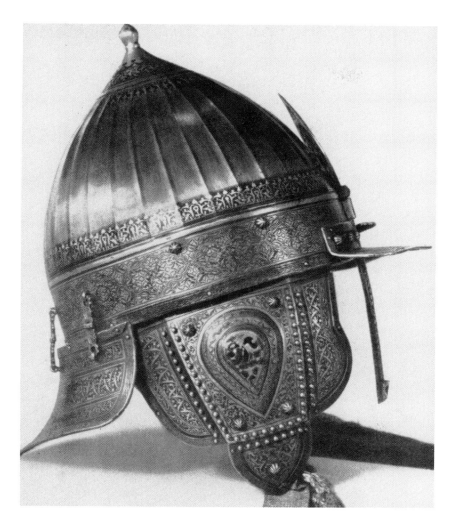

Ill. 57. Ottoman helmet, probably a gift of Sultan Selim II to Stephen Bathory as the voievode of Transylvania. By permission of Waffensammlung des Kunsthistorischen Museum, Vienna.

to enlarge on this theme. Instead, I will briefly concentrate here on an assembly of priceless value that has not so far been fully commented on by Turkish or other scholars: the arms and armor of Mehmed the Conqueror.

The armor consists of a large turban helmet and a body suit of mail with plates. This type was surely most popular among the early Ottomans and Mamelukes.[40] More remarkable is the accompanying

143

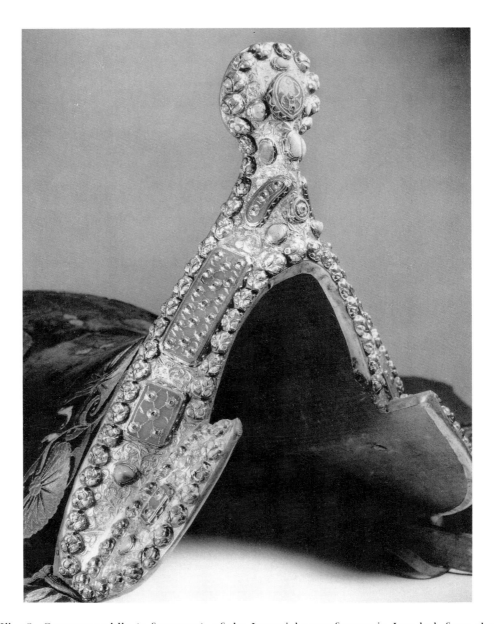

Ill. 58. Ottoman saddle (a fragment), of the Imperial manufacture in Istanbul, from the Vienna booty 1683 of Hetman M. H. Sieniawski. By permission of National Museum, Cracow, the Czartoryski Collection.

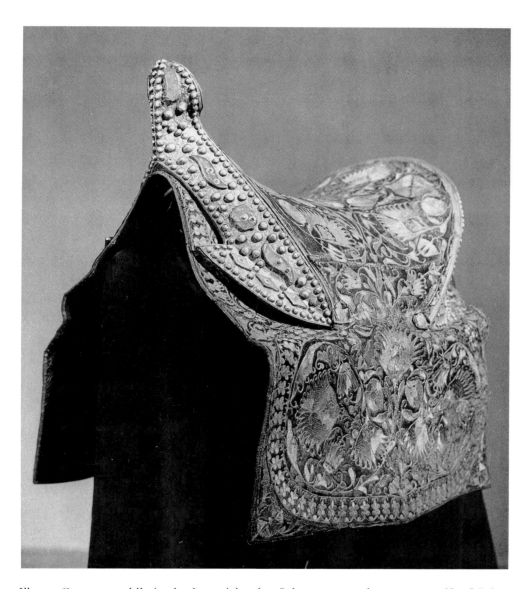

Ill. 59. Ottoman saddle in the Imperial style of the seventeenth century, a gift of Sultan Mustafa II to the voievode Stanisław Małachowski, a Polish legate to Karlovitz, in 1699. By permission of Wawel State Collections of Art, Cracow.

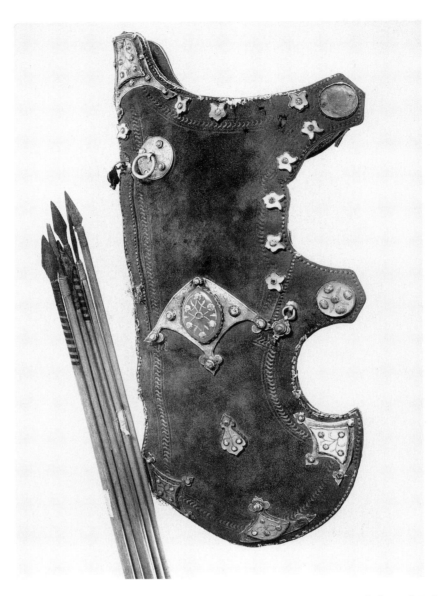

Ill. 60. Ottoman quiver and arrows of the seventeenth century. By permission of Polish Army Museum, Warsaw.

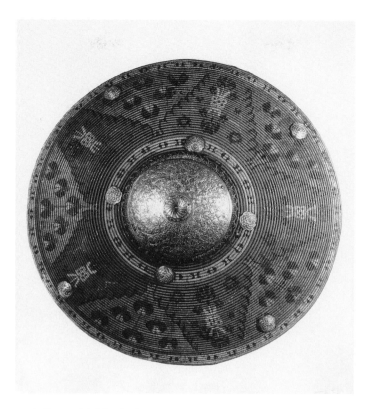

Ill. 61. Ottoman kalkan shield of the seventeenth century. By permission of National Museum, Cracow, the Czartoryski Collection.

set of edged weapons: a short sword, a heavy saber, a light saber, and a tuck (rapier)—every piece made en suite, of perfect steel, decorated with gold inscriptions and ornaments on the blades, with hilts clad in walrus ivory and cruciform quillons of steel. The scabbards are not extant. The Arab tradition of straight swords with heavy blades is obvious, the hilts being slightly curved. The same style of blades was maintained far into the sixteenth century, as proved by a sabre attributed to Süleyman the Magnificent, which is also in the Topkapı. While the hilts and scabbards became more and more ornamented with gold and stones, arms were finally changed into jewels.

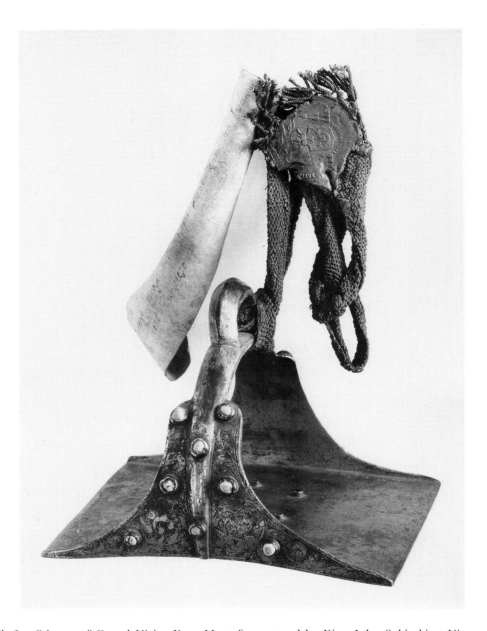

Ill. 62. Stirrup of Grand Vizier Kara Mustafa captured by King John Sobieski at Vienna and sent by him to Cracow with the news of victory, the Cracow Cathedral Treasury. By permission of Wawel State Collections of Art, Cracow.

148

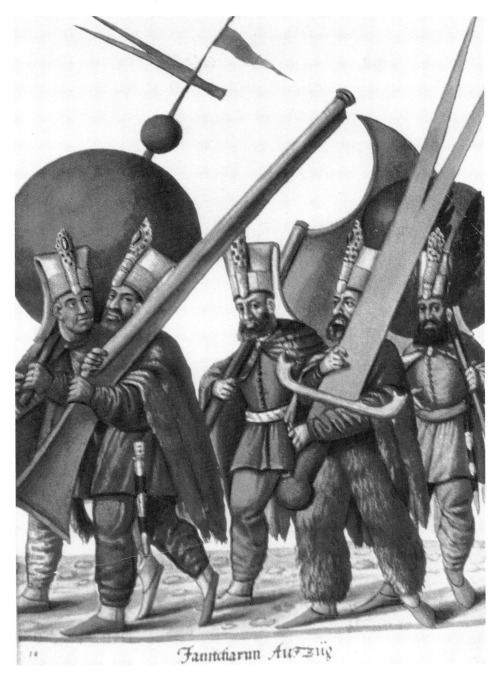

Ill. 63. Janissaries carrying gigantic arms. *Codex Vindobonensis* no. 8626. By permission of Nationalbibliothek, Vienna.

Notes

1. B. Lewis, *Istanbul and the Civilization of the Ottoman Empire;* P. Wittek, *The Rise of the Ottoman Empire;* H. İnalcık, *The Ottoman Empire: The Classical Age, 1300–1600.*
2. N. M. Penzer, *The Harem;* T. Öz, *Turkish Textiles and Velvets, Fourteenth through Sixteenth Centuries.*
3. R. Mantran, *Istanbul dans la seconde moitié du XVIIe siècle: Essai d'histoire institutionelle, économique, et sociale.*
4. For example, in the Şahanşahname from 1582, made for Sultan Murad III, in the Topkapı Saray Museum, TSM b. 200. See *Turkey: Ancient Miniatures,* preface by R. Ettinghausen, introduction by M. Ş. Ipşiroğlu and S. Eyuboğlu (Paris, 1961), pls. 24 and 25.
5. Öz, *Turkish Textiles and Velvets,* 56–60.
6. M. Önder, "Le mode de se vêtir et de se parer chez les dames seljoukides," in *Fifth Congress of Turkish Art,* G. Fehér, ed. (Budapest, 1978), 655–65.
7. Ibid., 658.
8. See W. Denny, "Textiles," in *Tulips, Arabesques, and Turbans: Decorative Arts from the Ottoman Empire,* Y. Petsopoulos, ed., 121–68; J. Scarce, "Das osmanische-türkische Kostüm," in *Türkische Kunst und Kultur aus osmanischer Zeit,* vol II, 221–40; I. Biniok, "Osmanische Stoffe und Kostüme," in ibid., 241–73.
9. Marsigli, *Stato militare dell'impèrio Ottomanno,* 1:64.
10. Ibid., 65.
11. M. Davenport, *The Book of Costume* (New York, 1956), vol. 1, fig. 856.
12. Russell H. Robinson, *Oriental Armour,* 61, pls. 12A and B.
13. C. E. Arseven, *L'Art turc,* pl. 11. This plate shows a sixteenth-century miniature by Seid Suleiman Kasim, Museum of the Turkish and Islamic Arts, Istanbul.
14. Ibid., pl. 18.
15. Osmanlı Kıyafetleri, *Fenerci Mehmed Albümü.* Ottoman costume Book.
16. Z. Żygulski, Jr., *Sztuka turecka* (Turkish art), 138.
17. Biniok, "Osmanische Stoffe und Kostüme," 252.
18. Żygulski, *Sztuka turecka,* 136.
19. Scarce, "Das osmanische-türkische Kostüme," 222–23.
20. Biniok, "Osmanische Stoffe und Kostüme," passim.
21. Öz, *Turkish Textiles and Velvets,* passim.
22. For example, in the miniature representing Rustam cooking, in the Firdawsi Shāhnāme, ca. 1535, Topkapı Saray Museum, H. 1499, fol. 303a.
23. Öz, *Turkish Textiles and Velvets,* 92, pl. 27.
24. These caftans of dolama type were presented at the Islamic Arts Exhibition on the occasion of the Fifteenth Centennial of Hegira, Istanbul, 1983, but not included in the catalogue.
25. Öz, *Turkish Textiles and Velvets,* 46, pl. 8.
26. Ibid., 91, pl. 22.
27. Biniok, "Osmanische Stoffe und Kostüme," 245.
28. Davenport, *The Book of Costume,* pls 294 and 295.

29. G. C. Stone, "Archer's Ring," in *A Glossary of the Construction, Decoration, and Use of Arms and Armour in All Countries and in All Times,* repr. (New York, 1961).

30. Arseven, *L'Art turc.* pl. 18.

31. S. Türkoğlu, "Höfische Goldschmiedekunst," in *Türkische Kunst und Kultur aus osmanischer Zeit,* vol II 300–10; D. Rohwedder, "Schmuck," in ibid., 311–19.

32. N. Berker, "Saray Mendilleri," in *Fifth Congress of Turkish Art,* G. Fehér, ed., 173–81.

33. Arseven, *L'Art turc,* pl. 18.

34. I thank Professor Lech Kalinowski from the Jagiellonian University in Cracow for turning my attention to this most interesting image.

35. For example, the Istanbul miniature under Persian influence from the first half of the sixteenth century. See Y. Petsopoulos, ed., *Tulips, Arabesques, and Turbans,* ill. 196.

36. Z. Żygulski, Jr., "Akcenty tureckie w stroju Batorego" (Turkish accents in Batory's dress), *Folia Historiae Artium,* 24 (1988):61.

37. Z. Żygulski, Jr., "Geneza i typologia buław hetmańskich" (The origin and typology of Hetman's maces), in *Muzealnictwo wojskowe* (Warsaw, 1964), 2:239–88.

38. "Art Treasures of Turkey," ill. 248.

39. A. R. Zaky, "Medieval Arab Arms," in *Islamic Arms and Armour,* Robert Elgood, ed. (London, 1979), 203; J. D. Lathan and W. F. Paterson, "Archery in the Lands of Eastern Islam," in ibid., 78–96.

40. Robinson, *Oriental Armour,* 62, pl. 7A.

Tents

SOME REMARKS ON THE ORIGIN AND IMPORTANCE OF TENTS

Considering the role that tents have played in human culture, in the past and still today, surprisingly little has been written on this subject. While the permanent, immovable architecture all around the world has had thousands of printed studies devoted to it in all languages, the movable architecture of tents, used since ancient times, has hardly any theoretical literature. A preliminary study of Persian tents in history was published by Arthur Upton Pope half a century ago, but the actual basis for this research was very limited, since no fully preserved examples existed.[1] A little earlier, G. Mentendon had attempted to classify Oriental tents in principal types according to structure, but his conclusions seem rather too simple.[2] Ethnographers have studied Arab tents,[3] while Polish scholars, basing their work on original materials, produced some studies of Oriental tents after World War II.[4]

As for the Turkish tents in old European literature, the descriptions by Luigi Ferdinando Count de Marsigli, an eyewitness (from

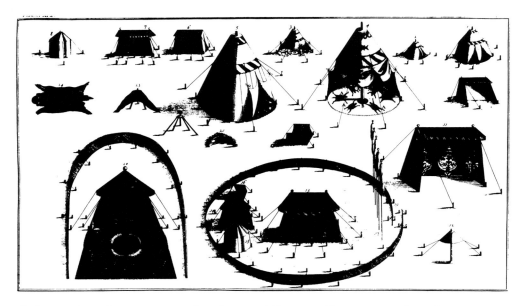

Ill. 64. Various Ottoman tents, after the Marsigli, *Stato militare . . .* , vol. 2, pl. 19.

the Turkish side) of the great siege of Vienna in 1683, remain unrivaled.[5]

Generally speaking, a tent may be defined as a movable or foldable dwelling made of skin, fabric, or felt and pitched on poles fastened to the ground by ropes and pegs or set on a wooden platform. The felt tent, or the *yurt,* is still used by nomads in Mongolia while Bedouins in Arabia use black tents made of goat's hair. Nomadic American Indian groups also used tents, mainly of skins and hides. Tents have always been used by soldiers, especially on campaigns or maneuvers. They are also useful on expeditions, on safari, in circuses, for recreational purposes.

The oldest recorded information on tents comes from ancient Greek, Persian, and Roman sources. No actual objects of that time have survived but from iconography we can reconstruct the simple forms of Roman military tents as seen on Trajan's Column in Rome: the basic form was that of a house with vertical walls and saddle roof, the officers' and chief commanders' tents being larger and sewn from red canvas.[6] We have written descriptions of sumptuous Persian, Greek, and Egyptian tents, particularly from Hellenistic times, made from gorgeous fabric, and threaded with gold. The influence of this structure on the much later Ottoman art of tents is undeni-

154

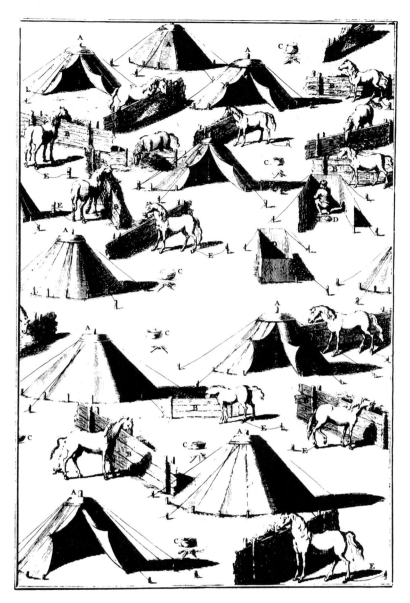

Ill. 65. Various types of Ottoman tents, after the Marsigli, *Stato militare* . . . , vol. 2, pl. 25.

able. If one excludes here the impact of nomads building huge tents of black wool in the Near East, some of which were gigantic and supported by a great number of higher and lower poles, the Mongolian yurt attracts attention as a possible source of inspiration for Turkish tent construction.

Although the word yurt is little known in English, it is a practical word to use, denoting a tent form that is old and established and has, until the present day, served a large part of the Mongolian community as well as some other ethnic groups in Asia.[7] Above all, there is also an important "yurt philosophy." In fact, it is one of the most perfect dwelling structures invented, embodied in a round and domed form, which constitutes a determined and separate microcosmos, a capsule of space and time. This shape appears to be most resistant to the shocks of winds and snowstorms in the steppe climate. Felt, the basic material of the yurt, covered the structure of wooden struts, the dome, and wooden trellises in the walls, which could be opened and closed like scissors; in effect, this brought a softness and cosiness that was lacking in stone, brick, or even wooden buildings. The interior of the yurt was totally clad with hangings, rugs, and cushions and was thus soft, comfortable, and colorful. A yurt could at any time be rolled up and transported to another place—a fact of prime importance in nomadic life. Sometimes yurts were carried across the steppes on large wagons drawn by oxen or horses.

The technical construction of both the old and modern yurts was thoroughly examined by Peter A. Andrews and it is thanks to him that this type of tent is better known than any other.[8] He writes: "The felt tent is characterised as possessing a rigid, domed wooden frame which, when erected, stands on its own and is not dependent on the covering for support. In this respect it differs radically from the black tent types used elsewhere by Arabs and others, the cloths and poles of which are interdependent".[9] He analyzes precisely the top of the roof (the roof wheel), the struts of the dome, the wall frame (trellis), and the door frame, the size of the tent and the felts, the pitching, the cane screens, the felt door and door carpets, the interior and exterior decoration, particularly the girths, the yurt's adaptability for weather conditions, and the transport of such tents.

For the purpose of this study even more important is work concerning the tents of Timur (called Tamerlaine) based on the report

156

written by the Castilian ambassador Ruy González de Clavijo. It appears that for Timur, tents were more than just tents. They were a means of advertising the splendor, power, and wealth of his empire, and this same intention was followed by the Ottomans almost until the end of their rule. Tents became a symbolic form. Later on Turkish architecture of brick and stone imitated some patterns of tents, as is evident in the composition of Ottoman sarays, which, with their numerous kiosks and pavilions, were in fact cities of tents.

The composition of the yurt expressed the Mongolian and early-Turkish concept of the world, being of an axial-and-crossed (and at the same time) rounded construction. Heaven was symbolized by the dome, while the cardinal points of the world made a cross. The yurt was oriented according to these directions and suitably divided inside, giving to each inhabitant his appropriate place. Buddhism, which reached the Mongols and the pre-turkish Uygurs, also articulated the "directional" conception of the universe as visualized in the mandala-labyrinth and in the *stupa*—a symbolic tomb covered with a dome, not much different in form from the yurt.

Early yurts were decorated inside with felt appliqué work, whose numerous examples survived in the East-Asian tombs called *kurghans*, especially those of Pasirik, which were investigated by S. I. Rudenko.[10] This was probably the source for the later tent appliqué decoration so lavishly applied in the Ottoman Empire. Various kinds of yurt were used for various purposes, even funeral yurts, adorned on the top with a three-dimensional felt swan, symbol of death (shown at the exhibition "The Gold of Scythes" in Vienna in 1989).

The regular yurt, unchanged for centuries, was white and undecorated, having only in its ideal form artistic features. As we know from descriptions, including those of Marco Polo, a yurt of a great ruler, however, a khan, was high, made of red felt, and sumptuously decorated with gold, like a fabulous domed palace.

Recollections of such yurts were surely in the Turkish minds of those who built the early sarays, after Islamization, and the idea of nomadic life in tents never left the Ottomans. Taking inspiration from their own pre-Islamic tradition and influenced by Persian and Byzantine tent creations, they developed their own art of tents, which proved to be most impressive and persistent. It still arouses the awe and admiration of today's spectator when outstanding examples are viewed in museums.

157

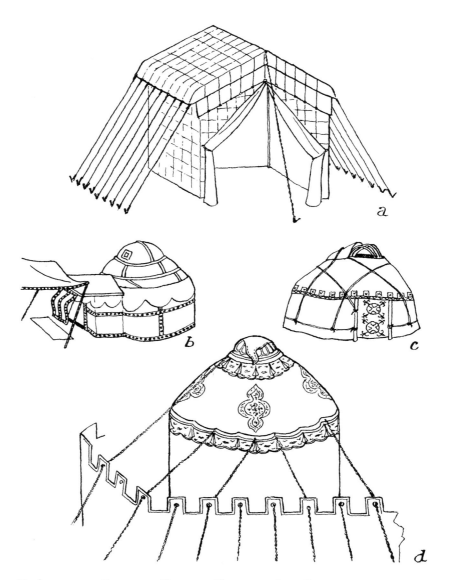

Fig. 23. Various types of tents a. Roman military tent for officers b. Chinese yurt of the twelfth century c. Kirghiz yurt of today d. Sultan Süleyman the Magnificent's tent, Otāg-i Hūmāyūn, as shown in the Hünernāme of Seyyid Lokman, vol. 2, Topkapı Saray Museum, H.1524.

158

The largest collection of Ottoman tents is housed in the Topkapı Saray Museum. Unfortunately it remains stored and poorly known, with almost no material about it published. It is said to number about seventy items, but it is not clear how many are entire objects and how many extra separate pieces. A magnificent eighteenth-century Ottoman tent of satin, embroidered in gold, silver, and polychromed silk has been reproduced in the *Encyclopedia of World Art*.[11] Of course, future research must be based on full and accurate inspection of this collection. A problem lies in finding suitable premises for examining, conserving, and displaying such huge objects, which were intended for the open air.

The second largest tent collection is at the Askeri Museum (Military Museum) in Istanbul. In 1983 a major exhibition devoted to the Anatolian civilizations was held in Istanbul.[12] The program included a special tent exhibition organized by the Askeri Museum, which was accompanied by a small catalogue.[13] Several dozen tents and parts of tents were exhibited for the first time in modern Turkey. Technically, they were mainly of cotton canvas, more rarely of woollen cloth, usually always with two layers of fabric, the outer one waterproof, the inner one with decoration. There were some very simple military tents, but most had an inner appliqué decoration of small pieces of colorful cotton canvas, and some even had windows made of cord. There were also fragments of enormous, three-poled tents of pashas, and a red tent with gold embroidery from 1809 belonging to Sultan Mahmud II. There were examples of the open tent, a sort of field canopy, called the *sayeban*, and also of the tent fences, or *zokak*, which encircled the sultans' and pashas' tents.

The exhibition in the Askeri Museum provided an opportunity for some important archival research that could throw new light on the Turkish art of tents.[14]

Not surprisingly, in Ottoman Turkey there was a specialized group of people busy in the "field of tents." These were not only the tentmakers but also those who transported and pitched the tents, furnished them with all the necessary implements and movables, and guarded, rolled up, and repaired them. The oldest records on this art go back to 1478, when Sultan Mehmed II established a guild of thirty-seven men, called *Mehterhan-i Hayme Cemaati*, and gave them

places for workshops at the Ağa Kapısı and the Golden Horn. Their leader was given the title *Hayme Mehter Başi*.[15] There was also a special group of tentmakers, *Çadır Mehter*, financed by the state, whose duty it was to prepare all the necessary materials and construct the tents. With time, this profession grew and included a great number of highly specialized people. They were responsible for preparing the tent called *Otāg-ı Hümāyūn* (the Royal Tent) for the sultan and for the grand vizier and high dignitaries of the state. The office of Çadır Mehteri was also responsible for all necessary furniture, prepared and housed in depositories. Every sumptuous tent was the result of astounding needlework, and it was always a problem to find trained stitchers. In time of war, when there was a need for thousands and thousands of tents, the office was authorized to requisition them from other cities. When a grand vizier or vizier died, his tents were brought to and preserved in the *Mehterhane*, a special depository. In peacetime the tent office was still kept busy. It was the custom of the sultan to spend the summer outside the capital in tents, hunting or at leisure. Sometimes, on the occasion of festivities, many tents were pitched within the courtyards of the Topkapı Palace or outside it at open air places of amusement. At that time the men from Çadır Mehteri were responsible for keeping good order.

Often the dismissal of a dignitary from his post on the order of the sultan was signaled by cutting the ropes of his tent while he was inside it.

After the massacre of the Janissary Corps (the emperor's bodyguards) in 1826 the guild of Çadır Mehteri expanded greatly and was reestablished according to new principles: a minister, with the title *Mehterhane-i Amire Naziri*, presided over it. It was indeed a very difficult task to prepare and keep the imperial tents in order. The office continued to operate until the end of the empire.

The oldest examples in the Askeri Museum exhibition are dated from the seventeenth century, but they are not very numerous. From that period and from the first years of the eighteenth century, important Ottoman tents, which were trophies of war but also presentation pieces and diplomatic gifts, have survived in some European countries. The principal trophies of the Turkish wars are housed in Cracow, Poland.

Here once again we must recall the letter of King Sobieski, written

160

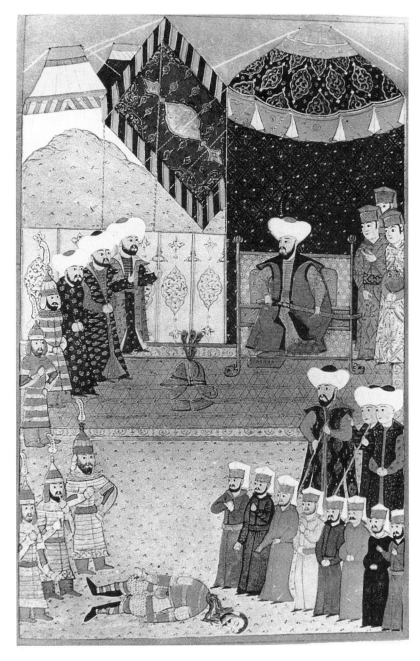

Ill. 66. Sultan Murad II in his Imperial tent, a miniature from Hünernāme, vol. 1. Topkapı
Saray Museum, Istanbul, H.1523.

161

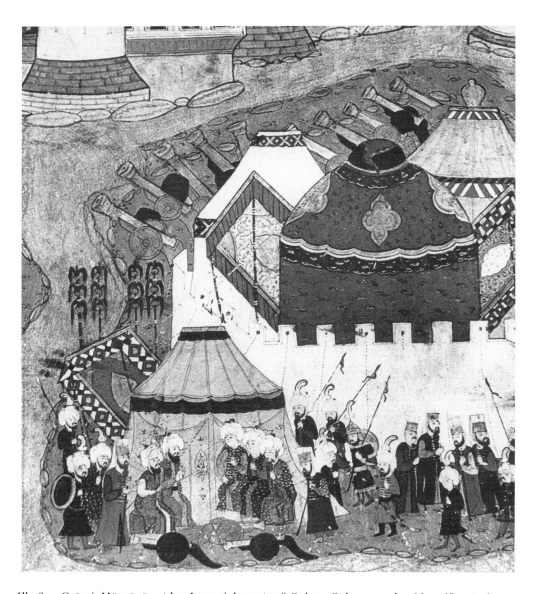

Ill. 67. Otāg-i Hümāyūn (the Imperial tent) of Sultan Süleyman the Magnificent, in a miniature of Hünernāme, vol. 2. By permission of Topkapı Saray Museum, Istanbul, H.1524.

162

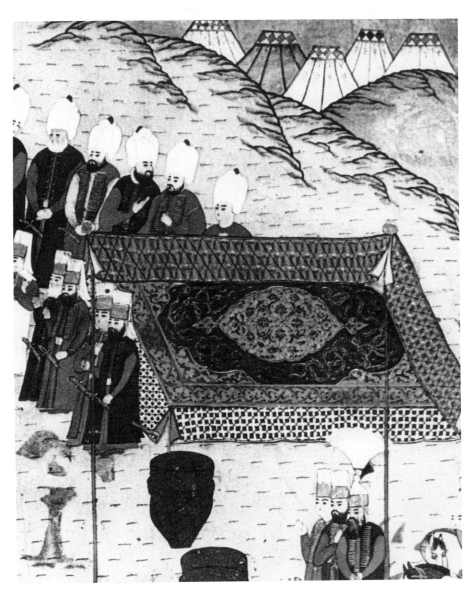

Ill. 68. A canopy from a miniature showing the enthronement of Sultan Selim II. By
permission of Topkapı Saray Museum, Istanbul, H. 1609.

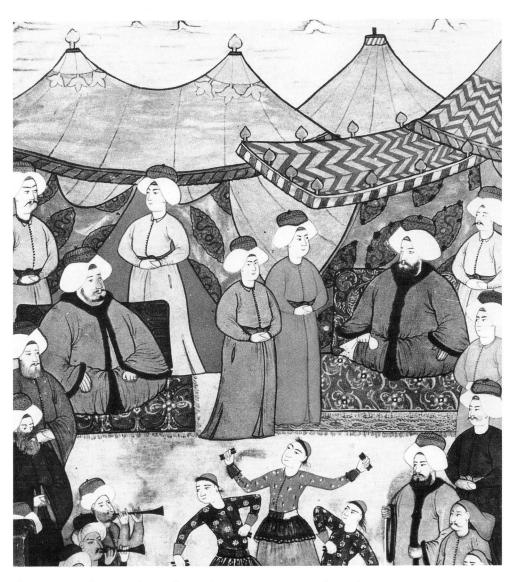

Ill. 69. Tents in a miniature from the Surname-i Vehti for Sultan Ahmed III (1703–30). By permission of Topkapı Saray Museum, Istanbul.

164

on the night of September 13, 1683, in the tents of the grand vizier Kara Mustafa, to his beloved wife Marysieńka:

God and our Lord blessed forever gave to our nation victory and fame not heard of in past centuries. All cannons, the entire camp, and inestimable riches have fallen into our hands. The enemy, covering the ditches, the fields, and the camp with the dead, retreats in confusion. . . . The vizier abandoned all in such haste that he barely took one horse and one robe. I have become his successor, as I have taken on his splendors. It happened that being already in the camp and chasing the vizier, I was informed by one of his courtiers where his tents were, which are as large as Warsaw or Lvov within the walls. I have all his signs which are carried above him; Muhammad's banner, given to him by his emperor, I have sent today to Rome, to the Holy Father, with Talenti, by post. I have captured tents and all wagons, and *mille d'autres galanteries fort jolies et fort riches, mais fort riches.* . . . I count one hundred thousand tents because they had several camps. People are dismantling them already two nights and a day, whoever wishes, also from the city but I doubt if they can do it in the whole week. . . . And what delicacies had [the vizier] in his tents, it is hard to describe. He had a bath, a garden, and fountains, rabbits and cats, even a parrot, but this was flying and we could not catch it.[16]

There is one place in the world where this unique, fairy-tale situation may be experienced, to some extent—the exhibition of an enfilade of huge tents in the rooms of the Royal Castle of Wawel in Cracow. This is the only place where the visitor can enter the tents and enjoy their breathtaking beauty. The exhibit is set in a harmonious setting of flowers, decorative vases and fountains, and arcades. Here and there on tent walls made of tiny pieces of stitched fabric on a plain ground are short inscriptions. Passing down the enfilade, one moves through various spaces enclosed by walls of various colors and designs, the whole imbued with an atmosphere to which lighting, invariably subdued and discreet, adds an extra dimension of mystery. Surely, the true intention of the maker was to bring paradise to earth.

The Wawel Collection houses five complete or almost complete pasha's tents of high quality as well as several separate walls, roofs, or canopies. All are double-layered, the outsides being of smooth greenish cotton canvas, the awnings occasionally trimmed with a frilled and patterned border.

Three vast tents of the Wawel Collection are worth a longer mo-

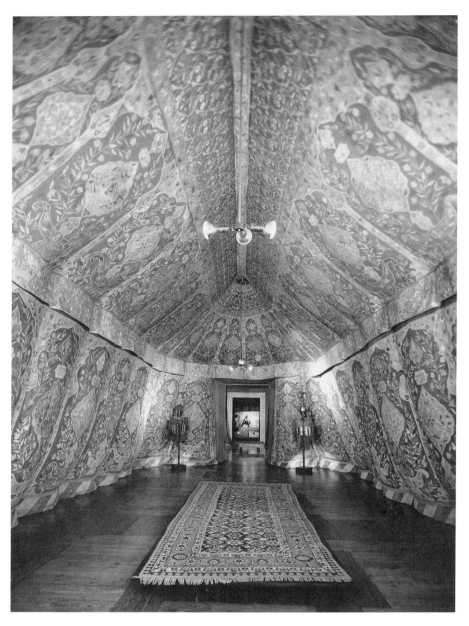

Ill. 70. Ottoman, two-poled, blue tent, captured at Vienna in 1683. By permission of Wawel State Collections of Art, Cracow.

166

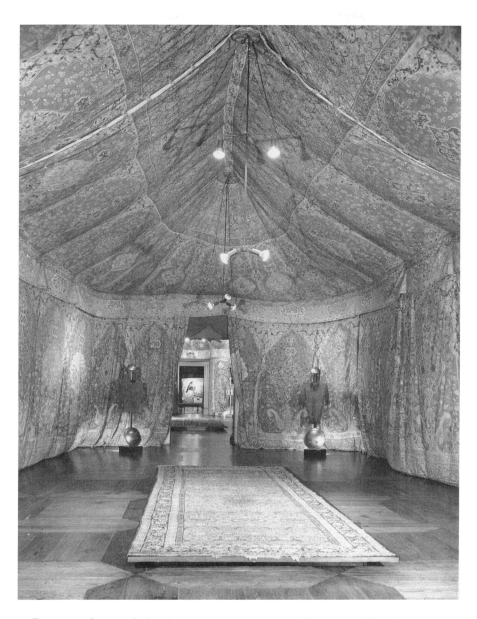

Ill. 71. Ottoman, three-poled, crimson tent, captured at Vienna in 1683. By permission of Wawel State Collections of Art, Cracow.

Ill. 72. Fragment of Ottoman red tent, seventeenth century. By permission of Wawel State Collections of Art, Cracow.

ment of inspection. The largest one (inv. no. 1376), with a wall height of 12 feet and length of about 78 feet, shaped in an oval, and three-poled, is of crimson canvas, with satin, canvas, and gilded leather appliqué and czintamani and the *t'chi* motifs of Chinese clouds in the lower border. At the beginning of the nineteenth century it was the property of Prince Joseph Poniatowski, who presented it to Frederick Augustus, Duke of Warsaw, a Saxon. In 1938 it was acquired from the Wettin Collections in Dresden and donated to the Wawel Castle by Szymon Szwarc, an antiquarian in Vienna.

The next Wawel tent (inv. no. 896) with a wall height of 10.5 feet and length of about 44 feet, oval-shaped, and two-poled, is of blue canvas and has satin, canvas, and gilded leather appliqué, as well as the repeating inscription "Be happy and blessed." It was bought from the Wettin Collections in the Castle Moritzburg in Saxony also by Szymon Szwarc and presented by him in 1933 to the Wawel.

The third one (inv. no. 283) is polygonal, with fifteen sides, the wall height being 6 feet and circumference 59 feet. It is made of red canvas, with canvas appliqué. It was a gift from the Potocki family in 1920.

Among various other items there is an extremely rare flat roof of a canopy constructed in front of a tent as well as a fragment of a most beautiful and delicate tent, that in the Wawel catalogues is described as Persian, but in fact is not alien to the Ottoman group.[17]

All these pieces are traditionally connected with the Vienna booty. Whether the ground colors—crimson, blue, and red—had any significance connected with the hierarchy of tents is at present unknown.

Some other interesting Ottoman tents are also housed in Cracow. In the Czartoryski Collection of the National Museum, in a permanent exhibition of trophies from the Battle of Vienna (inherited by the Czartoryskis from the treasury of the Sieniawski family—Mikołaj Hieronim Sieniawski, as field hetman of the crown, co-commanded the Polish troops) there is a magnificent, open tent of woollen cloth, which is traditionally connected with the grand vizier Kara Mustafa. In fact, the canopy and wings indeed date to the Siege in 1683, but the walls have the stylistic character of the eighteenth century.[18] When arranging the museum in about 1876 in Cracow, the Czartoryskis probably had several fragments of Turkish tents and reconstructed one in the style of a sayeban (open tent), making the roof

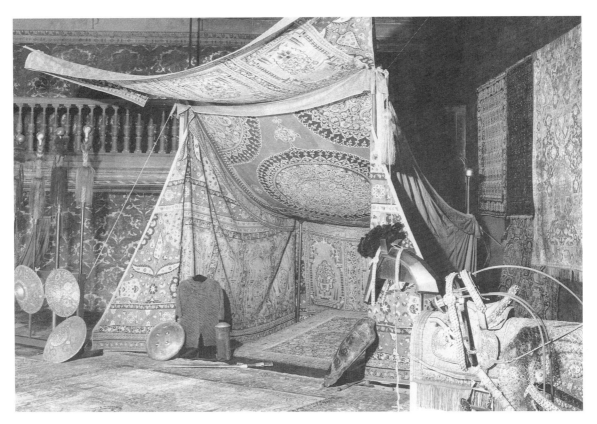

Ill. 73. Ottoman tent, sayeban type, composed of tent fragments of the seventeenth and eighteenth centuries. By permission of National Museum, Cracow, the Czartoryski Collection.

sloping so that the inner decoration was visible to the viewer. This was a typical compromise in exhibiting tents; museums always tried to show as much of the inner decoration as possible.

The same was true in the case of the beautiful small tent, coming not from Vienna but from the Battle of Żurawno (1676), which was in the possession of the Suffczyński family and displayed in 1880 at the time of the visit of Emperor Francis Joseph I to Galicia; now it is housed in the National Museum in Cracow. Some important Ottoman tents, booty from the seventeenth century, are still housed in Lvov, Ukraine SSR.

One of the most interesting, complete Ottoman tents can be found in the Royal Armory in Madrid. According to tradition, it was a gift

170

from Sultan Süleyman to King Francis I of France, which was captured by Emperor Charles V at the Battle of Pavia (1525) and then taken to the Spanish residence. It is one of the oldest tents extant and is made in the same appliqué fashion as the other tents from the second half of the seventeenth century.

A similar tent is now preserved in the Army Museum in Stockholm. It was in the possession of the Polish king and elector of Saxony, Augustus the Strong, but was taken as a trophy by Charles XII of Sweden during the Northern War, at the Battle of Klishov in 1704.

A small appliqué tent, displayed inside out, is shown in the permanent exhibition at the Hungarian National Museum in Budapest, and a very precious one of brocaded fabric from the Art History Museum in Vienna (Wagenburg) was exhibited at the Türks in Vienna exhibition in 1983.[19]

The polygonal tent from the Bavarian Army Museum in Ingolstadt, now on permanent exhibition, is made of red felt with appliqué work of silk and linen in patterns of flowers and leaves. It was captured at the Battle of Mohacs in 1687 by Elector Maximillian II Emanuel of Bavaria as booty from the grand vizier Süleyman. Five more tents are kept in Munich, but of these only a round tent, very damaged, has survived in the Museum of Ethnology in Munich.[20]

Several separate pieces of Ottoman tents are dispersed in various collections in and outside Europe.[21] It is clear that all future research will have to begin with the making of a full inventory, perhaps by computer, of all preserved tents and tent fragments. This will permit analysis and interpretation to go forward in this fascinating field of Ottoman creativity and culture.

HIERARCHY OF OTTOMAN TENTS

As in the system of flags and dress, the qualities and types of tents depended on the function and rank of those whom they served. The hierarchical system was displayed in visual fashion in the Ottoman Empire, and the arts were exploited mainly for its realization.

At the top of the hierarchy was the sultan's royal tent (or tents), the Otāg-i Hümāyūn, which was elaborate, ornate, and luxurious. The tent exhibited in 1983 in the Askeri Museum, associated with Sultan Mahmud II, belongs to this class, although it is a rather late

171

example. One can assume that some sultans' tents and fragments are preserved in the Topkapı Saray Museum, but information on them remains unpublished. Some sources and iconographical clues indicate that the main sultan's tent was round, domed, and made of red fabric outside; clearly it was modeled on the yurt of the great khan. The best image of this tent is a miniature painted by Lokman that appears in the second volume of the *Hünernāme* (1587–1588); it represents Sultan Süleyman the Magnificent at the first siege of Vienna in 1529.[22] Such an Otāg was shown by Stanisław Chlebowski, the court artist of Sultan Abdül Aziz, in his *Battle of Vienna,* which he painted for the bicentennial of this event.[23]

It is a great pity that, as he writes in his famous book, Count Marsigli never saw the sultan's tents.[24] There is no doubt, however, that sultans' tents were almost always built in a complex and encircled by a fence, or zokak. Apart from the yurtlike tent, described above, there was also an open tent, sayeban or sayban, for official activities, talks, and receptions of envoys, for leading a siege of battle in the field, or even for the interrogation of captives. There are fairly numerous images of such sayebans in miniatures. They are open, so that their inner ornate parts are visible; sometimes their domes are decorated as well, and they regularly have a flat canopy in front, supported by four poles, making a sort of antechamber. In miniatures they are shown from a pecular perspective—from the ground, to present their inner decorated surfaces. This was also a specific, conventional Turkish art perspective.

A large tent on three or more poles had a rectangular plan with a sloping roof and was used for ceremonial receptions as well as for banqueting. The floor was covered with splendid rugs, carpets, and cushions; low tables and a sofa, or low soft bench, might be set in one part of the tent. Usually two sleeping tents, one for warm nights and the other for cold, were at the sultan's disposal, but we do not know much about their appurtenances. The bathing and latrine tents were nearby. Sultans' tents were of the highest possible quality, always made of double fabric, waterproof outside—usually of green canvas saturated with copper oxides—and decorated inside. This interior could be of brocaded silk, ornamented velvet, embroidered cloth, or traditional appliqué work, which used small pieces of colored linen, satin, or gilded leather. The usual repertory of Ottoman flowers had roses, lilies, and carnations prevailing. The tent poles

172

were painted red and green in spirals; later on they were sometimes carved, gilded, and surmounted with balls of copper gilt, as the tughs usually were. The ropes were made of strands of various colors. The roof sometimes had zigzag motifs, while all around it was a kind of flounce with a checkered motif in red and green. The fence was also decorated and high enough to conceal everything from the eyes of the uninvited. In front of an Otāg-i Hümāyūn seven sultan's tughs were planted, while at the entrance in the fence, which was open but overlapped, a special watchtower was erected.

The second rank of tent was that of the grand vizier, although, apart from the great round tent of the sultan, his were almost of the same class. Here we have adequate information from Marsigli, who described in detail the camp of the grand vizier Kara Mustafa at Vienna in 1683—a description that can be compared with the report by King Sobieski, mentioned above, as well as with actual specimens from Vienna, or at least those bound to it by tradition. We also have at our disposal some valuable drawings made by the Polish court painter Martin Altomonte, who saw the pitched Vienna tents at the royal residence of Jaworów, where the king gave special receptions for magnates and diplomats.[25] The grand vizier's camp consisted of various tents for different functions as well as for various detachments of the enormous Ottoman army. According to King Sobieski's letter, it was like Warsaw or Lvov within the old city walls, although the number of 100,000 tents, mentioned by him, is much exaggerated. Most valuable to research are the plans of seventeenth century Turkish camps presented by Marsigli.[26]

After the grand viziers' came the tents of pashas of lower rank and those of various palace dignitaries. A great number of simple tents, usually round, domed, and fixed with one pole and several ropes, served for military units of sipahis, Janissaries, and others. Separate tents belonged to artisans and to merchants. Different again were the tents used for kitchens, for storing food and ammunition, for prayer, and finally for animals, such as horses, oxen, or camels. A tent for executions, on one pole and without walls—to give good visibility of the cruel scene to onlookers and thereby to promote discipline—was pitched in front of the high commander's tent.

In these camps of tents, the traditional life of the Turks, reaching back to nomadic times, was recreated and continued up to our own century.

Notes

1. A. U. Pope, "Tents," in *A Survey of Persian Art*, A. U. Pope, ed. (Oxford, 1939), 2:1413ff.
2. G. Mantendon, *Traité d'ethnologie culturells* (Paris, 1934), 303–8.
3. J. Müller, "Das arabische Zelt," *Benediktinische Monatschrift* (1919):68ff.; C. R. Raswan, *Au pays des tentes noires: Moeurs et coutumes de Bédouins* (Paris, 1936); R. Montagne, *La civilisation du désert: Nomades d'Orient et d'Afrique* (Paris, 1947).
4. T. Mańkowski, "Les tentes orientales et les tentes polonaises," *Rocznik Oriental-istyczny* 22, 1 (Warsaw, 1957):77–111; S. J. Gąsiorowski, "La tente orientale du Musée Czartoryski à Cracovie," *Folia Orientalia* 2 (Cracow, 1960); Z. Żygulski, Jr., "Turkish Trophies in Poland and the Imperial Ottoman Style"; M. Piwocka, *Oriental Tents*.
5. L. F. Marsigli, *Stato militare dell'impèrio Ottomanno*, 2:56–60.
6. P. Connolly, *The Roman Army* (London, 1982), 14.
7. G. Pugachenkova and S. Gitman, *The Art of Central Asia* (Leningrad, 1988), 289.
8. P. A. Andrews, "The White House of Khurasan: The Felt Tents of the Iranian Yomut and Gökleñ," *Iran* 11 (1973), and "The Tents of Timur: An Examination of Reports on the Quriltay at Samarqand, 1404," in *Arts of Eurasian Steppelands*, P. Denwood, ed. (London, 1977).
9. Andrews, "The White House," 95.
10. S. I. Rudenko, *Kultura nasyeleya gornogo Altaya skifskoye vremya* (Moscow, 1953).
11. *Encyclopedia of World Art* (London, 1965), vol. 10, pl. 453.
12. "The Anatolian Civilizations," Eighteenth European Art Exhibition of the Council of Europe (Istanbul, May–October 1983).
13. Cenap Çürük and Ersin Çiçekçiler, *Örnekleriyle Türk Çadırları*.
14. Nurhan Atasoy, unpublished paper on Ottoman tents presented at the Eighth International Congress of Turkish Art (Cairo, 1987).
15. Çürük and Çiçekçiler, *Örnekleriyle Türk Çadırları*, 5.
16. J. Sobieski, *Listy do Marysieńki* (Letters to the Queen Marysienka) (Warsaw, 1962), 520–21.
17. Jerzy Szablowski, ed., *Collections of the Royal Castle of Wawel* (Warsaw, 1975), nos. 235–237.
18. Gąsiorowski, "La tente orientale du Musée Czartoryski à Cracovie."
19. R. Waissenberger, ed., *Die Türken vor Wien: Europa und die Entscheidung an der Donau 1683*, cat. no. 11/21, p. 104.
20. P. Jaeckel, "Von türkischem Heerwesen und Heerlager," in *Osmanische-Türkisches Kunsthandwerk aus süddeutschen Sammlungen: Katalog zur Ausstellung im Bayerischen Armeemuseum Ingolstadt* (Munich, 1979), 24–25.
21. There is, for example, an interesting tent canopy in the collection of the General Sikorski Institute and Museum in London.
22. G. Fehér, *Türkische Miniaturen aus den Chroniken der ungarischen Feldzüge*, pl. 16. See Topkapi Saray Library, H.1524.
23. Chlebowski, informed about the Ottoman customs, tried to be correct in his

paintings. However, the Otāg-i Hümāyūn was not at Vienna in 1683. The painting is now in the National Museum in Cracow.

24. Marsigli, *Stato militare*, 1:57.

25. Max Emanuel Kurfürst, *Bayern und Europa um 1700*, 200 (a drawing from "Melker Skizzenbuch").

26. As, for instance, that of the camp of the Grand Vizier Süleyman at Arsan. See Marsigli, *Stato militare*, 2:76.

Conclusion

It is the norm that a great state, an empire, should utilize art for its specific purposes. So it always was everywhere: in ancient China, Egypt, and Mesopotamia, in Rome and Byzantium, in the Austria of the Hapsburgs and the France of Louis XIV and of Napoleon. From the fifteenth century in the Ottoman Empire art was, perhaps, even more consistently and expansively used by the state. Art was intended to create an atmosphere of pomp and ceremony, a manifestation of power. It was to amaze and subdue the psyche of both friend and foe, as well as the state's own subjects. From the taking of Constantinople on, the design and construction of flags, tughs, costume, arms, armor, and tents were no longer left to custom and tradition, they became a matter of law. These objects were produced by craftsmen instructed by official authorities, the Sunna orthodox doctrine of Islam being decisive in all questions of ideology.

The organization of the manufacture of various objects needed for the state was based on the Persian and Byzantine patterns. Most of the important workshops were located at the sultan's court in Istanbul, where, along with the native Turks, they engaged Persians, Greeks, Armenians, Syrians, Hungarians, and sometimes even Italians. Production was kept under strict control, the import of raw

materials and the export of goods were regulated, and all defects were eliminated. The artisans commanded the best techniques, which were the mutual and traditional property of many Oriental nations, and textile art, embroidery, leather decoration, metalwork, and goldsmithery achieved the highest possible level.

In the course of the sixteenth and seventeenth centuries Ottoman Turkey, with the proud ambition of leadership among the great family of Muslim nations, elaborated an original and uniform style visible in various fields of culture, particularly in military objects. This style is characterized by the following features.

Perfection of shape was determined by functional and aesthetic factors, although there was also a predilection for expressive, even gigantic forms. If the Persian ideal lay in subtlety, delicacy, and refined beauty, the Turks sought the expression of power, strength, and riches. This tendency was realized in extremely large flags, in huge tents, in broad scimitar blades with thick hilts, in powerful bows and maces, all of which seemed destined for use by superhuman beings.

Like other Oriental peoples, and in contrast to the colorless tendency of most European military objects, the Ottomans loved color. In the Turkish hierarchy of colors purple held the prime position as the symbol of empire, alongside green, the symbol of paradise, and blue, the symbol of heaven. To purple or crimson, gold was added, producing a sumptuous effect. Precious or semiprecious stones—especially blue turquoises and green jade but also emeralds, rubies, almandines, and carnelians, the bearers of luck and luster—were applied lavishly and were often accompanied by pearls. The favorite repertory of patterns was the not very large, floral motifs of the lily, rose, carnation, granadilla, and tulip, which appeared everywhere beside simple geometric designs, suns, stars, and crescents. All of these bore some clear or disguised symbolic meaning. Among these significant and signifying designs the place of honor was taken by inscriptions, which came mainly from the Koran.

Art well served the purposes of the Ottoman Empire. It declined as the state declined, but the numerous objects that survived in Turkey and beyond, thanks to their high artistic value, were valued by museums. In this way they immortalize their creators, the great Ottoman sultans as well as the innumerable anonymous craftsmen who carried out the sultans' will.

Select Bibliography

Abrahamowicz, Zygmunt, ed. and trans. *Kara Mustafa pod Wiedniem. Źródła muzuł-maóskie do dziejów wyprawy wiedeńskiej 1683 roku.* Cracow, 1973.

Akurgal, Ekrem, ed. *The Art and Architecture of Turkey.* Oxford, 1980.

Anafarta, Nigâr. *Die Portraits der Sultane.* İstanbul, 1967. *Anatolian Civilization.* Part 3: "Seljuk/Ottoman" (catalogue of an exhibition). İstanbul, 1983.

And, Metin. *Turkish Minature Painting: The Ottoman Period.* Ankara, 1978.

Arseven, Celal Esad. *L'Art turc.* Ankara, 1939.

———. *Les arts décoratifs turcs.* İstanbul, 1952.

L'Art de l'Orient islamique: Collection de la Fondation Calouste Gulbenkian (catalogue of an exhibition at the National Museum of Ancient Art). Lisbon, 1963.

"Art Treasures of Turkey" (an exhibition circulated by the Smithsonian Institution). Washington, D.C., 1966.

Aslanapa, Oktay. *Turkish Art and Architecture.* London and New York, 1971.

Atasoy, Nurhan, and Filiz Çağman. *Turkish Miniature Painting.* İstanbul, 1974.

Atıl, Esin. *Turkish Art of the Ottoman Period.* Washington, D.C., 1973.

———. *Süleymannâme: The Illustrated History of Süleyman the Magnificent.* Washington, D.C., and New York, 1986.

———, ed. *Turkish Art.* Washington, D.C., and New York, 1980.

Babinger, Franz. *Die Geschichtsschreiber der Osmanen und ihre Werke.* Leipzig, 1927.

———. *Mehmed der Eroberer und sein Zeit: Weltenstürmer einer Zeitenwende.* Munich, 1953.

179

Chruszczyńska, J., ed. *Tkanina turecka XVI–XIX w. ze zbiorów polskich* (catalogue of an exhibition at the National Museum in Warsaw). Warsaw, 1983.

Collections of the Royal Castle of Wawel. Introduced by Jerzy Szablowski. Warsaw, 1975.

Çürük, Cenap, and Ersin Çiçekçiler. *Örnekleriyle Türk Çadırları* (Military Museum Yayınları). İstanbul, 1983.

Denny, Walter B. "Ottoman Turkish Textiles." *Textile Museum Journal* 3, 2 (1972).

———. "A Group of Silk Islamic Banners." *Textile Museum Journal.* 4, 1 (1974).

Dilger, Konrad. *Untersuchungen zur Geschichte des Osmanischen Hofzeremoniells im 15. and 16. Jahrhundert.* Munich, 1967.

Egger, Rudolf. *Das Labarum, die Kaiserstandarte der Spätantike.* Vienna, 1960.

Fehér, Géza. *Türkische Miniaturen aus den Chroniken der ungarischen Feldzüge.* Budapest, 1976.

Fohler, Oskar, and Edith Fohler, eds. *Der Rossweif in der osmanischen Armee: Ein Anhang zur türkische Feldmusik.* Vienna, 1983.

Forster, Edward S., trans. *The Turkish Letters of Ogier Ghiselin de Busbecq.* Oxford, 1968.

Gąsiorowski, Stanisław Jan. "Folia Orientalia." In *Le tente orientale du Musée Czartoryski à Crocovie,* vol. 2. Cracow, 1960.

Von Hammer-Purgstall, Joseph. *Geschichte des Osmanischen Reiches.* 10 vols. Pest, 1827–1835.

Heiss, Gernot, and Grete Klingenstein, eds. *Das Osmanische Reich und Europa 1683 bis 1789: Konflict, Entspannung und Austausch.* Vienna, 1983.

İnalcık, Halil. *The Ottoman Empire: The Classical Age, 1300–1600.* London, 1973.

International Association of Museums of Arms and Military History and Dutch Committee for the Conservation of Textiles. *Conservation of Flags* (bulletin). Rijksmuseum, Amsterdam, 1980.

Itzkowitz, Norman. *Ottoman Empire and Islamic Tradition.* New York, 1972.

Kultur des Islam (catalogue of an exhibition in the Austrian National Library). Vienna, 1980.

Kurfürst, Max Emanuel. *Bayern und Europa um 1700* (catalogue of an exhibition). H. Glasser, ed. 2 vols. Munich, 1976.

Kurtoğlu, Fevzi. *Türk Bayrağı ve Ay Yıldız.* Ankara, 1938.

Lewis, Bernard. *Istanbul and the Civilization of the Ottoman Empire.* Norman, Okla., 1963.

———. *The Muslim Discovery of Europe.* New York and London, 1982.

———, ed. *The World of Islam.* London, 1976.

Mackie, Louise W. *The Splendor of Turkish Weaving.* Washington, D.C., 1973.

Mantran, Robert. *Istanbul dans le second moitié du XVIIe siècle: Essai d'histoire institutionelle, économique, et sociale.* Paris, 1962.

Mańkowski, Tadeusz. *Sztuka islamu w Polsce w XVII i XVIII wieku.* Cracow, 1935.

———. *Orient w polskiej kulturze artystycznej.* Wrocław and Cracow, 1959.

Marsigli, Luigi Ferdinando. *Stato militare dell'impèrio ottomano———L'Etat militaire de l'Empire Ottoman.* The Hague, 1732. Fascimile ed. (Graz, 1972).

Die Meisterwerke aus dem Museum für Islamische Kunst Berlin, Stuttgart, 1980.

Mouradgea d'Ohsson, Ignace. *Tableau général de l'Empire Othoman.* 7 vols. Paris, 1788–1824.

———. *Allgemeine Schiulderung des Othomanischen Reiches: Aus dem Französischen . . . mit einigen Abkürzung ünbersetzt und mit Anmerkungen, Zusäthen, einem Glossarium und Register vorsehen von Christian Danial Beck.* Leipzig, 1793.

Mrozowska, Alicja, and Tadeusz Majda. *Rysunki kostiumów tureckich z kolekcji króla Stanisława Augusta w Gabinecie Rycin Biblioteki Uniwersyteckiej w Warszawie.* 2 vols. Warsaw, 1973 and 1978.

Nowgorodova, Eleonora. *Alte Kunst der Mongolei.* Leipzig, 1980.

Osmanlı Kıyafetleri. Fenerci Mehmed *Albümü* (Ottoman Costume Book). İstanbul, 1986.

Österreich und die Osmanen: Gemeinsame Ausstellung der Österreichischen Nationalbibliotek und des Österreichischen Staatsarchivs (catalogue). Vienna, 1983.

Öz, Tahsin. *Turkish Textiles and Velvets, Fourteenth through Sixteenth Centuries.* Ankara, 1950.

———. *Türk Kumaş ve Kadifeleri.* 2 vols. Istanbul, 1951.

Paret, R. *Symbolik des Islam.* Stuttgart, 1958.

Penzer, N. M. *The Harem: An Account of the Institution as It Existed in the Palace of the Turkish Sultans, with a History of the Grand Seraglio from Its Foundation to the Present Time.* London, 1936 (reprint 1967).

Petrasch, Ernst, ed. *Die Türkenbeute: Eine Auswahl aus der türkischen Trophäen sammlung des Markgrafen Ludwig Wilhelm von Baden.* Karlsruhe, 1977 (reprint).

Petrus, J. T., M. Piątkiewicz-Dereniowa, and M. Piwocka. *Wschód w zbiorach wawelskich. Przewodnik.* Cracow, 1976.

Petsopoulos, Yanni, ed. *Tulips, Arabesques, and Turbans: Decorative Arts from the Ottoman Empire.* London, 1982.

Piwocka, Magdalena. *Oriental Tents.* Warsaw, 1983.

Raby, J., and J. Allan, "Metallarbeiten." In *Kunst und Kunsthandwerk unter den Osmanen,* Yanni Petsopoulos, ed. Munich, 1982.

Robinson, Russell H. *Oriental Armour.* London, 1967.

Rogers, J. M. *Islamic Art and Design, 1500–1700* (catalogue of an exhibition at the British Museum). London, 1983.

Scarce, Jennifer M. *Life in Istanbul.* Oxford, 1977.

———. "Turkish Fashion in Transition." *Costume* 14 (1980).

Schimmel, Annemarie. *Calligraphy and the Islamic Culture.* New York and London, 1984.

Smith, Whitney. *Prolegomena to the Study of Political Symbolism.* Boston, 1968.

———. *Flags through the Ages and across the World.* New York, 1975.

Stchoukine, Ivan. *La peinture turque d'après les manuscripts illustrés.* Part 1: *De Sulayman Ier à Osman II, 1520–1622.* Paris, 1966.

Sturminger, Walter. *Bibliographie und Ikonographie der Türkenbelagerungen Wiens 1529 und 1683.* Graz and Cologne, 1955.

Suleiman, Hamid. *Miniatures of Babur-Namah.* Tashkent, 1978.

Tavernier, J. B. *Nouvelle relation du l'interieur du serrail du grand seigneurs.* Cologne, 1675; *A New Relation of the Inner Part of the Grand Seignor's Seraglio.* London, 1677.

Traditional Turkish Arts (prepared for "The Age of Sultan Suleiman the Magnificant" exhibition). İstanbul, 1986.

Der Türkenlouis (catalogue of an exhibition in the Badisches Landesmuseum in Karlsruhe). Karlsruhe, 1955.

Türkische Kunst und Kultur aus osmanischer Zeit (exhibition catalogue). 2 vols. Recklinghausen, 1985.

Uzunçarşılı, İsmail Hakkı. *Osmanlı Tarihi.* 4 vols. Ankara, 1982–1983 (reprint).

Waissenberger, R., ed. *Die Türken vor Wien: Europa und die Entscheidung an der Donau, 1683.* Salzburg, 1982.

————, and G. Duriegl, eds. *Die Türken vor Wien: Europa und die Entscheidung an der Donau. 82. Sonderausstellung des Historischen Museums der Stadt Wien.* Vienna, 1983.

Wittek, Paul. *The Rise of the Ottoman Empire.* London, 1967.

Wurm, Heidrun. *Der osmanische Historiker Hüseyn b. Ga 'fer, gennant Hezārfenn, und die Istanbuler Gesellschaft in der zweiten Häffte des 17. Jahrhundert.* Freiburg, 1971.

Zajączkowski, Ananiasz. "Les Costumes Turc du XVIIe siècle d'après un album de la collection polanais." in *Atti del secondo Congresso Internazionale di Arte Turca.* Venice, 1963; Naples, 1965.

Żygulski, Zdzisław, Jr. "Studia do dziejów Wawelu." In *Chorągwie tureckie w Polsce ne tle ogólnej problematyki przedmiotu,* vol. 3. Cracow, 1968.

————. "Armi Antiche." In *Turkish Trophies in Poland and the Imperial Ottoman Sttyle.* Turin, 1972.

————-. "Islamic Weapons in Polish Collections and Their Provenance." In *Islamic Arms and Armour,* Robert Elgood, ed. London, 1979.

————. *Broń wschodnia: Turcja, Persja, Indie, Japonia.* Warsaw, 1983 (reprint 1985).

————. *Sztuka turecka.* Warsaw, 1988.

————. *Odsiecz Wiedeńska.* Cracow, 1988.

————. *Sztuka islamu w zbiorach polskich.* Warsaw, 1989.

Index of Names (Proper, Book Titles, and Museums)

Abbasids, 10, 33, 46
Abdül Aziz, 172
Abraham, 43
Abu Bakr, 34, 139
Adler, Cort, 71, 88
Ahmed I, 137
Ahmed III, 103
Ahmed, Fenerci, 111
ʿAin-i ʿAlī, 19
ʿAlāʾ ad-Dīn, 15, 24
Alfonso VIII, 10
ʿAlī, 34, 46, 49–53 passim, 91, 139
Almohads, 10
Almoravids, 10
Altomonte, Martin, 173
Andrews, Peter A., 156
Armeria Reale (Regal Armory, Turin), 35
Armémuseum (Army Museum, Stockholm), 96, 171
Army Museum (Paris), 71
Army Museum (Vienna), 70
Arnold, T., 41

Arsenal (Italy), 13
Arseven C. E., 70
Art History Museum (Vienna), 171
al-ʿĀṣ ibn Munabbih al-Hajjāj, 46
Aşikpaşazāde, 15
Askeri Museum (Army Museum, Istanbul), 13, 70, 89, 159 f, 171
Aslanapa, O., 70
Ayesha, 20
Augustus the Strong, 95, 171

Bābur Ẓahīr ad-Dīn Muḥammad, 88
Bāburnāme, 88 f
Badisches Landesmuseum (Baden Country Museum, Karlsruhe), 14
Bavarian Army Museum (Ingolstadt), 171
Bellini, Gentile, 111
Berker, Nuhayat, 127
Bonaparte, Napoleon, 71, 89
British Museum, 88
de Busbecq, Augier Ghiselin, 97 n2

Chardin, Jean 9
Charles V, 171
Charles XII, 171
Chelbowski, Stanislaw, 172
Ching-T'ai, 15
City Arsenal (Vienna), 88
Codex Vindobonensis, 27, 32, 83
Curatola, Giovanni, 71
Czartoryski Collection, 49, 91, 95, 169

Danish National Museum (Copenhagen), 71, 88
David, 59
Deniz Museum (Maritime Museum, Istanbul), 13, 25, 43
Denny, Walter, 14

Eannatum, 136

Fatima, 50, 53
Ferdinand, Archduke of Tirol, 91
Ferdinando, Luigi, Count of Mersigli, 19, 24, 27, 29, 32, 70, 83, 106, 153, 172 f
Fil Caravan (New York City), 14
Firdawsi, 9
al-Firūzābādī, 48
Flag Research Center, 1
Fogg Art Museum (Cambridge, Mass.), 14
Fohler, Oscar and Edith, 70
Francis I, 171
Francis Joseph I, 170
Frederick Augustus, 169

Gabriel, 34, 60
Genghis Khan, 75, 89
Giotto, 129
González de Clavijo, Ruy, 157

von Hammer-Purgstall, J., 19
al-Ḥarīrī, 10, 75
Harun ar-Rashid, 46
Hassan, 46, 50, 53

Hussain, 46, 50, 53
Hermitage (Leningrad), 14
Historical Museum (Dresden), 14
Historical Museum (Vienna), 46, 70, 88
Hünernāme, 25, 27, 88, 172
Hungarian National Museum (Budapest), 13, 70, 171

Ibn Zunbul, 19
Ibrahim, 121
Innocent XII, 24
International Federation of Vexillological Associations, 1
Ishtar, 39

Jalal ad-Dīn Rumi, 104
Jelalzade Mustafa, 32
Jesus Christ, 7, 59
John III Sobieski, 23, 35, 41, 95, 160, 173
Jove, 3
Judi ben Eliyaha Hadasi, 43

Kara Mustafa Paşa, 23, 91, 165, 169, 173
Kāvah, 9
Khayr-Bey, 19 f
Kossak, Julius, 95
Kurtoğlu, Fevzi, 24

Lāmi, 49
Las Huelgas, monastery of (Burgos, Spain), 10
Levy, H., 44
Livrustkammaren (Royal Castle, Stockholm), 97 n2
Lorck, Melchior, 97 n2
Louis XV, 42
Louvre (Paris), 39, 136
de Lucia, G., 42

Mahmud I, 111
Mahmud II, 22, 25, 125, 159, 172
Maḥmūd of Ghazna, 75

al-Maʾmūn, 10
Mánkowski, Tadeusz, 45
al-Manṣūr, 10
Maqāmāt, 10
Marco Polo, 157
Marius, Gaius, 3
Maximillian II Emanuel, 171
Mayer, L. A., 41
Mehmed I, 103
Mehmed II, 15, 102 f, 111, 125,
 127, 136–147 passim, 159
Mehmed III, 21
Mehmed IV, 23, 91, 106
Mehmed, Fenerci, 125
Mentendon, G., 153
Military Museum of Great Poland
 (Poznan), 97
Morosini, Francesco, 71
Moses, 59
Muhammad, 9, 17–22 passim, 34,
 41, 46, 55, 58 f, 91, 104, 137, 139,
 165
al-Muqtadir, 46
Murad III, 19, 21
Murad IV, 21, 32, 88
Museo Civico Correr (Correr Mu-
 nicipal Museum, Italy), 13, 71
Museum of Ethnology (Munich),
 171
Museum of Islam (Berlin), 55
Museum of Ulan Bator, 74, 88

Narmer, 71
National Library (Vienna), 27
National Museum (Cracow), 91, 96,
 169 f
Neşri, 15
Nur, Riza, 25, 41

Omar (the second caliph). *See*
 ʿUmar
Omayyads, 10, 113
Orhan, 36, 103
Osman (the third caliph). *See* ʿUth-
 mān

Osman I, 15, 24
Osman III, 103
Öz, Tahsin, 15, 26, 45, 121

Palace of Schlessheim (Bavaria), 14
Palace of the Doges (Venice), 13,
 17, 71, 88
Palaeologs, 7
Penzer, N. M., 20
Pergamon Museum (Berlin), 14
Poniatowski, Joseph, 169
Potocki family, 169
Pope, Arthur Upton, 9, 153

Qazvīnī, 55

Ridgeway, W., 41
Rodinson, M., 42
Royal Armory (Madrid), 170
Royal Armory (Turin), 13
Rudenko, S. I., 157
Rudolf II, 27
Rustam, 121

St. John in Lateran (Rome), 13
Sakisian, A., 42
San Stefano al Cavalierio (Pisa), 13,
 17
Santa Croce, church of (Florence),
 129
Santa Maria della Salute, church of
 (Venice), 71
Schimmel, Annemarie, 36
Selaniki, Mustafa, 19
Selim I, 18–20 passim, 24 f, 32,
 111, 125
Selim II, 136
Selim III, 25 f
Seyyid Lokman, 25, 88, 172
Shāhanshāhnāme, 27
Shāhnāme, 9, 91
Shah Tahmasp, 91
Shamash, 39
Sieniawski, Mikolaj Hieronim, 169
Sigismund Augustus, 27

Silahdar Mehmed Ağa, 19, 21, 23
Silahdar Tarihi. See Silahdar
 Mehmed Ağa
Sin, 39
Smith, Whitney, 7 f, 71, 75
Stephen Bathory, 129, 136
Soloman, 59
Stibbert Museum (Florence), 13
Suffczynski family, 17
Şükri, 19
Süleyman the Magnificent, 16, 19,
 24 f, 88, 103, 117, 147, 171 f
Sun Tzu, 7
Szendrei, J., 70
Szwarc, Szymon, 169

Tamerlaine, 46, 89, 156
Taranowski, Andrew, 26, 32
Tavernier, Jean Baptiste, 20
Timur. *See* Tamerlaine
Toledo, cathedral of, 10

Topkapı Seray Museum, 13, 15, 19,
 25 f, 43, 70, 88, 105, 121, 125,
 127, 136, 159, 172
Torteneti Múzeum (Military Mu-
 seum, Budapest), 70

ʿUmar, 21, 34, 139
Urbino, cathedral of, 13, 35
ʿUthmān, 21, 34, 139
Uzunçarşili, 24, 26

Victoria and Albert Museum (Lon-
 don), 121

Wace, A. J. B., 121
Waffensammlung (Vienna), 91
Wawel Castle (Cracow), 13, 35, 43,
 54 f, 165, 169
Wettin Collection (Dresden), 169

Yaḥyā ibn Maḥmūd, 10

Index of Foreign and Technical Terms

Aġa, military officer, 23
'Alam, amulet, 41, 75, 89
'Alam as-sa'āda, flag of good fortune, 18
'Alem-i osmāni, Ottoman standard, 24
'Alem-i pādişāhi, padishah's standard, 24
Anka, giant bird, 113
Ars Odasi, throneroom, 91

Balikçil, plume, 111
Basmak, high boots, 118
Basmala, to say "In the name of Allah," 34 f
Bayrak, banner, 17
Beduh, magic square, 36
Beneki, technical term used in dress making, 121
Beylerbey, commander-in-chief, 26, 84

Boncuk, amulet, 41, 89, 91
Bulawa, sign of the mace, 136

Çadir Mehter, tentmaker, 160
Çatma, technical term used in dress making, 121
Çedik, slippers, 118
Çisme, slippers, 118
Çuhadar, official for sultan's dress, 117
Csintamani, astral symbol, 44, 46, 59, 105, 125, 169

Dalmatica, Byzantine fur, 125
Defterdar, treasurer, 22
Dhu al-faqār, or *Al-fiqār,* Muhammad's sword. *See* Zulfikar in Subject Index
Diba, technical term used in dress making, 121
Dirafsh-i kāvyānī, Sassanian flag, 9

Divan kürkü, type of caftan, 118
Divani, calligraphic style, 37
Draca. See Dragon in Subject Index

Entari, inner garment, 118
Erkan-i kürk, type of caftan, 118
Eviādī, fabric, 15

Firman, royal edict, 16

Gömlek, shirt, 118

Hadith, traditions of the Prophet, 34
Haliş, Turkish flag, 10
Hayme Mehter Başi, guild leader, 160
Hetman, Polish military leader, 91, 96, 169
Hilats, ceremonial caftans, 117, 121
Hırka-i Şerif Odası, 21

Iklim, climate or sphere of earth, 24

Jihād, holy war, 48

Kadife, velvet, 121
Kaftan, caftan, 117–127
Kaftanci, guardian of caftans, 117
Kallavi, turban, 111
Kanun-i teşrifat, law of ceremonies, 117
Kapaniça, large mantle, 125, 127
Kapaniçaci, guardian of the furs, 117
Kapikulu, cavalry, 29
Kavuk, inner cap, 107
Kemer, metal belt set, 118
Kemha, brocade, 121
Khurshīd-i sipehr-i nubuwwat, the sun in the firmament of prophecy, 59
Kistar Ağasi, inspecter of the Holy Cities, 21
Külliye, complex foundations of sultans, xii
Kurghans, tombs, 157
Kuşak, sash, 118

Liwāʾas-saʿāda, flag of good fortune, 18
Liwāj-i sultāni, sultan's standard, 24
Lo Shu, Chinese magic square, 36, 53

Māgên Dâvîd. See Shield of David in Subject Index
Manipulus, early Roman military sign, 3
Mappa, Byzantine handkerchief, 127
Medresse, school, 37
Mehter, military band, 96
Mehterhane, tent depository, 160
Mehterhane-i Amire Nasiri, minister of tentmakers, 160
Mehterhan-i Hayme Cemaati, guild, 159
Mest, shoes, 118
Mimbar, pulpit, 22
Mücevveze, turban, 111
Mudra, Buddha with hand stretched out, 51
Muhr-i Süteymān. See Soloman's Seal in Subject Index
Muvahhidī, turban, 111

Naskhi, calligraphic style, 37
Nasr, eagle or vulture, 55
Nayarlik, amulet, 41

Örf, turban, 111
Orāg-i Hümāyūn, royal tent, 160, 171, 173, 175 n.23

Paşali kavuk, pasha's headgear, 111, 117
Peri cini, angels, 129
Phalerae, round metal medallions, 3
Phanar, ship's lantern, 13
Pluviale, cope, 123

Rajet, Muhammad's flag, 9
Rika, calligraphic style, 37
Roc, giant bird, 113

Saihai, tugh of Japanese commander, 75
Salvar, trousers, 118
Sancak. See sanjak
Sancakbey, provincial governor, 26, 84
Sancakdar, servant of the sacred banners, 22
Sancak-i şerif, noble standard, 17–24
Sancak mushafa, small Korans carried on flags, 32
Sanjak, standard, 17, 19, 23, 29, 33, 38
Saray, palace, xii, 20, 24, 83, 91, 101, 121, 125
Sayeban or *sayban*, tent, 159, 169, 172
Schellenbaum, German tugh, 96 f
Selimī, turban, 111
Seraser, brocade, 121, 125
Serengi, technical term used in dress making, 121
Seyyid, descendant of the Prophet, 22
Shahāda, profession of faith, 32, 34
Shāh-i Dhu ʾl-fikari, Shah of Zulfikar, 50
Signa militaria, Roman military emblems, 51
Simurgh, fabulous bird mentioned in the Shahnamah, 54
Sipahi, regular cavalry, 27 f, 173
Sorguç, aigrette, 111, 113, 127
Sorok, sable skins, 121
Stupa, symbolic tomb, 157
Sülüs, calligraphic style, 37
Sunna, path, 16, 33

Tablion, ornamental patch, 125
Tamga, emblem, 13
Tʾchi, cloud motif, 169
Tirarhane, workshop, 104
Toprakli, cavalry, 29
Topuz, mace, 132
Tuğçik, tugh-bearers, 83
Tugh or *tuğ*, animal hair standard, 7, 27, 36, 69, 173; origin of, 71–77; and Polish army, 91–97; survey of the stock of, 70–71; types of, 79–91
Tughra or *tuğra*, calligraphic monogram, 25, 36, 59
Tülbend aḡesi, aga of turbans, 111

ʿUqāh, Muhammad's flag, 9, 17, 20, 55
Üst kürk, type of caftan, 118

Vali, deputy, 19
Veda kürkü, the fur of farewell, 125
Voievode, governor, 136

Yang, the male principle in Chinese mythology, 8, 54
Ying, the female principle in Chinese mythology, 8, 54
Yurt, tent, 154–157

Zerhaft, brocade, 121
Zihgir, thumb-ring, 125
Zokak, tent fences, 159, 172

Index of the Koran

Koran, 9 f, 20–22, 32–37 passim, 69, 125; inspiration for Ottoman flags, 57–60. *See also* sancak mushafa in Word Index

Koranic verses: sura 2: verse 2 58, 2:115 59, 2:255 35; 4:95 35; 7:54 58, 7:108 59; 10:5–6 58; 11:88 35; 27:15 and 17 59; 32:2 58; 37:1–10 58; 48:1 35; 53:1–2 59; 54:1 58; 56:11–24 69; 61:13 35; 86:1–3 59; 91:1–4 59; 112 35; 113:1–3 59

Index of Subjects

Achaemenids. *See* Persia

Arabs: flags of pre-Islamic period, 8 f; use of tents, 154, 156

Armenians, xii

Assyrians, 38–40, 43 f, 74, 136

astrological symbolism: appearance on flags, 37–46

Babylon: use of flags, 37–41, 43 f, 51

Buddhism, 51, 157

Byzantine, xi, xii, 7, 13, 16, 24, 41, 43, 107, 117, 125, 127, 157; court traditions, 101–104

China: development of flags, 7–10; influence on Ottoman court, 101–104; influence on Ottoman flags, 24, 36, 53 f; precious stones, 127; silk exports, 15; tents, 169

Court: development of Ottoman style, 101–105

Dragon, 3, 8, 54–56, 59

Egyptians, 38, 71, 154

Fabrics: in Ottoman court dress, 103–105; and Ottoman flags, 14–17

Flags: and astrological symbolism, 37–46; definition of, 1; hierarchy of Ottoman, 17; history of, 2–10; inscriptions on, 33–37; of the pashas, 26 f; of the sultans, 24–26; symbolic elements, 32 f; system for carrying, 32; for tactical use, 26–32

Guilds, 103

Handkerchiefs, 127–129
Handprints, 50–54
Hittites, 38

India; sword manufacture, 49
Islam: and early use of flags, 9 f; influence on Ottoman art, 16, 20, 33 f, 37

Janissary, 19, 22, 25, 29, 46, 83, 160, 173
Japan, 74 f
Judaic symbols, 43

Kaaba, 9, 20–23 passim, 32, 55

Mace, 132–136
Mamelukes, 53, 71, 89, 143
Mesopotamia, 3, 8, 39, 136
Messiah, 43
Mongols, 74, 88; and use of flags, 7 f; influence on Ottoman court, 102; use of tents, 154–157 passim
Mythology: ancient Near East, 37–46

Naramsin's stele, 39

Ornamental motifs, 56

Persia, xii, 3, 8–13, 15, 48, 54, 74, 89, 107, 121, 136; influence on Ottoman court, 101–105; symbol-ism on flags, 37–40 passim; use of tents, 153 f, 157, 169. See also Safavids
Phoenicians, 138
Phoenix, 8, 54 f
Poland: use of tuchs, 91–97. See also hetman in Word Index

Roman Empire, xi, xii, 24, 41; use of military signs, 3, 7, 51; use of tents, 154

Sabaeans, 40
Sacred banner. See sancak-i şerif in Word Index
Safavid, 9, 107. See also Persia
Sasanians. See Persia
Seljuk, 13, 15, 24, 42, 56, 104
Shield of David, 43
Soloman's Seal, 37, 43 f, 50, 59, 125
Sumeria: symbolism on flags, 38 f

Tents: Collection of Ottoman, 159–171; hierarchy of Ottoman, 171–173; origin of, 153–157
Turbans, 106–117, 125
Turks (pre-Ottoman), xi; use of flags, 3, 8, 10, 13, 15, 33, 36, 41, 55; use of tents, 157; use of tughs, 74

Zulfikar sword, 29, 44, 46–50, 57, 59